WOMEN

I Have Dressed (*and Undressed!*)

Arnold Scaasi

A LISA DREW BOOK

SCRIBNER
New York London Toronto Sydney

SCRIBNER
1230 Avenue of the Americas
New York, NY 10020

SCRIBNER and design are trademarks of Macmillan Library Reference USA, Inc.,
used under license by Simon & Schuster, the publisher of this work.

A LISA DREW BOOK is a trademark of Simon & Schuster Inc.

For information about special discounts for bulk purchases,
please contact Simon & Schuster Special Sales:
1-800-456-6798 or business@simonandschuster.com

Text set in Berthold Garamond

Manufactured in the United States of America

1 3 5 7 9 10 8 6 4 2

Library of Congress Cataloging-in-Publication Data

Scaasi, Arnold.
Women I have dressed (and undressed!) / Scaasi.
p. cm.
"A Lisa Drew Book"
1. Scaasi, Arnold. 2. Fashion designers—United States—Biography.
3. Fashion design—United States—History—20th century. I. Title.
TT505.S27S23 2004
746.9'2'092—dc22
2004052159

ISBN 0-7432-4695-0

For Parker

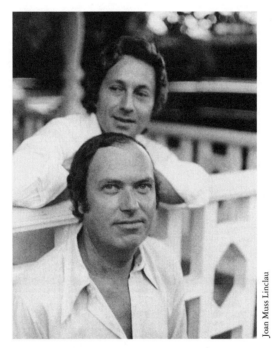

Arnold Scaasi and Parker Ladd, 1970

Joan Muss Linclau

TABLE OF CONTENTS

WOMEN

I Have Dressed (*and Undressed!*)

INTRODUCTION

In going over the seventy-eight scrapbooks of press clippings on my career from 1955 to today, I realized that I have indeed met and designed for some of the most charismatic women in the world. Those press books led me through a kind of analysis—so many memories were conjured up. To date, I have designed five hundred collections and made twenty thousand original samples! Because of the celebrity my work brought me, I have had a marvelous time. From the age of sixteen, when I started design school, life has been mostly joyful. I am a Taurus and my credo is "take the bitter with the better"—I am happy to say that my work has made my life *really* better.

I have met thousands of women and through them, presidents, Hollywood producers and directors, statesmen, politicians, generals, and financial wizards—interesting women *do* attract the finest of men. There just isn't space to write about all the women I've met. If you are not in this tome, don't take it personally—perhaps I will write again and *you* will be included.

After reading this book, my octogenarian friend Bettina McNulty, with those sparkling wise eyes, laughingly said, "Well, darling Arnold, I guess there's no one you haven't met whom you ever wanted to meet!" Probably she's right.

Rereading these personal stories and stripping away "the gossip," I find the book is a kind of social history. This record of my memories illustrates how the world changed—my life has surely been one great adventure with these amazing WOMEN!

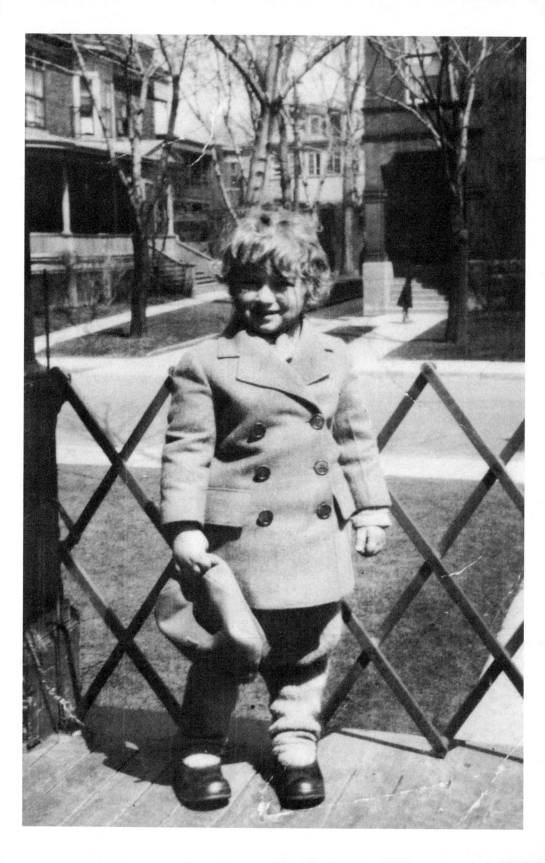

CHAPTER I

BEGINNINGS

When nearly four years old, so family lore has it, I cut the sleeves off one of my mother's evening dresses. That was the beginning, I guess, of my becoming a designer. Of course, I don't recall that particular incident, but I do remember several others that pushed me toward the world of fashion. When I was five or six, I remember *distinctly,* I vehemently told my mother she should not wear her corsage of gardenias on her shoulder, but that she should pin it to her evening bag. She happily complied, and I have been telling women what to wear and how to wear it ever since.

I was born in Canada in the bustling city of Montreal and lived there until I was fourteen, when I went to visit my Aunt Ida in Australia with my sister, Isobel. Isobel, fifteen years my senior, had been through an unpleasant divorce, and it was decided that someone had to accompany her on this long voyage, and that the someone would be me.

My brother, Monty Isaacs, fourteen years older than I, was in the Canadian Air Force.

Up till then, I had shown the usual precociousness of a child born under the sign of Taurus. I was smart and bright for my young age, and had a definite bent toward the arts. This may have been because my father, Samuel Isaacs, as a young man had studied painting and the violin. Though he never did either professionally they were both hobbies he enjoyed.

My father's mother had come from Russia and settled in New York, but being widowed early on, she was unable to keep all eleven children together. So my father and his brother Ben were sent to a wealthy

3

great-aunt in Montreal. I believe this occurrence was quite commonplace among oversize families at the early part of the twentieth century, when a widow did not have the means to keep all her children with her.

My mother, Bessie, was born in Montreal. *Her* mother, my grandmother, was born in Moldavia, a province of Romania. At an early age, it was discovered that Bessie had an exceptionally beautiful singing voice and at age sixteen she went to audition in New York for Giulio Gatti-Casazza, the then head of the Metropolitan Opera Company.

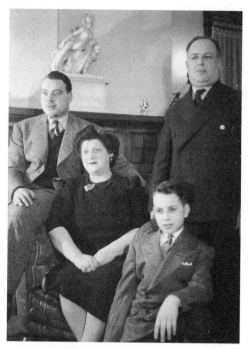

With Mother, Father, and my older brother, Monty.

As a gifted child, Mother was offered the chance to stay and study in New York—her vocal range was three notes higher than Madame Tetrazzini's, the major soprano of the day.

The story is recounted that both my grandmother and my father, to whom Bessie was engaged, were horrified.

"I will not allow my beautiful sixteen-year-old daughter to live in that city of sin," her mother cried. My father threatened, "Our engagement is off unless you come home *immediately!*"

Mother returned, heartbroken. Happily, though, she did marry Sam, and through all my years at home, she sang beautiful arias from different operas each evening to the family.

As a youngster, I painted and drew constantly and I was also quite musical. At the age of twelve, I had the lead in the Gilbert and Sullivan operetta *The Gondoliers*. Strangely enough, I had a deep baritone voice, so puberty must have set in early!

I hated school and, not being interested in sports, I read a great deal.

I also favored the home economics class that was attended by teenage girls. I did have a high school girlfriend, named Leatrice. But, after our third date, when her father took me aside and asked what my intentions were, I quickly flew the coop. I left school at midterm to accompany Isobel to Australia and, though I had some private tutoring abroad—I never did graduate from high school.

Before we left, there were shopping sprees for both me and my sister. I supervised everything and told my parents I knew best. It turned out I did. I had a fine wardrobe for the trip, including proper clothes for shipboard. We would be passing from fall weather in Montreal into subtropic weather in the Pacific.

My mother and sister were both very pretty in a 1930s way. Isobel's appearance was often compared to screen stars of the day such as Hedy Lamarr and Deanna Durbin. I was allowed to indulge my fantasies of what my beautiful sister should wear and we ended up with much too much luggage, even though we planned to stay away for nearly a year.

Remember, in those days stylish women had hats, gloves, handbags, and sometimes shoes to go with each outfit. My mother had a little French dressmaker named Madame Archambeau and a milliner, Mademoiselle Josephine. So clothes were always being revamped and hats were being made. In a way, I received my first training at the knee of Madame, the dressmaker, watching her cut a dress, and seeing the milliner block a hat and then tie it with a bow and add some ornamentation.

My father was a furrier by trade; Isobel had a gray Persian-lamb coat and hat and an ensemble in cheetah plus a silver fox bolero—very fashionable then. My mother, Bessie, wore her full-length mink coat and matching hat to ward off the fall coolness! I remember all this vividly and it obviously began my fascination with designing furs, which I do to this day.

On the way to the Land Down Under, my mother, Isobel, and I left Montreal by train to visit an aunt in Toronto. Leaving my hometown was a godsend, seeing a whole new world, making me better understand myself and the people I met along the way. It's true there's nothing like travel to broaden one's mind. From Toronto, Isobel and I went on alone to San Francisco, where we picked up the ship for Australia. You can't imagine how exciting this was to an impressionable teenager—going halfway round the world!

Aunt Ida, formerly married to a philosopher from the Sassoon family in England, had no children of her own and was looking forward to welcoming us. Though she was not beautiful, she possessed great innate style. Ida and her first husband, Arial, lived on and off in Montreal, while traveling around the world. Both were staunch Zionists, working toward Palestine becoming a Jewish state in the twenties and thirties. When she returned home from her sojourns in Europe, she inevitably arrived with steamer trunks filled with beautiful clothes. She was dressed often by Schiaparelli, Vionnet, and Chanel. It was right out of *A Thousand and One Nights* for me as the wondrous luggage was opened. All through my childhood, my aunt would arrive from faraway places and my fantasies of beautifully dressed women were enhanced.

Ida's first husband died young and she did not marry again until the 1940s when she was lecturing in Australia and met Samuel Wynn, a vintner of fine wines and liquors who owned a beautiful vineyard in Adelaide; he was also a rabid Zionist. They lived in a wonderful Tudor-style house in Melbourne's toniest section and had an amazing garden with great camellia trees, oleander bushes, and sweet-smelling jasmine, and great beds of multicolor oriental poppies, which Ida would arrange in huge bowls she had brought from China. Aunt Ida knew many world leaders such as Mahatma Gandhi and Golda Meir, who was a very close friend. In her travels she picked up all sorts of ethnic robes, saris, and wonderful embroidered caftans. I found when I arrived in Melbourne that these were part of her everyday wardrobe, along with the couture clothes she bought in Europe. I believe that my love for saris and exotic fabrics began in this period of living with my stylish aunt.

The Wynn family was one of the prominent Jewish families in Mel-

bourne, and any celebrity passing through would come to the house for dinner. I remember, in particular, the world-renown violinist, Yehudi Menuhin and his beautiful sister Hephzibah visiting us. The day after the Menuhins had been to dinner, I was on my way home from school and saw the famous violinist walking toward me. Embarrassed, I tried to avoid him but he stopped and said, "Hello, Arnold," and we chatted for a moment. When I returned home I told Ida what had happened and how surprised I was that this great man had stopped to speak to me, this teenage kid. My aunt smiled and said, "You know, Arnold, you are very special and through your life people will always single you out." In that one sentence, Ida had given me the confidence to go on and be myself.

I stayed in this rarified atmosphere for almost a year and then, after much discussion, Ida and I decided that I should return to Montreal, go to design school, and try to become a dress designer. Montreal boasted the amazing Cotnoir-Capponi Design School, run by an Italian woman who had studied and worked for long periods in Paris. It didn't bother me one bit that I was the only boy in a classroom full of girls—in fact, I was spoiled rotten by my classmates! The courses were very intense, and I loved every minute. I learned to sew, drape, and cut from patterns that I had made, and found I had a great aptitude for the courses I was taking. At one point, my teacher said, "You have golden hands, and if you continue you will surely be successful in the world of fashion."

The school was affiliated with the famous Chambre Syndicale de la Couture Parisienne college in Paris. After a year and a half, I had completed the three-year course in Montreal and decided I would take my final year in Paris. At a very young age, I went off to this illustrious school, and so another phase of my life had begun.

Isobel and Ida outside the house in Melbourne

I loved being on my own and found Paris fascinating. Being originally from Montreal, I had spoken French from childhood and also been tutored in Melbourne by a French lady who was a stickler for pronunciation— rolling your *r*'s and all that. Consequently, I speak French fluently—but have no concept of the grammar!

As you'll read in what's to follow, I arrived in New York in 1953 and my life began anew. However, before you read about the wonderful experiences I've had and the very special women I've met, I think you should understand what kind of a person one must be to design made-to-order clothes and to be able to work with these famous and rich and often spoiled women.

On the way to Australia, outside a native hut in Fiji

You have to know their lifestyle and, very often, become part of it. You must go to the places that they inhabit—have lunch with them at really elegant restaurants like Le Cirque 2000 or dine at the luxurious Four Seasons, and, of course, one must attend the charity balls. This is vital if you're going to see what's being worn and what these special women need in their wardrobes. Sometimes it's tedious, but often it's glamorous and wonderful fun!

You have to be like a psychoanalyst. Usually within fifteen or twenty minutes of your first meeting, you're standing before the client—who may be very well known—and she's undressed, almost naked, wearing only her bra and panties, and you're having her try on clothes. Sometimes you're trying to change her persona, bringing out her best attributes. I can't say that everyone is slim and tall the way a model is, but usually women who spend a great deal of money on clothes also spend a great deal of money on their bodies and faces. And I want to tell you, they look great—I mean, there is nothing left undone that can possibly be done!

These women are amazing—good-looking, intelligent, savvy—but to be able to work with them is a very individual thing. I don't think it's something every designer can do—there must be a rapport. They like the clothes you design or they wouldn't come to you in the first place. Obviously, they're going to go out looking either wonderful or terrible—your job is to make them look wonderful. They have to trust you and sometimes be willing to change their ideas about how they should look and adopt *your* more professional view.

It's always interesting to me that the thinnest women will say, "Oh, my God, I'm so fat." And of course, many people find all kinds of reasons why they can't wear something—"My skin is too pink to wear red" or "I've never worn green before." Well, that's just bull! These ideas and phobias were told to them and nurtured by their mothers. It takes a long time for women to shake off their mothers' first criticisms.

Also, fashion frequently changes. Quite often I will have said something to a client that they never forget—they take it as gospel. I remember a while ago doing a fashion show in Texas, and I spoke to one of the models who had worked for me earlier in New York.

"What color shoes are you going to wear with this dress?" I asked.

"Beige?" she said, hesitantly.

"But why? They have nothing to do with the dress. The shoes should be red or silver" (or whatever), I suggested.

"But Mr. Scaasi, you told me when I first met you that I could always wear beige shoes with everything, and I have done that for the last five years."

Of course I was shocked, but I *had* really told her that. I might see a client and say, "This black dress is perfect for you."

"But Arnold, you told me that I must not wear black." So there you are. Fashion changes and your ideas change. You hope that women will go along with it and change too. The designer's eye changes all the time, and what looked great to you a year ago might look wrong today. Of course, that's what keeps your adrenaline going and what makes fashion really exciting!

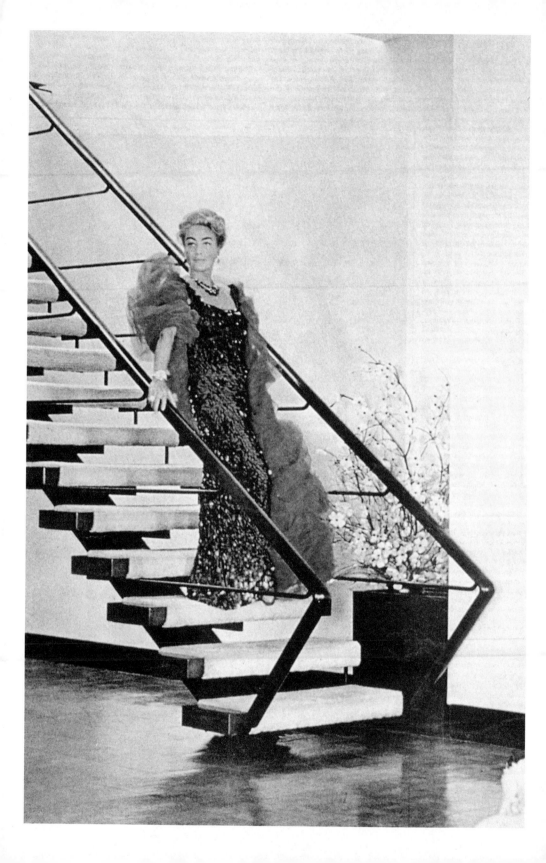

CHAPTER II

JOAN CRAWFORD

Recently one Monday evening—the night the fabulous Bobby Short does *not* appear—I went to the Café Carlyle to hear Woody Allen play the clarinet with his New Orleans jazz band. He was the center of attention and absolutely terrific. As my eyes became accustomed to the dim café light, I noticed the charming, whimsical wall murals, done in the late forties by Vertes. These fantastical paintings of people floating around the room are a tribute to his originality as an illustrator. In the thirties, Vertes illustrated fashions for *Vogue* and *Harper's Bazaar.* He did get the shape of the body and the feeling of what people looked liked, but then always put them into imaginative situations. At the Café Carlyle, for instance, one of the walls has a ballerina floating in space among the clouds with her legs askew, and next to her a topless girl in harem pants hugging a horse! Seeing these paintings took me back many years to my really first important night in New York City.

The year was 1953; I had just arrived from Paris and my studies at the Chambre Syndicale de la Couture Parisienne. My ship docked in New York City and my parents had driven from Montreal to take me home the next day. Well, I dressed up in my best navy suit and excitedly went off to meet Charles James, the famous American couturier to whom I had an introduction. I had talked to Mr. James on the phone earlier in the day. In his pseudo British-Chicago accent he said that he was "going to a vernissage of Vertes work at the Iolas Gallery on East Fifty-seventh Street—do come along and join me there."

I arrived at the gallery and there were many of the fantastic Vertes

11

paintings—still in my teens, I had never seen anything like them! I remember an enormous three-panel screen at least eight feet high with these extraordinary painted wash-type Impressionistic figures floating around in pastel shades—sort of like Marie Laurencin but much freer in feeling, much more amusing and imaginative. Going up the circular staircase to the show, I was told that Mr. James had not yet arrived, so I sat on a bench that faced a sheer white curtain forming an almost transparent wall around the exhibition. Through the curtain I could glimpse bits of the Vertes paintings. Remember, this is years and years ago, and I was very young but felt very sophisticated, having just spent almost a year in Paris on my own.

I was very nervous, never having met Mr. James before. But I knew if I made a good impression he might offer me a job in his atelier, which Christian Dior told me was the greatest in the United States. While contemplating the Café Society world of New York around me, in came this extraordinary figure wearing ankle-strap shoes, a black broadtail suit with a big diamond pin on the shoulder, and a tall peaked hat veiled in black tulle. It was Joan Crawford—the quintessential movie star.

Accompanying Miss Crawford was Anita Loos, the infamous author of *Gentlemen Prefer Blondes,* like a little wren, a bird of a thing totally dressed in brown from head to toe; they made an unlikely pair. The couple passed me by and continued into the exhibit. A shiver went up my spine and I thought then and there, "I am not going back to Montreal—I'm staying right here in New York, where it's all happening!"

In a short while, the brilliant, egocentric Charles James arrived with a curious

look on his face as if he was thinking about everything around him, noticing everything, taking it all in swiftly. We said hello as we moved into the main gallery. He introduced me to everyone, and said that I was a young Canadian designer who had just arrived from Paris. Of course, I was lost in the sophisticated conversation of the art world of the early fifties. Iolas, who owned the gallery, was a large man, a Greek and perfectly charming. He took care of me until I left with Mr. James later on in the early part of the evening.

We went back to the atelier and Mr. James, having listened to my qualifications, invited me to come and work for him. This was the greatest coup of my life up to then.

"If you can work for Charles James then you must go back to the United States, bring fashion to America, and find your future there—the future of fashion is in America," Christian Dior had, in fact, said to me.

The thing that struck me during that whole evening, as exciting as it was, was not being offered a job in New York. No, the thing that stood out most was that I had seen and met the fabulous movie queen Joan Crawford. It's a moment I will never forget. Of course, it was the begin-

ning of my whole life in New York—what a beginning! I went back to tell my parents at the hotel.

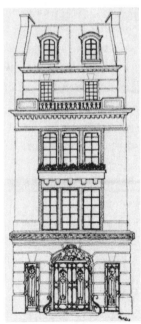

"I'm not going home to Montreal, I'm staying in New York. I have a job and Monday I start working for Charles James. I'm going to make forty-five dollars a week; isn't that wonderful?" My parents were great about it and really happy for me—they let me stay.

We fade to 1959. By then, I was well known—a kind of fashion superstar. I had won my Coty Fashion Award in 1958, the most prestigious fashion honor at that time, and was selling my designs to about a hundred and fifty of the finest stores across America. So let's face it—I had become famous!

I had bought the Stanford White house on Fifty-sixth Street just off Fifth Avenue and

Stanford White house

13

Valerian Rybar decorated it for me—I was well on my way. I was the new couturier, though Mainbocher still existed. Mr. James by that time had gone out of business and Isaacs had been turned backward into Scaasi, and SCAASI was the designer you went to for fabulous clothes. My peers were Norman Norell and James Galanos. There were the three of us to choose from if a woman wanted extraordinary clothes. We did very different types of designs and some people shopped from all three houses.

One day an advertising executive contacted me and said, "We'd like to take you to lunch at La Côte Basque," then the restaurant of the moment. He explained that Joan Crawford had asked if I would do the clothes for the Pepsi-Cola ads on television. The company was run by Alfred Steele, Miss Crawford's husband, and Crawford wanted the clothes for the ads done by Scaasi. I was asked to fly that evening to Jamaica, British West Indies, where they had a magnificent home, to discuss the project.

"I am terribly sorry but I have to go to my house on Long Island this weekend. I cannot go to Jamaica, and I don't think I really want to do the clothes for the Pepsi-Cola ads anyway!" Really, the things you say in your early twenties!

Time passed and a few weeks later the salon was told that Joan Crawford would like to come and see the collection. Of course, I was thrilled. I hadn't seen her other than on the screen since the evening at the Iolas Gallery. Inside we all waited with bated breath, looking out the windows of the Stanford White house onto Fifty-sixth Street, waiting for the great movie star to arrive. Sure enough, a long gray limousine cruised down the street and stopped in front of the house. As we waited, her chauffeur, dressed in gray, got out of the car and opened the rear door and out came the fabulous Joan Crawford. She was dressed in gray—a gray mink turban and a long swirling gray mink coat. The outfit was complemented by a gray suede handbag and gloves and matching ankle-strap shoes. She was accompanied by her twin daughters who were by that time about thirteen years old but dressed as little French schoolgirls in navy blue pleated very short dresses, uniform style, wearing hats with streamers down the back. It was definitely a performance—this supposedly wonderful mother and her two teenage daughters were meant to be the lov-

ing mother and her little girls from a past film—the problem was that they weren't so little anymore, being about five feet tall!

Crawford came up the grand staircase with the "children" trailing behind obediently. She arrived at the second floor salon and we greeted her effusively. We began to look at clothes. She was charming and attractive but definitely the "grande dame," although making a great effort to be "the people's choice" and really a very simple person—unfortunately, one was always aware of being in the presence of royalty—granted, Hollywood royalty.

After showing her many things, we settled on a striped Kelly green and lime taffeta dress from the collection; a sort of calf-length dress with a full skirt very much of the moment, late fifties. It had a boat neck and little cap sleeves. We also decided on a white silk coat that would be lined in the same striped silk.

"Oh, Scaasi, this will be *perfect* to wear to the country clubs and convention evenings where I have to go with my husband," she said.

"Now, Miss Crawford," I interjected, "I'm going to give you a swatch of the fabric and perhaps you can find a really lovely pump that would look nice with this outfit," because there had been so many bad jokes about her ankle-strap shoes. She looked me straight in the eye.

"Scaasi, you take care of the dresses, I'll take care of the shoes." Well, of course, I never mentioned the word "shoe" again.

At the time, we had a wonderful African-American maid in the house named Sarah Minor. Sarah would help clients while they tried on clothes and put away things that had been discarded. Joan made a great point of not having Sarah do any menial task, insisting that her two girls hang up all the clothes that she had tried on. We found that very strange, but the girls did what they were told and hung up everything—while Sarah Minor stood by, watching in disbelief.

The thing that struck me most that day was the appearance of Crawford—the makeup and the face and the hair, all perfect, and even though she had begun to age, she had this wonderful look that no other face had. She was definitely Joan Crawford, the movie queen.

When she undressed—and she was not shy at all about taking everything off, standing only in her bikini panties—I was amazed to see that she was built very much like a man. Her shoulders were very, very

*Surrounded by sketches for Joan Crawford and Lauren Bacall
in my "grand" town house office, 1959*

wide and her hips very slim; she had a long torso that tapered to these slim hips. The first thing I noticed was her shoulders and realized of course that Adrian, who had created the Crawford look with wide padded shoulders on suits in the forties had no other choice. These were really her shoulders! I realized that the Adrian style that Crawford was so associated with began, as so many things in fashion do, with her own features and the fact that Crawford had these "football player" shoulders. The designer was very clever in camouflaging things of this type. He dressed women for the character of the roles they played in pictures—Crawford, being famous for portraying tough businesswomen, needed a more masculine look, but indeed she really was this type physically. Adrian did a wonderful camouflage job on Greta Garbo (who had the same wide shoulders). In *Camille,* where she was to look very wan and sylphlike—you know, the heroine dying of consumption—her period evening clothes were mostly off the shoulder, baring the shoulders but making what went beneath the shoulder line very big so that they looked smaller. He could obviously not do this with Crawford's modern-day suits, so we have the wide-shouldered look of the forties.

We continued making clothes off and on mainly for her appearances at Pepsi-Cola Company functions. They were always dramatic, but also very pretty. She seemed to want to get away from that tough look that she had been known for in films and really wanted to become the picture of a sophisticated housewife, which enhanced the image of Pepsi-Cola.

In 1961, I was doing clothes for many Broadway and film actresses and *Holiday* magazine said they would like to do a story, covering people in the theater that I dressed. They asked for a list and I gave them quite a long one of maybe fifteen actresses. I included Eva Gabor, who was with Noel Coward that year in *Present Laughter,* and the charming Kitty Carlisle Hart, my dear friend and fine actress Arlene Francis, and also Dina Merrill. Melissa Weston was a beautiful young blond model just getting her first break on the stage—that career went nowhere, but she is still a beautiful blonde to this day. I put down Joan Crawford's name, of course.

The editor called me, having chosen some of the people I suggested, and said we should begin to decide what clothes they were going to be photographed wearing and where the photography shoots would take

place. Most of them were photographed around Broadway, though Kitty Carlisle Hart was shot in her wonderful duplex apartment.

I was shocked that they had not picked Joan Crawford.

"Of all the actresses I dress, Crawford is certainly the greatest star, the best known, the most popular."

"Yes, we like her very much but let's face it, she's really too old," the editor said.

"Well, you can always retouch," I suggested.

"No, no, we cannot retouch color photographs and most of these will be in color."

"Well, I don't know," I continued, "I just think you should try it because she really looks wonderful and she's a really big star." Anyway, I insisted upon it, and they finally agreed.

I talked to Joan about being photographed and she was very excited. She had not done a movie in quite some time and I think she felt it would be very prestigious to be with all the great actresses from Broadway. That summer, before we shot the photographs, she rented a house in Westhampton on Long Island; we were neighbors, as I had my own house in Quogue, next to Westhampton. So, in order to fit the outfit, I said I would bring it to the country and we would meet over the weekend to see how it all looked. On Saturday I went to the beach, and when I got home, Sarah Minor, who also came to the country with us, had a message, saying that a lady had called. I asked her who it was.

"Well, I don't know. She said that she was Joanne Crawfor."

"Oh, Joan Crawford?" I asked.

"Yeah, and dis here's ha number," Sarah said in her island twang. I called the number and she answered the phone.

"Oh, Joan, I'm sorry, I just got back from the beach," I said, "Can I come over and fit the dress and coat on you?"

"Oh, absolutely. I have a film producer here from London. So we're a little busy, but I'm dying to see how it turned out and I'd love you to come, please come now, dear—oh, by the way, *who* do you have working for you in your house?" she asked.

"We have the wonderful lady that you met at the salon, Sarah Minor." There was a pause.

"Well. I guess she never goes to the films."

"What do you mean?" I laughed.

"She asked me to *spell my name*—J O A N C R A W F O R D." Well, you can bet the Queen Bee was more than a little upset.

That afternoon I took the dress over to the house she had rented, one of those grand estates in the Hamptons, and there, again, were the twin girls. The young teenagers asked if they could go out and play tennis.

"Absolutely not," Joan said. "You will stay with Mother and you *will* be charming to the people from England. After all, *Mother* is doing this for *you,* not for herself." This gave me another insight into Joan Crawford's personality.

While I was there, I went to the bathroom. The sink was full of small items of underclothing that were being washed in soapsuds. This really surprised me. Then I began to think back how my friend Maryanne had told me about staying in Joan Crawford's home at one time, and how Crawford had this fetish about cleanliness. We always thought it was part of her guilt complex about how her film career got started—it was widely rumored that she had made soft-core pornographic films in the beginning. Maryanne told me she had left underwear from that day on the chair when she went to bed. Waking up the next morning she found it had all been washed and pressed beautifully. I never believed that story, but suddenly I thought, it's probably true because here is a sink full of washing, which, obviously, Miss Crawford was taking care of herself.

Crawford that day was dressed very casually in white shorts (she had great legs) and a pink man's shirt and, of course, there were the sexy ankle-strap shoes. She excused herself from her guests, we fitted the dress and long cloak, and I went on my way back home.

The day arrived when we were to photograph Miss Crawford in her Fifth Avenue apartment—the famous, all-white apartment. When you arrived she made you take your shoes off so that the white carpet would not get soiled, and all of her white couches were covered in clear plastic slipcovers. The photographer and I arrived at the appointed time and, naturally, I was a bit anxious because I had been told that we couldn't retouch the color film—a far cry from the digital camera of today where you can do anything with the push of a button!

I rang the bell, and Crawford opened the door herself. She evidently was all alone in the apartment—this very grand apartment.

"Hi, how are you? I'm so happy to see you. Please come in after you've taken off your shoes." We dutifully did as we were told and went into this wonderful space with the free-floating staircase. It was really quite spectacular. Still, I was shocked that Crawford had greeted us at the door with her hair pulled back into an elastic band, a very sleazy-looking bathrobe wrapped around her, and no makeup. Indeed, she did look old. I thought I had made a terrible mistake; the editors of *Holiday* were correct—what had I done? Well, it was too late. We were there, the dress was there, the matching tulle coat was there, and it was time to get ready for the photograph. The photographer set up his camera.

"Come upstairs and let's get this show on the road," Joan said. I followed her and we arrived in her dressing room, an enormous space with hundreds of pieces of clothing around on racks—all built in—and hundreds of pairs of shoes.

"Okay, now, which shoes do you like? Do you like blue or do you like green?" she asked. I went around and picked the proper pair of shoes— ankle-strap shoes, of course, her trademark. Then she opened the jewel box and there was this wonderful necklace, a diamond necklace, which had big grape-size drops of cabochon emeralds. As the dress was in green and blue thumbnail sequins and this great meringue of royal blue and green tulle forming a long, sweeping coat, I thought the emerald necklace would look wonderful.

"You know, if you don't like the emeralds there are hook-on diamonds just as big, or there are giant pearls. What do you think, Arnold?"

"I think the emeralds are absolutely perfect," and that's what she wore. All the time we were doing this, I had real trepidation that when we finally took the photograph I would have this beautifully dressed *old* woman with her extraordinary diamond-and-emerald necklace, and it really worried me.

"Okay, let me get ready now. I'll be down in ten minutes," she said. I thought, Oh, my God! I helped her on with the dress and then I went downstairs and tried to placate the photographer who I think was more than a little worried also. He set up his camera at the bottom of the free-floating modern staircase, and we nervously waited.

Suddenly, Crawford appeared at the top of the stairs, this absolute vision. There were the green and blue sequins sparkling against the tulle

coat, which was off the shoulders and flung behind her. Above it all, the diamond-and-emerald necklace. And, of course, the wonderful Joan Crawford face—that extraordinary face. It had been totally made up, totally redone in a period of fifteen minutes. The red hair had been swept up, and down she came. The photographer and I were mesmerized.

She literally floated down the staircase, and he began to click pictures. Every time he took a picture, her head turned and a different expression appeared on that marvelous face. He must have taken at least forty photographs. In each one, as she descended the staircase, the face changed. And she was, indeed, Joan Crawford, the great movie star. The camera loved her and she knew exactly what the camera was doing.

When the *Holiday* article came out, the largest photo—the full-page one—was, of course, of Miss Crawford. Dazzling everyone!

Joan Crawford died in 1976 of ovarian cancer. Though she may not be in our lives anymore, that face will always be on film to remind us what a truly great movie star is.

With, top, left to right: *Liz Gillet, Kathleen Hearst, Gayfryd Steinberg, Bunty Armstrong, Austine Hearst, Edna Morris, Arlene Francis;* middle: *Kimberly Smith, Louise Nevelson;* bottom: *Tootie Wetherill, Patty Raynes*

CHAPTER III

NEW YORK GIRLS

For over forty years, there have been—if not precisely, then certainly close to—one thousand women who have had clothes made-to-order in one of the different New York spaces that *Scaasi Couture* has occupied. It would take at least three volumes to write about *all* these wonderful ladies. For the sake of brevity, let me tell you about just a few of the exciting and interesting women that come to mind.

In the mid-1950s, I decided *not* return to Paris to seek my fame and fortune. Instead, I would make clothes for a handful of special women, and invest the two thousand dollars I had saved in making a few dresses that I could show to some of the more prominent stores in New York, with the hope of starting a ready-to-wear business. The "railroad" flat I lived in (one room following the next in a line) consisted of a living room, which acted as the "salon," a tiny bedroom for "fittings," and a nice sized "dining room," which was my workroom. There was also a kitchen, big enough to have a breakfast table. I had sublet the space from a "Mr. Brown" (whom I never met) for the magnificent sum of eighty-five dollars a month. (Also, there was one very small room at each end of the flat that was mysteriously locked!)

Personally draping all the toiles (patterns), with the seamstress and tailor I had hired cutting and sewing away, I had quite a nice little made-to-order business going at the time.

Muriel Maxwell (an ex-*Vogue* editor), who had more style in her little finger than anyone around, and Jane Gray (an ex-*Harper's Bazaar* editor), who was six feet tall and extremely thin—she looked like a Modigliani painting—had formed a public relations firm, Maxwell-Gray, devoted to

the fashion industry. They had seen the coat and dress ensembles I created for the Fisher Body car ads, where SCAASI was credited for the first time, and wanted me to design something for a Lucky Strike cigarette ad. The two fashion mavens arrived at my cluttered flat and viewed with astonishment the sophisticated clothes I was making for my small clientele, including Arlene Francis; the model Carmen, who is still photographed today; Mrs. Irma Schlesinger, Nan Kempner's very chic mother; Mary Tae Nichols, whose husband was the editor-in-chief of the *New York Times* Sunday magazine; and Miss America, Mary Ann Mobley. Many other ladies wanted clothes made especially for them that looked exciting and were different from the norm. They all found their way to my unorthodox space on East Fifty-eighth Street.

When the Misses Maxwell and Gray arrived, we were working on a short black draped matte jersey dress for Mrs. Schlesinger that was inspired by a dress my mother had from the Paris designer Madeleine Vionnet. (Aunt Ida had bought it for my mom on one of her many European trips.) I remember Mother wearing it to synagogue on high holidays, with a black satin draped toque hat, white kid gloves and silver foxes draped about her shoulders. In those days, one dressed to go to a place of worship.

On the cover of my previous book, *Scaasi: A Cut Above*, you will see me at barely twenty with a striking dark-haired model, Gillis McGill, who was probably *my* original New York Girl.

Gillis fitted for me for at least ten years—starting when my name appeared on the *Dressmaker Casuals* label in 1955. I had met her late in 1954, while doing clothes for a fashion show for the petite French milliner Lily Daché. Remember, from the thirties through the fifties hats were a must for every stylish woman, and Miss Daché was the rage of her industry. However, *she* changed all that in the early sixties when she launched Lily Daché Wigs.

"No chic woman should wear a hat today—only a wig!" she proclaimed. One day before a Daché press show, Gillis McGill was modeling one of my dresses for the French spitfire and wearing one of her newly designed hats.

"McGillis"—not ever getting her name right—she shrieked in her thick French accent, "you have *le chapeau* on *backwards!*"

"I know, Miss Daché," Gillis responded sweetly, "it looks better this way." The milliner laughed and agreed. I knew at that moment that the strong-willed stunning young model and I would bond—we have been friends ever since.

You might say she was my muse, as she quickly told me when she disliked something during our fittings (like not making a skirt short enough) or be overjoyed when I designed a dress that was new and "really glorious."

With Gillis McGill, 1959

Gillis started her career at Bergdorf Goodman as a part-time stock clerk at fifteen, and told Mr. Goodman, at sixteen, that she thought she could be a model. He said "okay," and suddenly she was one. At big fashion shows like Eleanor Lambert's, she would move down the runway, smiling from side to side, as if she were welcoming you to her home. She had a wonderful look, seeming really to own the clothes she was wearing. Gillis was the first to wear my green-shaded feather dress to the very swanky *Bachelor's Ball*. Next day she told me that Babe Paley, the epitome of style, said, "That's the most beautiful dress I've ever seen!" Gillis was intelligent and amusing—and still is today. She went to almost every chic party in New York, mainly wearing my designs. She had great style and certainly helped spread the word that you would look beautiful if you were wearing a Scaasi outfit.

*　　*　　*

One of the most remarkable experiences I had in the railroad flat was the day Mrs. "Bobby" Silverman trudged up the stairs to have an evening gown made for her son Jeffrey's Bar Mitzvah. Mrs. Silverman was a pretty,

strawberry-blond young woman who had seen my gowns in the Fisher Body ads and wanted, more than anything, to own one.

"But my husband will have a fit if he finds out that I paid fifteen hundred dollars [an exorbitant amount then] for an evening dress!" she confided. However, she explained, the family, living in a large house in Great Neck, owned seven cars. She asked if I would accept one, along with a small amount of cash (three hundred dollars) in return for making this special gown. I accepted with alacrity, and soon found I was the proud owner of my first car, a 1952 navy blue Buick convertible with extended fins in the rear! Mrs. Silverman looked wonderful in her ruby velvet-topped ball gown with a big skirt draped in scarlet duchess satin. We were both thrilled, and Jeffrey turned thirteen with all the pomp his loving mother imagined.

* * *

I have adored Nan Kempner for more than forty years, ever since her mother, Irma Schlesinger, the matriarch of a San Francisco banking family, first brought her daughter to my studio. Mrs. Schlesinger was a *grande dame,* who loved the clothes I had designed for a friend, and then came along to "discover" me for herself.

Nan was a tall and rather reserved young lady, who had married Thomas Kempner, heir to an investment banking family from New York. Little did we know that the very young and pretty Mrs. Kempner would appear on every best-dressed list and become one of the much publicized reigning queens of New York society for over four decades.

Nan, excited about the dresses I made for her mom at this early stage in my career, later asked me to design some clothes for her. One was a beautiful black silk coat, lined in organza embroidered and appliquéd with a garden of multicolor flowers. The little sixties minidress that went with it was made of the same extraordinary flowered fabric. Another short dress was all covered up with three-quarter sleeves and a bell-shaped skirt made of a deep green reembroidered lace. Tommy Kempner still mentions it today, saying, "It is one of my favorite dresses that Nan owns."

By the seventies, Nan had pretty much abandoned American designers and was dressed almost exclusively by the European couture.

Last year I saw a photo of Mrs. Kempner dressed in imperial splendor at Lynn Wyatt's chinoiserie birthday party on the French Riviera. Nan

loves all sorts of people and travels the world over to attend their fabulous parties. It has been said a lot that "Nan Kempner will go to the opening of an envelope!" However, under all this bravura you have a really nice, good-hearted person with a merry sense of humor, a fact that her glamorous façade often hides.

Nan just seems to love parties and can't resist a photo op. A couple of years ago on a charity weekend in Venice planned around the Biennale art fair opening, Larry Lovett gave a smashing dinner party for the American group in town. It was on the terrace of his fabulous palazzo, overlooking the Grand Canal. Nan was to be photographed by a glossy magazine. She didn't appear, and we all wondered what had happened. Suddenly, she made her entrance about an hour late, limping in with two strapping young men supporting her. After a glass of champagne, the photos were taken, with Mrs. Kempner smiling through it all. She stayed on for dinner, seeming to have a fine time.

The next day, when she didn't appear at any of the Biennale festivities, we heard that she had gone to the hospital—with a broken leg! The night before, racing to the palazzo, she tripped in her stiletto heels on the stone steps of the place where she was staying. That would certainly not stop the tenacious Nan from going to a good party or a photo op. She may have arrived limping and late, but the glamorous Mrs. Kempner was there!

* * *

In 1956 I finally opened my first ready-to-wear collection, though still living and working out of the Fifty-eighth Street flat. Maxwell and Gray did my public relations and, as I didn't have a showroom, they arranged to do my opening show in the corner suite overlooking Central Park on the mezzanine floor of the elegant Plaza Hotel. Because they had both been editors on the two major fashion magazines, they were able to get all their buddies from the press to attend. Even though I showed only twenty-one pieces, the next day the papers were unanimous: "A fashion star is born." Unfortunately, the Plaza would not allow one to sell a dress collection from within the hotel; we moved across Fifth Avenue to the Savoy Plaza Hotel, now the site of the General Motors Building. Betty Ann, my only assistant, and I phoned every buyer in town from all the fine stores across the U.S. to persuade them to come and see the collection. You can't be shy if you want to be in the dress business!

By 1958, I had moved into a beautiful Stanford White house on Fifty-sixth Street off Fifth Avenue. Doing three collections of ready-to-wear a year, a major fur collection, children's wear, plus an important jewelry collection, and still seeing the odd made-to-order client when time permitted—we were selling to over one hundred and fifty of the finest shops across America—I was getting rich!

* * *

One of the most charming people who came for something special was Kitty Carlisle Hart, married to Moss Hart, the exceptional stage director of the smash hit *My Fair Lady*. Mrs. Hart wanted a spectacular outfit to wear for the opening of the musical in London, where she and her husband would be presented to the Queen of England.

She arrived with her assistant, and we began to show the collection of luxurious clothes. We were chatting on about the clothes when suddenly she said, "Arnold, I

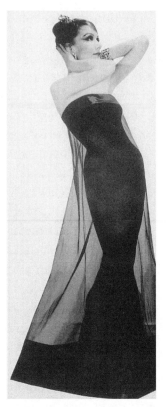

Black sheer "cage" over black satin sheath, 1961

just love your last name, especially the way you changed it by turning it around from Isaacs to Scaasi—it's brilliant! You know, I changed my name, too. I was Kitty Conn. At the start of my singing career, my mother took me to a numerologist and asked her what would be a good stage name for her theatrically ambitious daughter. The numerologist did a lot of tinkering with numbers and finally said, 'Well, Mrs. Conn, you have three choices—the *first* name I can suggest is Carlisle,' she said, nodding toward me. 'You would then be *very* successful in the theatrical world and you would marry a *very rich,* handsome young man. The second name I would suggest could be'—before the soothsayer could finish, Mother interrupted, saying, 'Never mind the others, we'll take number one!' And so I became Kitty Carlisle. But, Arnold, you were much cleverer when you became Scaasi—I never could have turned *Conn* backward!" she laughed.

She then showed me a magnificent diamond necklace, which had been Mrs. Conn's, and said she would like a dress appropriate for the occasion so that she could wear her mother's jewelry. I designed a simple, elegant white chiffon draped strapless gown that was perfect for the actress.

During the final fitting, Moss Hart, always the genius control freak, arrived to see if he approved of what Kitty had chosen. Though he was not very tall, with his handsome Semitic face and dark hair, he made a commanding figure. He was enthusiastic about the way his wife looked in the white chiffon gown.

"Scaasi, don't you have something spectacular Kitty could wear over the dress to make a grand entrance—I want her to look outstanding that night and make the Queen envious!" he said. I brought out an evening coat of pale blue moiré shot through with silver thread. It was luxuriously lined in white fox with a great cape collar of the same fluffy fur. I draped it across Kitty's shoulders.

"Wow, that will do it," Moss exclaimed. "Kitty, you look magnificent! Now, you know, of course," he continued, "we're buying the gown, but

we can't afford to *buy* the coat, too—I'm sure you'll loan it to Kitty for the London opening." I was confused, here was Moss Hart, one of the most financially successful dramatists/directors/producers in the world—"hondeling" (Yiddish, for bargaining) about the coat.

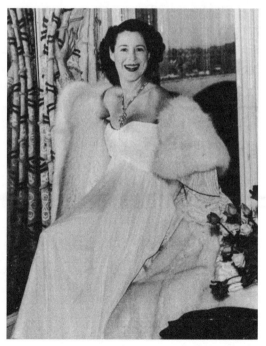

"Well, Moss," I answered, "If *you* can't afford it, I guess nobody can. Of course, I'll loan it to Kitty." He left with a smile on his face, knowing he had won.

Kitty Carlisle Hart went to London and curtsied

Kitty in the fox-lined coat

before the Queen, wearing the shimmering coat. I was happy to know that she felt beautiful on that very special night in her life, all those years ago.

Today, she remains a dear friend. In her early nineties, with wavy black hair, sparkling blue eyes, and a broad smile, she is the epitome of charm and wit—one of the truly glamorous New York Girls!

* * *

In the sixties, I had great fun doing amazing white swans-down short coats over brightly beaded fringe dresses for Rosemary Clooney's night-club act in the Empire Room of the Waldorf-Astoria Hotel. The work-rooms were covered in swans-down from floor to ceiling and everyone was sneezing! The outfits were a smash on the enormously popular, world-famous blond chanteuse.

Frequently dressing celebrities, not too long ago I did a zebra-printed, black-and-white brocade long dress for Julie Andrews for a special bene-fit at Carnegie Hall. One of the most important musical talents to come out of films, she has also become a professional writer. One year, she came and read to us from her wonderful children's book at the *Literacy Partners' Gala Evening of Readings* that my dearest friend Parker Ladd, Liz Smith, and I chair at Lincoln Center.

The list of women who came to my New York premises to have clothes made through the years surprises me, even now. They were the socialites of America.

When I first opened the made-to-order salon in 1964, I did almost all of Mrs. Cortwright (Tootie) Wetherill's clothes. A Philadelphia Main Line heiress, she had invested in my new venture as her mother, Gertie Widener (who had racing stables outside Paris) had done with the couturier Main-bocher, sort of keeping up the tradition. Tootie only wanted couture clothes and felt Mainbocher dressed her too matronly. I made her short, col-orful, lavish sixties designs, and she delighted in her new persona. Cortie and Tootie Wetherill insisted on paying full duty on Tootie's astronomically priced French couture clothes. I thought this was a fine testimony to their classy roots. I continued to dress the ebullient, champagne-sipping Mrs. Wetherill until she died, much too young, of liver problems in the 1980s.

Mary Rockefeller, Jean Vanderbilt, Enid Haupt (of the philanthropic Annenberg clan), and the charming Diana Strawbridge Wister, another

Main Line close friend, were some of our early clients who continued being Scaasi fans.

<p style="text-align:center">*　　*　　*</p>

The very elegant Mrs. John A. (Edna) Morris, who was extremely tall, a size six, with extraordinary breeding and style, came to the salon in the late sixties. She had an unusually long aristocratic neck and always wore four-inch collars of Oriental pearls. Like Tootie Wetherill, she left Mainbocher for my luxurious, more contemporary style. John Morris's father started the first American racing stable. It's interesting to note, when American racing began, the four primary colors were chosen for the jockey's outfits by the first four recognized stables. While making a grand dress for Edna to wear to an award ceremony in her honor at Belmont racetrack, I found that her "racing silks" are simply scarlet. Obviously, the Morris stables had chosen the brightest primary color. Edna Morris adored red, as I do, so we got on famously. When choosing her new clothes each season, she would very often bring the then octogenarian John Morris along. He was always impeccably dressed in the English style, often wearing a black bowler hat—his white mustache perfectly trimmed.

"Now, Mr. Scaasi, my wife has the most wonderful figure, so be sure that you put her into clothes that will show off her best assets"—quite a statement from the horny, little eighty-four-year-old investment banker. Clearly, we followed his lead and Edna Morris always stepped out looking glorious.

<p style="text-align:center">*　　*　　*</p>

Another impeccably dressed husband was the brilliant writer Alan J. Lerner, one of the most erudite charmers around—just listen to any of the lyrics of his hit songs from *Gigi, My Fair Lady, On A Clear Day You Can See Forever,* and others. He knew the English language like almost no other lyricist, rhyming words that many wouldn't use, yet telling the story clearly. He adored pretty women and was a sucker for a girlish smile, marrying eight times in his all-too-short life! Alan loved my designs and if he stayed married long enough (more than a year) he would usually send his new wife to the salon for some Scaasi clothes.

One of my favorite Lerner wives was Karen, a cheerful, very pretty young woman who wanted only extraordinary outfits. When she first came to me in 1970, she immediately ordered a man-tailored, bell-bottom

<p style="text-align:center">31</p>

pantsuit pavéed in pearlized apple-green sequins. She was a size four and looked stunning. It was Alan's favorite.

Not long ago, I asked Karen to loan me a long white evening dress for my retrospective at the Fashion Institute of Technology in New York. The ball gown had a very simple long-waisted strapless top and a voluminous skirt of flying white ostrich feathers.

"But Arnold, don't you know what happened to that dress? I had been separated from Alan for a long time before our divorce [they'd been married eight years]. One night, I went off to this wonderful ball with my steady beau and, of course, I was a smash hit, dancing madly all evening. When it came time to leave, we decided to go to *his* grand place on Park Avenue. I woke up at nine the next morning to find he had already left the apartment. The butler served breakfast and then the reality set in! How could I go out in the bright morning's sunlight wearing my white ostrich feather ball gown? I hunted through the closets and put on a pair of Edgar's blue jeans and a shirt, with my stiletto-heel silver dancing slippers—I hightailed it through the front door and into a taxi. Finding my beau had left for a long stay in Europe, the romance quickly cooled. By the time he returned, I had traveled myself, with a *new* boyfriend to England. I didn't talk to Edgar again until almost a year after the ball. By then, he had remarried and moved to Fifth Avenue. I was too embarrassed to ask him where the dress was. Arnold, that was thirty years ago and for all I know, your white feather creation is still hanging in some closet on Park Avenue!"

* * *

In 1972, I was pleased that my longtime chic grande-dame client Annie Laurie Aiken brought in her lovely blond daughter, Sunny von Bulow, to look at the collection. Mrs. von Bulow adored the clothes, ordering a long evening dress and some other things. Of course, it is sad to imagine this vibrant, life-loving young woman now lying in a comatose condition.

* * *

The same year, someone who was anything but comatose, Mrs. William Randolph Hearst Jr. (Austine, to friends) began ordering small wardrobes of clothes each season. These might consist of a coat in bright yellow lined in turquoise satin with a fuchsia satin large scarf, a pair of matching

turquoise pants and also fuchsia pants; the obligatory turquoise overblouse and, of course, a turquoise wool jacket lined in the other colors! Austine had enormous style, was on several best-dressed lists, and could interchange all these pieces, looking prettier and more original than any woman in the room.

She had been a journalist in Washington, marrying Gigi Cassini before setting up house with Bill Hearst for over forty years. Austine was a great horsewoman, being Master of a Westchester County Hunt. She had that unusual mixture of beauty, intelligence, class, and great wit, often telling *very short,* off-color jokes, which she learned in the freezing dawn of the hunt meet "before the bugle blows and your horse bolts after the fox," she liked to say. "If you don't speak quickly enough, Arnold, you never get to the punch line!"

Parker and I had many wonderful times with Austine and our mutual great friend, Esme O'Brien Hammond, who was an equally amusing client. The four of us had a "lunch club," taking each other out once monthly to different restaurants. I always chose La Caravelle; Esme, the magical five-star Grenouille, which we all loved; Parker, something really new and amusing or Chinese. Austine, sometimes uncharacteristically frugal, chose the inexpensive Colony Club. After the first time, when Parker was refused a second helping, we all agreed "never again." The next outing, the unique Mrs. Hearst surprised us by taking the group to Petrossian, where they specialize in the finest caviar and chilled Russian vodka. She insisted we each have a quarter of a pound of beluga with delicious tiny blinis. We had a ball and returned often—usually leaving a little tipsy.

We visited the Hearsts many times at *San Simeon Castle,* the fabled two-thousand-acre estate that Bill's father had built in the twenties. We also went to *Wyntoon,* the beautiful enormous fishing compound that his grandmother had built on the McCloud River in Oregon—boy, those were the days!

* * *

In 1978, Patricia Gay arrived at the Fifth Avenue salon with the multimillionaire media mogul John Kluge in tow. She was tall, statuesque, with long dark brown hair almost reaching her waist—he was shorter and somewhat stocky. Patricia was a great Iranian beauty who'd been brought

up and gone to school in England. She was charm personified, and one could tell they were in love. As she sat on Mr. Kluge's knee, on the gray silk banquet, we began to show her the collection. She picked only the prettiest and most flattering clothes, veering toward pastel colors. John Kluge was consulted on each item, sometimes, between smooching. Miss Gay became a good client and friend, someone Parker and I liked being with very much. One day in February 1981, Patricia telephoned, all excited.

"Arnold, John and I are getting married and we must plan the most magnificent wedding dress." Indeed, we did, of virginal white silk organza ribbon lace completely embroidered with tiny seed pearls. The dress had a cathedral train, sweeping far behind the full skirt. It was almost classic, with long tight sleeves and a very high Edwardian neckline rising on Patricia's swanlike neck.

As Mr. Kluge was Lutheran, having been married before, and this was the bride's second betrothal also, I was surprised that the wedding was to take place at the very Catholic St. Patrick's Cathedral. However, nothing seemed impossible where Kluge's wealth and Patricia's ambition were concerned. The day of the wedding, the church was decorated with the most beautiful white flowers. The music soared as the bride came down the aisle looking ravishing, her hair coiffed in the Edwardian manner, wearing a delicate diamond tiara. Patty Davis Raynes, Barbara and Marvin Davis's pretty young daughter, was my date.

"Arnold, could a Jewish girl be married here?" she whispered to me as the bride passed. I told her I thought that with her father's zillions, it could probably be arranged! The wedding ball afterward was very grand and certainly a precursor of the extravagant eighties. John Kluge, having as great a sense of humor as Patricia, recounted the story that when he asked his bride-to-be "Darling, how are we ever going to fill St. Patrick's? There are over a thousand seats," she answered, "John, you're the king of the media world. Just hire some actors and fill the place up!"

They were a great team and had a wonderful son, John Jr. After many years of what seemed like a happy marriage, one time while Kluge was away, the gregarious Patricia strayed, and not too long after, the couple was divorced. Happily, they have both remarried and live on adjoining several-thousand-acre estates in Virginia. Patricia sometimes

wears her Scaasi designs. Not long ago, she appeared in a brown tweed suit with mink sleeves, looking stunning, as always.

<p style="text-align:center">* * *</p>

Another exotic, tall, model-like dark-haired beauty, Lamia Kashoggi, wife of the Saudi Arabian billionaire Adnan Kashoggi, came to see the collection in 1982. As I've always been known for my extravagant evening-wear designs, I was not surprised when she wanted to see only the most dazzling long evening dresses. I knew the couple owned an enormous opulent apartment in the Olympic Tower, overlooking St. Patrick's Cathedral, and entertained in lavish royal style.

"Lamia, you must be going to a lot of grand galas. [She had ordered eight gowns in a period of two hours!] You haven't ordered any suits, though you seem to like them very much."

"Oh, but Arnold, dear, we almost never go out. When Adnan comes home in the evening, he's often quite tired—he expects me to be dressed to the nines. It cheers him up when I'm well turned out, and, of course, I do like to please him. Don't worry, your beautiful gowns will be seen to great advantage and we'll keep him happy as a clam!"

The eighties was a wow of a time for Scaasi Couture—everyone from "Nouvelle Society" (as *Women's Wear Daily* named the then current young rich) seemed to want a made-to-order design. Clothes were exaggerated and seductive, either very skinny or very grand, full with petticoats. There were vibrant colored prints, jewel-colored luxurious satins and brocades, and fur trimming was the rage—on suits, coats, and evening dresses. We did pouffed-up sleeves, pouffed-up skirts, pouffed-up hair, and pouffed-up bustles on ladies' derrieres. Clothes were fun and fantastic, and Scaasi designs were

Blaine Trump
in Scaasi Couture

everywhere. It became a game, counting how many Scaasis were at each major event. One night at a Metropolitan Museum of Art gala, there were forty-seven of my dresses. We began the *Me and My Scaasi* ads in the eighties, and later the Scaasi fragrance.

<p align="center">* * *</p>

I dressed many of the young socialites of the time; Anne Bass, the strikingly beautiful Texas divorcee, who has great taste in art (Monet, Jasper Johns, Matisse, et al.), oodles of money, and is a fervent supporter of the New York City Ballet. Also the lovely Blaine Trump, who, amidst all the social folderol, is down-to-earth and a major player in keeping God's Love We Deliver a success. This amazing organization delivers over three thousand meals daily to AIDS patients and others too ill to leave their homes. Blaine is very special with a great sense of humor. The blond dynamo Nina Griscom came to me in the eighties and is featured in a charming *Me and My Scaasi* ad; we share the same birthday, May 8. Another *Me and My Scaasi* girl, Princess Yasmin Aga Khan, started the Alzheimer's Association, when her mother, the actress Rita Hayworth, was stricken with the disease. She's as vivacious as her mom was and a beautiful look-alike.

My clients were varied types, all wanting to be part of the eighties glamour scene. The streamlined Ivana, ex-wife of "The Donald," Donald Trump, came often to the salon. She had several fittings on a short, strapless, really skinny red dress, always wanting to look healthy and sexy at the same time (maybe they do go together?). The dichotomy was Brooke Astor, then in her early eighties, but with a spirit and chic that was unmatched. We made many wonderful suits of tweed, which the dowager always wore to luncheons with great big pearls and a diamond pin. For evening, we did glamorous long dresses, always covered up with skirts that moved—she so loved to dance—and there were always the obligatory diamond necklace, earrings, and bracelets. Someone who loved shopping at Scaasi Couture was Libet Johnson, the pretty, fun-loving, often married pharmaceutical heiress—we did beautiful clothes for her. On another front, we did cocktail and pouffy evening dresses for the hardworking, pretty Evelyn Lauder, who started the Breast Cancer Research Foundation, and the sharpshooter, author-heiress, amusing Charlotte Ford, who sometimes came along with her sister, Anne.

* * *

In 1986, I was pleased that Barbara Walters asked me to do her wedding dress when she married Merv Adelson. The gown had big pouffy sleeves on a tiny bodice of black silk velvet. The grand skirt of white satin was draped up to one side—very Edwardian. The bride-to-be came to an inordinate amount of fittings and, though she is usually a cool lady, then she was overly nervous and indecisive.

"It was because I *really* didn't want to get married," she told me recently. Whatever, she's still the best-looking, best-dressed, articulate journalist on television. I was pleased to do the wedding gown for the TV economist Maria Bartiromo (the "Money Honey")—what a bright, sparkly lady she is! I particularly enjoy dressing Christine Schwarzman, a willowy beautiful blond, who's a longtime friend and smart as all get-out.

* * *

One night in the mid-eighties, I saw a stunning young dark-haired woman across the vast Great Hall of the Metropolitan Museum of Art in New York. She was wearing a black velvet topped, fuchsia-and-black appliquéd ball gown of mine, which I had sold to Saks Fifth Avenue. I asked my friend Danny Berger who she was.

"Her name is Gayfryd, spelled with two y's," he said. "She's married to Saul Steinberg, the millionaire leverage buyout genius—he was my roommate at Wharton—they live in a thirty-four-room triplex that was formerly owned by John D. Rockefeller Jr. on Park Avenue. They're very good friends, a really great couple."

"She's so beautiful," I said. "I'd really love to meet her." Well, that was the beginning—we met and have remained great friends ever since. I found that not only was Gayfryd wonderful-looking, but she has great taste—she is intelligent and kind and has made Saul's life possible. A fine stepmother to Saul's children and caring mother to her daughter, Holden, and son, Rayne—she brought the whole family together. Though they have had financial reversals, I've never heard Gayfryd complain and she remains as beautiful today as she was the first time we met. I did many, many designs for her, and at my retrospective in New York at the Fashion Institute of Technology, the most clothes shown from any one person were Gayfryd's. When Saul Steinberg walked through the collection, he was ebullient.

"Arnold, this is just incredible, all these clothes [of Gayfryd's] bring
back such wonderful memories—thank you."

Many of the eighties girls continued ordering designs through the
nineties and onward. One of my favorites is Mona Ackerman, a wild, eru-
dite redhead, the daughter of Meshulam Riklis and a doctor of psy-
chology in her own right; she comes to fittings when she isn't helping her
patients. She is great to work with, always wanting clothes that are dif-
ferent yet wearable for her serious lifestyle: a caramel cashmere tweed coat
lined in burgundy cashmere jersey, with several short dresses that go with
it, is a good example. The outfits are chic, a little funky, yet elegant! Ann

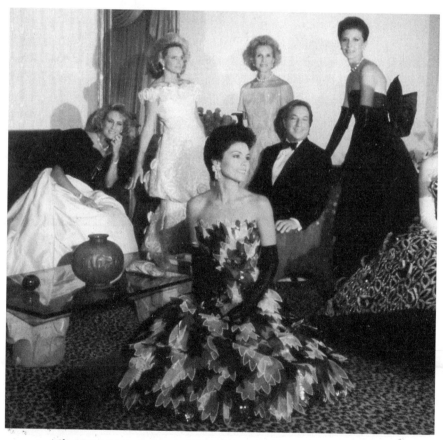

The '80s Girls, left to right: *Patty Raynes, Charlotte Ford,
Carroll Petrie, Kimberly Smith;* center: *Gayfryd Steinberg*

Ziff, formerly of the Ziff-Davis Media empire is similar, only wanting clothes that are different—"not out-there." Ann is petite and prettily exotic-looking—one of the nicest people I know, and loves making beaded hairclips to go with each outfit! We did a bright fuchsia satin crepe draped halter-neck gown and big chrome yellow stole for the opening of the Metropolitan Opera—she looked stunning and was a smash hit, as always.

Women like Gayfryd Steinberg, Mona Ackerman, and Ann Ziff are special New York Girls—they're intelligent and challenging to a designer, but also fun to work with.

<p style="text-align:center">*　　*　　*</p>

Of course, this city, New York, and many others across the nation would not be much fun without the "Big Three" columnists; Cindy Adams, whom I made clothes for way back when; Ailene Mehle ("Suzy"), who looked fabulous in two extraordinary feather evening gowns of mine, one in white, the other in red; and, of course, the resilient Texas glamour gal Liz Smith—I've made so many special clothes for Liz, I can't remember them *all*. One that does come to mind is the night I won a *Council of Fashion Designers of America Award* in 1987. I had done an off-the-shoulder long-sleeve dress of black sequin lace over red with a big black taffeta skirt that Liz looked great in. Still, I worried that with her Texas walk (sometimes in boots) she wouldn't show the really feminine quality of the gown.

"Now, Liz, when you go out there, think Scarlett O'Hara—don't walk as if you're in the army!" I whispered, just before she went onstage to introduce me. Of course, she laughs and tells this story on herself often. Still, she did sashay out like Scarlett, looking perfectly grand—sometimes, a girl has to be told—especially, a New York Girl who comes from Texas!

The exuberant Mica Ertegun, born in Romania, where my grandmother was from, is one of my favorite New York women. Pat Buckley, another grand lady, hails from Canada where *I* come from. So, you see, a real New Yorker probably doesn't come from New York at all—it's all in the way she thinks and lives. It's all about style—that wonderful, special New York style that makes a true New York Girl.

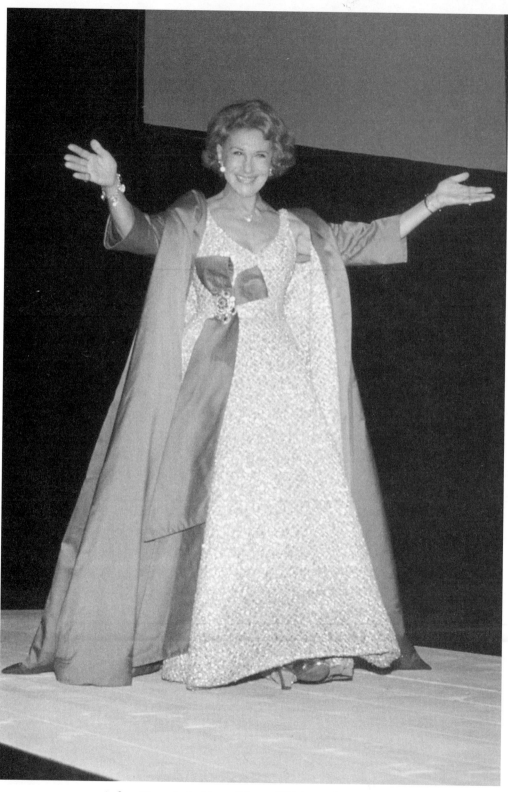

Arlene Francis in Once More, With Feeling, *1958*

BROADWAY GIRLS

It's always been a special treat for me to dress the star in a Broadway show. It's a wonderful diversion from designing, fitting and overseeing the production of a total dress collection made for a fashion show that a hundred or so fashion editors will see and critique. On Broadway, you only have one star and you can make your creative point with less than six outfits, if necessary. The one and only you're designing for is happy (usually!), the director is happy, and the producer is happy. You have a contract, which insures your agent and you of prompt payment. Also, it truly helps feed your creative ego. Though I would never say this about most business ventures, creating the clothes for the star in a Broadway show *can* be fun! Here are some Broadway girls I have designed for.

In 1954 Arlene Francis appeared on the cover of *Newsweek* magazine, having been voted one of the three "most popular women in America." The two other celebrated ladies were Eleanor Roosevelt and the then first lady, Mamie Eisenhower. Miss Francis was a universally known television personality who hosted the *Home* show, a precursor of the morning *Today* show. She was very good looking and sophisticated, with a biting, but always positive wit. She wasn't called "the first lady of television" for nothing—she had an enormous following.

In 1955 I started working for *Dressmaker Casuals* on Seventh Avenue in the Garment District—designing unusual coats and suits with blouses that matched the inside of jackets and dresses of the same fabric as the coat linings, forming an ensemble. This was unheard of in American fashion at the time. The collection, the first with my own "SCAASI"

label, was a success and was much publicized across America. It started a look I continue doing to this day.

That same year I was thrilled when Muriel Maxwell and Jane Gray brought "the most popular" Miss Francis to the Fifty-eighth Street flat. I began designing a series of separates for the TV star that she could interchange daily on the show, without having the same look appear during a one-week period. She was famous among her friends for being very frugal, and loved the idea of not having to buy new clothes every day for the show. She would laugh, saying, "It's just terrible, Scaasi, I *cannot* find *anyone* who will sell me my groceries wholesale!"

My first "star" client, Arlene had a great personality and an infectious laugh. Appearing weekly on the hit game show *What's My Line?* she always wore an exciting Scaasi dress, usually with an attractive above-the-table neckline since she was seated throughout the show. She also appeared on *The Price Is Right,* wearing other Scaasi clothes. In fact, Scaasi became known as Arlene Francis's designer. As she was a great friend of all the columnists, we received an enormous amount of press on her clothes. I knew her so well that I would automatically do designs for the collections that would suit her.

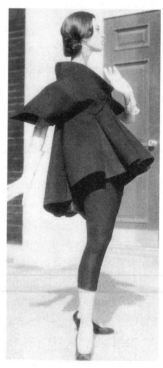

In 1958 Arlene starred on Broadway with Joseph Cotton and Walter Matthau in the Harry Kurnitz comedy *Once More, With Feeling.* When she asked me to do her costumes, she apologized, saying, "Don't get too excited, darling. I play a very plain-Jane character who's a music teacher and not glamorous at all." I read the script and, indeed, her role was that of a music teacher married to a Leonard Bernstein–type—a world-renowned egomaniacal symphony orchestra conductor.

We met to discuss the clothes. "I think I should come in wearing a sweater and wool skirt for my first entrance—don't you,

An evening "suit,"
Dressmaker Casuals, 1955

Scaasi?" Arlene said immediately. "Then for the next scene, something equally simple—you know what I mean."

"Absolutely not!" I said. "It's true you play a teacher, but you are married to this great conductor who's very, very rich! Also, he never would have married you if you were dull and boring-looking. I think you should make your first entrance wearing the fabulous sheared otter fur coat with the lining and big collar of Norwegian blue fox. After all, it *is* winter in the script, and you know how you love that coat! Arlene, dear, here's a way of getting the coat for yourself and letting the production company pay for it." Well, of course, she *loved* that. Being still a little wary of the whole idea, she said, "But, Scaasi, don't you think that's a little too glamorous for the role?" "Not at all," I assured her, "and here are some other things that I think might work for the play." I showed her some clothes from the new fall collection, and she became excited at the prospect of looking glamorous onstage. She said, "Well, I do like the idea, but we've got to ask Harry. After all, it's his play."

The very next day Arlene Francis and Harry Kurnitz arrived at the temporary salon I had on West Fifty-seventh Street. Arlene put on the fox-collared otter coat and modeled it for Harry. "Fabulous!" he said. "You look gorgeous!" "But don't you think it's a bit much for the character?" she questioned. "Character, schmaracter. Arlene, you're a great star and your fans expect you to look like one. Arnold, we'll take the coat. Now, what else you got?" he asked, beaming, and falling into a fast Broadway lingo. I started to explain what I thought the star should wear in some of the other scenes, and Mr. Kurnitz loved the ideas. "Scaasi, you're a genius— just make her look gorgeous!" With that he departed in a cloud of cigarette smoke. Harry Kurnitz was a very elegant man, tall and thin with curly salt-and-pepper hair. He was a prolific screenwriter, a successful novelist, and a great playwright. He was also very funny and endearing.

I started to work on the designs immediately. I had already decided that Miss Francis would enter in the fox-lined coat—but she had quite a bit of dialogue in the scene, so I had to get the coat off of her quickly or she'd boil. I created a burgundy matte jersey dress that had a soft skirt and high neckline to wear under the coat—it worked perfectly.

For the opening of act two, I designed a royal blue mohair coat with a big cape collar and patch pockets lined in coppery yellow satin, that

43

was worn over a matching blue silk dress with a pleated skirt. Arlene really wanted this outfit in yellow, her favorite color, but the walls of the set were yellow, so the clothes could be any *other* shade.

The next scene was at night in the conductor's hotel suite and Arlene had just been awakened. There were many discussions about night-gowns and men's pajamas, but I persuaded the star to wear a very short sexy pale blue chiffon nightshirt that showed lots of leg—the guys loved it!

I went all out in the last scene, putting Arlene into a floor-length off-the-shoulder red satin evening cloak over a glistening silver brocade, very bare, long evening dress tied in red satin at the waist. In the dialogue, the conductor compliments her on how lovely she looks. "Oh, this old thing—I picked it up in Macy's basement years ago," she answers, and throws the coat open (a maneuver we rehearsed a lot), revealing the silver dress and matching lining of the coat. There was always an audible gasp from the audience, and then howls of laughter. After Kurnitz saw the outfit in rehearsal, he put in the line about Macy's—being a classy gent, he thanked me for inspiring him. Because of the audience reaction, the scene had to be retimed by the director, George Axelrod, while Arlene stood onstage preening.

Once More, With Feeling opened on October 21, 1958 to fairly good reviews for the playwright. However, it was Arlene who received all the kudos from the press, and I quote: "The immense popularity of Arlene Francis was clearly evidenced this week as television's first lady came back to Broadway. The mob outside the National Theatre was the most enthusiastic of the season. New York's Finest couldn't budge them. And the mob inside gave Arlene a welcome usually reserved for such theater greats as Helen Hayes or Julie Harris. In attendance: Bennett Cerf, Hedda Hopper, Janet Gaynor and husband Adrian. Moss and Kitty Hart came with Lillian Hellman. Gloria Vanderbilt, Rita Gam, Budd Schulberg, and Mr. and Mrs. Billy Rose were all first-nighters. It was obviously Miss Francis' evening. Never one to disappoint, she looked stunning in a series of gorgeous theatrical outfits designed by Scaasi, and gave a luminous and winning performance." The clothes were mentioned in every review of the show in the most superlative way. Just three weeks before, I had won my Coty American Fashion Critics Award as Designer of the

Year, and three weeks before that, had moved into the Stanford White house and received great reviews for my opening night collection—I was on cloud nine!

Once More, With Feeling played for nearly eight months in New York. Afterward, Arlene toured with the show across America. In the sixties, it was made into a hit movie with Yul Brynner as the conductor and Kay Kendall in the role of his wife.

Arlene Francis was married to Martin Gabel, and they had a son, Peter, who played the violin and was on his way to being a child prodigy. Martin was a prolific character actor who had great success. Though he was a most elegant man in real life, he was able to play any role from a murderous gangster to a hot-headed politician. His sense of humor equaled Arlene's, and until his death, they were one of the most sought-after couples in New York society and I made many evening and cocktail dresses for her.

With Arlene on a night out

Something she wore often and loved a lot was a black taffeta full-skirted long dress with poufs of the fabric around the shoulders, caught with large black velvet cabbage roses. When Martin was working, we would sometimes go out on the town together and she wore the black taffeta on many of these evenings.

I continued to make clothes for the multimedia star until she became ill with Alzheimer's disease in the eighties. We often spoke on the phone, though some of what was said did not make sense. In the early nineties, her son, Peter, the president emeritus of New College of California in San Francisco, took his mother home to make sure that she was well cared for. Arlene obviously never lost her sense of humor. After boarding the plane for the West Coast, she looked around, and turning to Peter, said, "Obviously, my dear, this is not a black-tie affair!"

When her dearest friend, Mary Cooper, went to visit, she found that the disease had taken a turn for the worse and that Arlene had not spoken for several months. Trying to get a rise out of her old pal, Mary chattered on about events happening in New York, at one point saying, "You know, Arlene, it's so sad, Adolfo has closed his business and retired." Suddenly, Arlene broke her long silence, "What do I care—I am dressed *only* by Scaasi!"

Arlene Francis died peacefully in her sleep on May 31, 2001. She was the first lady of television and remained the first lady in the hearts of all who knew her.

<p style="text-align:center">* * *</p>

Enjoying immensely the challenge of designing for the Broadway stage, I was pleased when, in 1964, I was asked to create the clothes for Geraldine Page in the play *P.S. I Love You*, Lawrence Roman's English adaptation of a French farce. We set up a meeting with the great actress, having some trepidation, as she was known to be enormously eccentric and hard to please—a little on the neurotic side! Still, I had no idea of what I was really getting into when I accepted the assignment with alacrity.

Miss Page arrived at my salon one summer afternoon, looking particularly bedraggled, her hair pulled up with lots of straggly strands hanging down, no makeup, and wearing a not-too-clean man's shirt over blue jeans—not exactly the vision a designer wants to have of a famous star.

This was to be Miss Page's first appearance on Broadway in a while. Her character was a wealthy woman in her late twenties from an old Boston family who falls in love by correspondence with a dashing Frenchman. The director, Henry Kaplan, wanted his star to be fashionably dressed in the most up-to-date clothes. The actress was forty, and still breast-feeding a child—however, when she got undressed, we realized she *was* a size ten, tall and curvy. The idea was to make her look glamorous and hip—a formidable challenge!

The director had seen Geraldine Page on the stage in the highly dramatic *Separate Tables,* playing the role glamour girl Rita Hayworth did in the movie—he thought she would be perfect for the comedy *P.S. I Love You*. The whole idea was a mystery to me, as the actress had never been seen in a modern-day comedy before—but a job's a job, so I started sketching.

The prologue takes place outdoors at a fancy resort in France in autumn. I designed a bright red double-breasted suit with brass buttons and a very short skirt for the star's first entrance. It looked great on her, and certainly established the character immediately. There were several other outfits that Miss Page seemed to be excited about during fittings.

She was always to look elegant, not flashy or particularly sexy until the very last scene, where she comes out of her shell and *does* look sexy. I did a long slip dress embroidered in glittering gold beads that showed off her figure and I knew was perfect for the character, as I had just made a very similar dress for my friend and client Mrs. Cortwright (Tootie) Wetherill, who was wealthy and from an old Philadelphia family—in fact, she could have been the character that Mr. Roman wrote about!

At this point in time, shows did an out-of-town tryout in other cities to attempt to get the kinks out before coming to Broadway. At the end of October, *P.S. I Love You* opened in New Haven. What should have been an ominous sign happened as I descended the stairs of the theater in New Haven to the wardrobe room in the basement. The little wardrobe mistress ran up to me gushing, "Mr. Scaasi, oh, I'm so thrilled to meet you—the clothes are just *gorgeous*. That red suit and the beautiful coat and the gold dress, oy, just *gorgeous!* Unfortunately, with the breast-feeding and everything, they're going to be so schmutzig by the end of the week, I don't know what I'll do!" I placated the nice lady as much as

I could, and told her, "Not to worry—I'm sure it will all work out fine."

As I remember, the show went quite well in New Haven, and Geraldine Page went on each night, valiantly trying to be comedic in a role that should have been played by Doris Day. Oh, yes, I forgot to say that the hairdresser John Bernard designed for the actress a special wig of golden red hair in a short pageboy style popular in the sixties. The problem was that each time the fittings for the wigs came up, Miss Page kept pulling the hair forward to cover more of the sides of her face. Everyone backstage giggled, anticipating the two sides of the wig meeting under Miss Page's chin to form a kind of beard!

I got along very well with the fabled actress and had sympathy for her in trying to tackle the star role. I also dressed the French actress Dominique Minot, who played the chic wife of the amorous Frenchman. She was very pretty, petite, young, and blond. Of course, I liked her a lot, as she *loved* all the costumes I designed for her.

One week into previews for *P.S. I Love You,* I left what I thought was a cheerful Miss Page in New Haven, thinking all the costumes were set in stone, I flew to Chicago to do a personal appearance for my licensed ready-to-wear dress line. Returning to New York a few days before the opening, I found frantic messages from the director, Mr. Kaplan. "We have to change the gold dress," he bellowed over the phone. "It looks cheap, and a girl like Julie [the character Miss Page was playing] just wouldn't wear it." I countered, "Henry, you're all wrong. I just made a dress for Tootie Wetherill that was very similar, and she really is exactly like Julie, rich and from an old American family. Besides, Gerry looks fabulous in the gown." "No, no, no," he said, "she wants to wear a black dress, and it's in work right now!" I was stunned, but knew better than to push the point when a doubting director and an insecure actress have made a decision. After all, it was three days before the opening curtain.

I won't go into the boring details of how all this got straightened out. Suffice to say, the credits read "Miss Page's clothes designed by Theoni V. Aldredge and Arnold Scaasi." The play opened in New York on November 19, 1964 to generally bad reviews and closed twelve performances later. Howard Taubman of the *New York Times* ended his review, and I quote, "You would expect, at least, a generous helping of gags, but they are sparse in *P.S. I Love You.* If you miss them, you can concentrate on the

clothes. This production comes equipped with two excellent costume designers."

The extraordinary dramatic actress Geraldine Page went on to do several plays and films after the debacle, winning an Academy Award for her portrayal in *The Trip to Bountiful* in 1986. As you know, I went on to win every major fashion award and continue to this day to design luxurious clothes—but hey, that's show biz!

* * *

I met Eva Gabor in the late fifties with her two sisters, Zsa Zsa and Magda, and her mother, Jolie Gabor. There was quite a fuss made over them by the press at that time including a long picture essay in *Life* magazine, where they appeared on the cover.

Eleanor Lambert, the doyenne of fashion publicists, who invented the best-dressed list and the Coty Award (the forerunner of the prestigious Council of Fashion Designers of America Award) and who was instrumental in forming the Costume Institute at the Metropolitan Museum of Art, had organized a major fashion show in aid of the March of Dimes. The shows were done twice a year on a Monday at lunchtime in the ballroom of the Waldorf-Astoria. Two thousand of America's most fashionable society women attended, and every major fashion house showed their most striking outfits. Ms. Lambert, being the cleverest of women, was able to get every star performer on Broadway at the time to appear in different vignettes in the show, knowing that Broadway was dark on Sunday and Monday nights and that the stars would attend this important charity benefit. The Gabors appeared in one of the vignettes for which I made the clothes.

Though Zsa Zsa was the most married and publicized of the family with a budding film career, there was a kind of aggressive quality about her which made her less likable than Eva, who was equally gorgeous but more petite and with a softer quality and great sense of humor. We became instant pals and remained good friends until she died in 1995.

In 1958 Eva asked me to do her clothes for the play *Present Laughter,* in which she would appear with its author and great star, Noel Coward. We had many discussions before settling on some gorgeous clothes that would best show off Miss Gabor's beauty. When the day arrived for the dress rehearsal, we were so pleased with our choices that we couldn't wait

to show everything to Mr. Coward. To our surprise, the great man immediately objected to Gabor's bright orange mohair day coat worn over a short yellow and orange chiffon dress. "Nobody will look at me if you are wearing that," he fussed at Eva. "Mr. Scaasi, you must *change* that outfit!" he boomed at me over the footlights. Coward became even more irate when he saw Gabor appear onstage wearing a dramatic long evening cloak over a sexy white chiffon strapless gown. After considerable persuasion, he agreed to change his dinner jacket to a more flamboyant style. We then added certain touches to other clothes that he would wear—we assured him that he would "not fade into the woodwork"! That seemed to satisfy Mr. Coward—and Miss Gabor appeared in all the Scaasi glamour to great applause.

It is recorded in the tabloids of the time that Gabor was seeing Ben Gazzara, who was also appearing on Broadway in *A Hatful of Rain.* The beautiful blond Hungarian and the sexy young Gazzara made a handsome couple and it was hard for them to keep the romance from the paparazzi. What with *all the activity* in her life, it was difficult to get Eva in for fittings, as their romantic liaison kept Eva in the bedroom more than the fitting room! Obviously, precedence for her free time went to the stunning actor rather than a mere dress designer. It really didn't matter, though; I always had a wonderful time with the Hungarian heartthrob!

<p style="text-align:center">* * *</p>

The Broadway producer Leland Hayward called me in the spring of 1959 and asked if I would design Lauren Bacall's costumes for the play *Goodbye Charlie,* a new comedy by George Axelrod. (Coincidentally, Axelrod was the director of *Once More, With Feeling.*)

I had made some great clothes for Leland's infamous wife Pamela, who was married before to Randolph Churchill, son of Winston, and had a string of famous rich lovers. In her early days she was known as *La Grande Horizontale!* After Leland, she married the octogenarian Averell Harriman, who had been ambassador to the U.S.S.R. in 1943, and later governor of New York State in 1955. She was quite a dish and totally disarming. Pamela Harriman ended her days in Paris, where she was the American ambassador to France under President Clinton. She helped cement Franco-American relations at the time, speaking the language fluently and being very rich, chic, and full of charm. She was much loved by the

French and her many American friends.

Mr. Hayward mentioned that the American couturier Mainbocher had already done a set of costumes for the glamorous film star, Miss Bacall, that were too classic and uninteresting. Instead, he wanted her to have clothes that were feminine and witty. *Goodbye Charlie* was about a man who was a total cad with women, who then died and came back to life in the female form. It was a funny premise to begin with, and I agreed that the clothes should

Fitting Lauren Bacall in feathers, 1959

be witty. One of the outfits that I did for Betty Bacall was a midi-length pink silk coat that was lined in ombré ostrich feathers that went through the color range from bright reds to shocking pinks. This was worn over a matching short dress in the same shades of ostrich feathers—Miss Bacall looked divine. The actress always got a big laugh when she appeared in the outfit and flung the coat open, saying the line, "I've just come back from shopping at the supermarket." Bacall was great in the role, and Leland Hayward and I were both very happy.

In June of 2001, we met Betty by chance while on the Concorde (the now defunct fabulous supersonic plane) going to London. Parker Ladd and I were on our way to a weekend charity event where Prince Charles would be the host. We were very excited about meeting the prince and spending some time with His Royal Highness.

On the first evening, there was to be a dinner dance for three hundred and fifty at the newly restored premises of the Prince of Wales Foundation's headquarters, which was an old landmark building. Camilla Parker-Bowles, his mistress, was to accompany the prince for almost the first time publicly. In fact, she was to be by his side at each function dur-

ing the whole weekend. On the plane, chatting to Betty, I went on about all the events we would be attending, like going to Ascot—all dressed up in gray top hat and tails, going to a *small* formal seated dinner for one hundred at Buckingham Palace, and finally visiting the gardens and having lunch on the Thames on Sunday.

Betty Bacall said, "It sounds like fun but *totally* exhausting, my dear." When we left each other at customs I promised that I would call her at the Connaught, the chic "homey" hotel where she was staying, and perhaps we could meet for tea the following week. We went off to Claridges, one of the best hotels in the world.

It weighed on me more and more that I was rude in not having asked the star to join us at one of the festivities. Parker said, "Just telephone her and ask her if she'd like to attend."

I called the next day and explained about the dinner dance and asked if she would like to go with us.

"No, no, no," she said—I thought a bit hesitantly. "Besides, I have nothing to wear."

"Oh, don't be silly," I countered. "You'll look great in anything."

"Listen, really, Arnold, all I have for evening is a pair of black satin pants and a long black coat."

"Sounds great," I said, "After all, you are Betty Bacall and they'd love to have you any which way!"

"Well, *I do have*—my pearls," she said, giving that famous deep laugh.

"It'll be fun," I said. "We'll pick you up tomorrow night at six-thirty."

The next evening, Parker and I arrived, wearing black tie, to pick up Miss Bacall in our rented, chauffeur-driven Bentley (we *owned* our tuxedos!). She came into the lobby looking splendid—black satin pants and top, a smart black soft floor-length cardigan-coat flowing behind her—and THE PEARLS. Off we went to Prince Charles and Camilla's dance. Of course, Bacall was a great hit, doing a lovely curtsy upon meeting the Prince. She was pleased that he remembered her from another time they had met. Still, who could forget the one and only Lauren Bacall! We had a delicious, fun dinner in the newly decorated hall of the building.

Before leaving, I asked Camilla, "Where did you get your beautiful diamond necklace [thinking all the time that maybe it was a gift from His Royal Highness]?"

"It was my great-great-grandmother's," she said, smiling ingenuously. "I'm so glad you like it, it is one of my favorites." I realized at that point that the necklace had come from Mrs. Keppel, the mistress of a *past* king, Charles's great-great-grandfather Edward VII. History does repeat itself.

When I told Suzy Menkes, the exuberant fashion reporter who was at the dance, what Camilla had said, the scribe wondered, "Does the necklace have to go back to the Crown after she's through with it? After all, Arnold, that's where it came from in the first place!" The British are so practical.

After a great evening, we drove off. When we got back to Miss Bacall's hotel, we hugged and said good night.

"Well, boys, I *did* have a very nice time tonight," the actress enthused. "But I must tell you, that was really not *my* world. It's fine for you all— but *my world* is the th-e-a-a-tah!" We all laughed and the lady with the pearls disappeared into the elevator.

Though Lauren Bacall had a reputation for being one of the most difficult actresses to work with on Broadway, I never saw that side of her. Very intelligent, she does not suffer fools lightly, but with me she has always been warm, good-natured, and terribly amusing—I always get a great lift every time I see her.

<p style="text-align:center">*　　*　　*</p>

Late in the summer of 1990, my assistant informed me that Aretha Franklin, the Queen of Soul was on the telephone and had to speak to me *right away*. Surprised, I picked up the phone.

"Hi. Is this really Aretha Franklin?" I asked, incredulously.

"Mr. Scaasi?" the gentle voice asked back.

"Yes." I said, "What a pleasure to speak with you."

"Well," she replied, "I refuse to open at Radio City Music Hall next month unless I'm wearing a Scaasi. Now what can you make for me?" I liked her direct approach.

I had heard a lot about Miss Franklin from my friends in the music business, the legendary Ahmet Ertegun, head of Atlantic Records, and the equally perspicacious Clive Davis, head of the RCA Music Group. Both are veterans in their professions. Everyone agrees that Aretha is an amazing vocalist (she's not called "the Queen" for nothing), but there are a few idiosyncrasies I was to learn almost immediately.

"I'd love to dress you for Radio City, but you're not giving me much time. When can you come to New York?" I asked.

"Well, I don't know, but you can send me some sketches. I want to look really *grand*, you know."

"But Miss Franklin, I have to take measurements and we have a wonderful selection of fabrics and embroideries *here*—it would really be so much better if the fitters and I could see you at my New York salon. Why don't you fly in one morning, spend a couple of hours with me, maybe have lunch, and then fly right back—we could accomplish a lot—"

"I DON'T FLY," she said. I almost fell off my seat!

"Never?" I asked.

"NEVER," the diva replied *vehemently*. "Can you send me

Aretha in aqua beads and yellow coat lined in feathers

some sketches today and I'll get my dressmaker to send you my measurements? Please send lots of beautiful fabrics, also. Maybe," she said hesitantly, "I *could* come down some time in a few weeks—I have my own tour bus, you know, that is outfitted like a little home—it only takes about ten hours to drive from Bloomfield Hills to New York. Maybe I could do the final fittings then."

I said I would go over everything and telephone her in the next couple of days to see what could be done. I was really excited about this assignment—I just had to figure out how to dress my new star by long distance. We began by sending our special measurement sheet with directions on how to take the sixty-five measurements: "The person must stand

relaxed and upright with her head up and looking straight ahead, etc., etc." It's something we do with all new clients.

Fast forward. After much going back and forth via FedEx, we decided on a beautiful aqua chiffon that was beaded with crystal and pearls in a sunburst design. The dress was off the shoulder with a low neckline showing the diva's ample cleavage. Cut straight until the knee and then flaring out to the floor, it made the size-fourteen singer look slimmer, yet curvaceous. Over this, I did my signature long evening coat in heavy bright yellow silk lined in aqua ostrich feathers. Bright colors, beads, and ostrich feathers are the best ingredients for a standout look onstage—they invariably demand an hysterical audience ovation.

As Aretha wouldn't travel to New York, I sent my fitter to Bloomfield Hills, Michigan. For the final fitting, I flew to the diva's home myself with my assistant.

The house was quite modern—white walls everywhere and curved glass—set in a kind of woods. What I remember most was that the residence was in a total mess with lots of cardboard boxes and just "stuff" everywhere. There seemed not to be a place to sit down, as all the sofas and chairs had so many things on them. Also, there were five or six people wandering around—some of whom seemed to be related to Miss Franklin but not really doing anything. It was strange and a little unnerving. Aretha was all charm and grace and very hospitable, offering us lunch. No matter, we had a great fitting and she was very pleased with the outfit. Her fans went wild when she appeared on Radio City's stage, opening the yellow silk to reveal the feathers and beads.

I made many dresses for the diva of soul, sometimes sending the fitter to Michigan when Aretha couldn't make it to New York. Sometimes, though, she surprised me and arrived in the big city. Two gowns that stand out in my mind are the ones for her appearance at the Kennedy Center and at the White House, where she received one of the Kennedy Center Honors for lifetime achievement in the arts.

It was near Christmas of 1994, so a red dress and a white dress seemed appropriate. The dress for the award ceremony at the White House was red velvet with an off-the-shoulder neckline and full skirt, quite classic and very appealing in the drawing room of the mansion, which was decorated for the holidays. The other dress, which she wore

onstage at the Kennedy Center, had to be visible from far away. So we did it in white lace with satin ribbon embroidery and a big Elizabethan collar. It was eye-catching and dramatic.

We did lots of wild things for the singer, like the multicolor sequin shorts (*yes, shorts*) and top under a ruffly red taffeta mini coat and a beautiful yellow to red ombré chiffon floating gown and scarf for another gig at Radio City. That night her long chiffon scarf got caught in the wings and she got tangled up. Her fans, loving her as they do, laughed and applauded wildly, thinking that it was a bit of business meant to be in the act. On another night, not long ago, for one of her farewell performances at the music hall, she suddenly took off her hairpiece while playing the piano—the audience loved it and hooted and applauded.

On the last Tuesday of 1992, Clive Davis took over the ballroom of the Plaza Hotel in New York City and gave a major pre-Grammy party. Clive has been doing this for years and it's always a lot of fun because of the eclectic mix. Many of the young stars and groups doing music today attend and often perform. The dinner guests include heads of music companies, Café Society types, movie stars, restaurant owners, and lots of just plain "beautiful people."

On this particular evening, I recall, Whitney Houston wowed everyone by singing "I Will Always Love You," the hit song from her movie with Kevin Costner, *The Bodyguard*. She wore a shimmering white beaded gown and looked beautiful.

The Queen of Soul, Aretha Franklin, was there also, looking great in her Scaasi—a bright red satin low-cut slinky long dress with a loose panel that fell capelike to the floor from two big bows at the neckline in the back. She caused quite a stir when she insisted that her tall bodybuilder security man walk behind her holding her train! She came on after everyone and brought down the house when she closed the evening with a medley of her hits. Aretha Franklin has great charm and wit and, above all, that wonderful instrument—her voice.

I called Aretha from Europe last year to see if she'd join us in Turkey.

"It's so easy—you get on the boat, travel in *great* luxury, and five days later, after a wonderful shipboard crossing, you arrive in England."

"Really," she answered sarcastically, "*I'm* not sailing anywhere—look what happened to the *TITANIC!*"

The other day, a call came through: "Arnold, I need some clothes," the deep, chirpy voice said. "Something elegant but fun—how about a long coat of red ostrich feathers—you know, with a train. Let's put it over a red satin gown with diamond straps—I'm losing *a lot* of weight."

Well, what does it matter—weight, shmeight. Whatever she wears will be fabulous. the moment she opens her mouth and we hear that glorious sound—fantastical as she is, I love her and let's remember—red ostrich feathers are right up my alley—and the beat goes on!

Mamie in white chiffon strapless gown and green panels,
with President Eisenhower and the King and Queen of Nepal, 1960

CHAPTER V

MAMIE EISENHOWER

1958 was really a blockbuster year for me. In addition to moving into my Stanford White town house and winning the Coty Fashion Critics Award, I went to the White House for the first time. Mamie Eisenhower was first lady and her staff organized a tea for a small group of designers. I don't think there were more than ten of us and besides Geoffrey Beene and Anne Klein, I can't remember who the others were. I suppose one of them must have been Mollie Parnis; she had made a great many things for Mrs. Eisenhower and had done her inaugural dress when Ike became president in 1953. We flew on a chartered plane to Washington and were marvelously received at the White House. Of course, we were bug-eyed. Most of us had never been there before, and we were charmed by Mamie Eisenhower.

The first lady had a wonderful way with people. She was totally natural, very sweet and very, very feminine—very southern belle, though she was from Denver. I don't believe that she had a political idea in her head, but she certainly was not a silly woman, which was the impression that you might have had from her photographs. She was always laughing and smiling in pictures and, of course, her famous fringe of hair covering her forehead became a much-imitated style. Hairdressers across America reported that women were coming in and saying, "I want my hair just like Mamie Eisenhower's."

Anyway, we had a really nice afternoon in the White House with the first lady and I remember thinking how very pretty she was, so much prettier than her photographs. She had beautiful skin and wonderful, sparkling, bright blue eyes. She had a vivacious laugh and made her

guests feel very much at home and comfortable, sort of like going to see your favorite aunt. When I was leaving to come back to New York, Mrs. Eisenhower said to me, "You know, Mr. Scaasi, I love the clothes that you do for Ruth Buchanan and I hope that you'll do something for me."

Ruth Buchanan was a client, a very pretty, petite woman for whom I had made many things. Mrs. Buchanan first found my clothes at Neiman Marcus near where she lived, then finally she contacted me when her husband, Wiley Buchanan, came to Washington to be the chief of protocol for President Eisenhower. Of course, she loved the Washington life, and was a great hostess; she had a very good figure and she wore clothes beautifully. She also had two beautiful young daughters. So it was a great coup for me at that stage of my career to be dressing the Buchanan women. One of the daughters, Didi Wilsey, lives in San Francisco and has remained a dear friend.

Before long, Mrs. Eisenhower's secretary contacted me. I sent color sketches and swatches down for her to see, and she began to order clothes. One of the first things was a white chiffon dress that was strapless. It had a great panel of green chiffon floating down one side. In the fifties and early sixties, strapless clothes were all the rage, and I was very pleased that Mrs. Eisenhower wanted to look so stylish. She ordered many evening gowns and, in fact, I don't remember any of her long clothes that weren't strapless. I found after she'd undressed and was in her slip that she had a wonderful bosom and had never worn a bra. Now we're talking about a woman in her fifties—I remember remarking on it and saying, "Oh, should we find you a strapless brassiere" (as they were called in those days). And she said, "Oh, no, Mr. Scaasi, I never wear a bra. I don't want those terrible little wrinkly creases and marks that most women have where the arm meets the body from wearing those push-up bras today. No, no, I prefer to look natural." Of course, I complimented her—her body was in great shape and she had never worn a bra!

Mrs. Eisenhower came once to New York at the beginning when we took measurements and chose some of the first clothes. She loved the Stanford White house that Valerian Rybar had decorated for me. It was very beautiful and she compared it to the White House, which was not true, but nice of her to say.

After that, I would go to Washington to fit her clothes and very

often, because I didn't much like flying in the days of propeller planes—if the truth be known, I would insist on a seat by a window over the wing, imagining I could do something if the propellers stopped! I would grip the seat arms during the entire flight, never going to the bathroom—really difficult on a thirteen-hour flight to Paris. I just never understood what kept the plane up (still don't!). When jets came in in '58, I had nothing to watch, so I said a little prayer and relaxed. Sometimes I would go to the capital by train. Mamie was always very sympathetic because she didn't like to fly either, telling me she always worried when the president was off flying somewhere. She would say, "Oh, Mr. Scaasi, now don't you worry, we'll just start a few hours later. We'll have the car meet you at Union Station. Do take the train and relax."

I would arrive at the White House and be brought in through the main portico. I remember the very first time I went to fit the first lady, I was in the Great Hall at the bottom of the majestic staircase waiting to be ushered upstairs and I heard this sweet, trilling voice from the second floor, "Oh, Mr. Scaasi, Mr. Scaasi, you're here, how wonderful. Come right up, please." So I went up the grand staircase, and there at the top was Mamie Eisenhower, our first lady in a pink wrapper! She had on full makeup and her hair was done. Whenever I met her, she was in full makeup and her hair had always just been done. For her fitting, she took me into the bedroom that overlooked the main entrance of the White House on Pennsylvania Avenue. Interestingly, this is the bedroom that Jacqueline Kennedy made into an upstairs family dining room, where often I had lunch, many years later, with first lady Barbara Bush. Before the Kennedys, the first family usually ate downstairs in a small dining room off the State Dining Room, although, as history has it, the Eisenhowers often ate upstairs on TV tables, watching television sets that were built into the gallery walls. When Mrs. Kennedy arrived, all that changed.

Mrs. Eisenhower said to me, "Would you like some tea or coffee or would you like a Coca-Cola? You know, *we buy* our own Coca-Cola." I always thought that was a strange remark, but it comes back to me after all these years, because at the time the government was critical of what the presidential household spent for their personal use. So in essence, Mrs. Eisenhower was saying to me, "We buy our own Coca-Cola, so it's okay to have some!"

Because we had taken so many measurements and had a very good dressmaker dummy of the first lady, the fittings always went well—how she loved those pretty clothes.

"Oh, I love the way you make my clothes move—they move so beautifully," she always said. "You know, the President loves to dance—you must always make my evening clothes, Mr. Scaasi, so that we can dance. We dance a lot at all the state dinners."

Early one day in 1959, I received a call from Mrs. Eisenhower's secretary. "Mr. Scaasi, do let me put the first lady on the phone. She'll be with you in one moment."

"Good morning. How are you? Is it nice in New York? It's perfectly beautiful in Washington. You really should be here. Tell me, when are you coming for my next fitting?" Before I could answer, Mamie went on. "Mr. Scaasi, I have the most exciting news. Nikita Khrushchev, the chairman of the Soviet Union, is coming to Washington very soon, and I must have a wonderful dress. You know, no one has visited us from that country since the end of World War II, so this is a very special occasion—do put on your thinking cap." A week later, I was on my way to the White House with a full red coat and some afternoon dresses that Mrs. Eisenhower had previously ordered.

On arriving, I went up the familiar staircase with a bolt of gorgeous, dull gold puffy flowered damask under my arm.

"Mr. Scaasi, do let me see what you have there. What are you hiding from me?" the first lady said, playfully. With that, I unrolled the piece of golden damask silk.

"Oh, how beautiful. I'd love a dress in that. What shape would you do it in, and for what occasion? Do you have anything specific in mind?"

"Absolutely." I answered. "Why not do it for the Russian state dinner?"

"Don't you think it's a little bit *too* luxurious? After all, it's a communist country—they may not wear formal clothes that evening."

"You're probably right," I continued, "but I think this is a chance to make an important statement. Why not wear a gold dress, emphasizing that we are a rich, powerful country!"

Mamie laughed, her blue eyes twinkling. "Why not—let's do it!" In retrospect (it was forty-five years ago), I can't believe I was so brash as to suggest trying to make a political statement. We did the strapless gown

with two wings going up over the bosom and the first lady wore long white kid gloves, a must for formal occasions in the late fifties. Mr. Khrushchev wore a navy blue suit, and his wife a navy silk dress with long sleeves—Mamie looks radiant in all the photos standing beside the Russian First Citizens. Of course, I'll never know if the young designer (me) had anything to do with improving our relations with Russia over the long run.

Mrs. Eisenhower was pictured in *Life* magazine wearing the stunning red coat to welcome the president home from a tour of our armed forces abroad. She accessorized it with a small red hat worn back of her famous bangs, a red scarf, and red gloves, making sure that her husband would see her immediately as his plane landed!

One time in particular, I arrived late in the morning on the day President de Gaulle was coming to Washington for the first time since World War II. This was a momentous occasion and there was a great parade down Pennsylvania Avenue. I was fitting a candy-pink satin strapless evening dress—Mrs. Eisenhower loved pink—the top completely covered in crystal beads and embroidered "dewdrops." She adored the dress and it looked wonderful on her. The first lady intended to wear it that evening at the state dinner for President and Madame de Gaulle. As soon as the dress was fitted, it had to go immediately to the dressmaker who had come down with me. There was an adjoining little room that had a sewing machine and the wherewithal to alter clothes—the young woman was going to finish the gown after the hem had been taken. At that point, I left the bedroom and joined her to look after what had to be done.

Mamie in the golden gown

When I returned, Mrs. Eisenhower was in her pink wrapper, kneeling at the window with her elbows on the windowsill. She said, "Oh, come, Mr. Scaasi, come, come and look out the window with me." So I took the windowsill next to her and we both peered out to where the parade with President Eisenhower and President de Gaulle was going by. She was so excited, like a child. Of course, I was even more excited. Here I was in the White House, kneeling next to the first lady, with our arms on the windowsills and our chins in our hands looking at this grand parade. It reminded me of two housewives in sort of a country village watching the world go by. Mamie turned to me with true adoration in her eyes and said, "Oh, Mr. Scaasi, look at the president—doesn't he look handsome?" Well, of course, he did, and it was a great moment for Mamie to see her husband with the French president. It was great for me, too; I was witnessing a special time in history that we would never see again.

We made many things for the first lady until the end of Ike's long presidency. One occasion I will never forget was the state dinner for the president of Colombia in 1960. Remember, I was doing luxurious clothes, but they were ready-to-wear, sold in many stores across the country, and I mostly did not know the women who bought them. Earlier, I had designed the most beautiful fabric of large cut-velvet stylized roses on a white satin ground—loving the incredible material, I ordered it in three colorways: pink with rose, blue with turquoise, and orange with russet. The night of the Colombian state dinner, Mrs. Eisenhower wore the strapless gown in the pink version. Her secretary called me early the next morning to say that the first lady wanted to speak to me—with trepidation, I picked up the phone.

"Arnold, I wanted to call you early, before you saw the papers—you know, when the Marine band piped us in down the grand staircase last night as we made our entrance, the president whispered in my ear to look at the bottom of the stairs. There, standing ready to greet us was a lovely red-haired lady wearing my gown, but in shades of orange! Now, don't get upset—we all thought it was amusing. I greeted her and we both laughed and were photographed together."

"Oh, Mrs. Eisenhower, I'm so sorry. She must have bought it at Saks in Los Angeles. I know we sold the orange version to them. I'm so dreadfully sorry," I stammered.

"Don't be silly—I love my dress and the president complimented me on how pretty it was—so don't worry. I just wanted you to know before one of those newspaper people got hold of you. See you next week." What a considerate, nice lady.

The next time I arrived, Mamie was standing by the window, looking out toward the White House lawns and wrought-iron fences.

"Oh, Arnold, come and look out—look at all those people taking pictures—they're there *all* day long, photographing this old house—it never fails to amaze me!" Her naïveté was charming, but I did wonder a little where the first lady thought she lived—after all, it is the most famous house in America.

Very often during our fittings, the president would look in on us to say good-bye on his way to a meeting.

"Hello, Arnold. It's really nice to see you here, and what a beautiful dress you're making for my wife," he would comment, glowing with pride.

"You know, dear, we'll have to go dancing soon," he'd say to Mamie.

It never failed to amaze me at what an extraordinarily strong personality President Eisenhower had. He would pop in for only a few moments, but the whole room would light up with his wonderful charismatic charm and broad smile. You understood why America loved him so.

Eleanor Roosevelt and Bess Truman at a Democratic rally. The stylish lady with white gloves is Lady Bird Johnson.

ELEANOR ROOSEVELT

One day in 1959, my friend, Mildred Morton, the executive editor of *Vogue* magazine, called and asked, "Arnold, can you come for a drink this evening? Eleanor Roosevelt will be coming, and I think you would both enjoy each other very much. She's a great friend of mine and our families go back a long way together." I remembered that Mildred knew many of the Roosevelt children and that occasionally Mrs. Roosevelt stayed at her penthouse apartment on East Fifty-seventh Street.

Mildred Morton was a wonderful woman, full of life and different interests. To my knowledge, she was married a few times and had many famous gentleman lovers. She was in her late fifties then, but didn't look a day over forty—she was slim and very stylish, wearing the newest clothes featured in *Vogue*. She was fascinated by life and went at it with a voracious appetite. Mildred had a deep throaty laugh, which she often interjected into her conversation. I can see her now with those sparkling dark eyes and white, white skin and the swinging bob of platinum blond hair. She was model size and had bought one of my very first coat and dress ensembles: a slinky strapless dress of orange silk faille worn under a floor-length coat of fuchsia satin that draped off the shoulders, lined in the same orange faille. She bought the outfit from my very first collection in 1956 and wore it well into the seventies. Remember, most fashion industry events at that time were black tie and the fashion crowd loved dressing up. Long dresses in a fashion editor's wardrobe were necessary. Of course, they had the whole industry to choose from and always culled something they loved from their favorite designers. Mildred Morton's favorites were Norman Norell and Scaasi. She always looked so

wonderful in our clothes that I was very happy to be part of *her* fashion pack.

I arrived at Mildred's at six-thirty that night and she greeted me affectionately and led me into the small study. There, indeed, was Eleanor Roosevelt seated in the deep sofa and, as I remember it, dressed in shades of browns and grays. Mrs. Roosevelt must have been seventy-four or seventy-five and she was dressed correctly for her age at that period. However, when you looked at her face she had this broad cheery smile with all those teeth and the most amazing twinkling eyes—certainly, the eyes of a much younger woman. Mildred left the room to get the drinks.

Mrs. Roosevelt immediately said, "Mr. Scaasi, I watch with great interest what you're doing for Mrs. Eisenhower. It must be very exciting to dress such a pretty woman." I allowed as how I enjoyed designing for the first lady very much and how exciting it was to go to Washington. We talked about certain rooms in the White House where I did my fittings, and, of course, she knew the areas very well. She then said to me, "I've always loved bright cheerful colors, but when I was a young girl my aunt told me that they did not suit me, so whenever I did wear them I always felt conspicuous."

Our talk then turned to Washington and politics. She surprised me by saying, "There would be much less confusion if each state governed itself, separate from the federal government." I never expected the wife of a president to say such a thing, but her thinking seemed so clear and she was so direct and spoke with such great authority that I could really see how it might work. She was charming and though her strong character came through, she was also very feminine. Those wonderful hands moved constantly and seemed to articulate everything she was saying.

About a month later, I was flying to Washington and there was Mrs. Roosevelt on the plane. She waved me over and in that unique crackling voice said, "Mr. Scaasi, come and sit by me." This was a propeller plane— there were no jets then—and it had seats that faced each other, two seats in a row that faced two other seats, with a table in between, just like on a train. There were many journalists crouched around her—obviously people she knew from her White House days—but she made room for me, and began immediately to talk about our mutual friend, Mildred Morton,

and also about what I would be doing in Washington. When the plane landed, I went to the airport waiting room and found the man from the White House staff. I said good-bye to Mrs. Roosevelt and went to the car that had been sent.

I had no luggage, as the clothes that were to be fitted had been sent ahead. I got into the car and we took off on the road to the airport exit. When we got to the exit and were about to go onto the highway, I spotted Mrs. Roosevelt, all alone, standing at the curb of the roadway trying to hail a cab. I remember she raised her arm and waved at every cab that went by. At that moment, I couldn't decide what to do. My first inclination was to stop and give her a lift, but then I thought, "Well how can I do that, I'm in a White House car, I'm in the car of a Republican White House and she is a Democrat." But still, I thought I must do something to help this elderly woman, and also I wondered why no one had met her, one of the most admired first ladies that we had ever had. All these thoughts kept rushing through my head, but before I knew it we had passed her and were farther down the road. My last image was of this elderly lady, this American treasure waving furiously, trying to get a cab to take her wherever she was going. It's a moment that has stayed with me all my life and that I have regretted deeply.

I met Eleanor Roosevelt many times after that and was always impressed by her down-to-earth charm and graciousness.

Recently, I saw a tape on public television of Mrs. Roosevelt in the late fifties at the Democratic convention where she was pushing the nomination of Adlai Stevenson, her great friend, and suddenly all of the memories came flooding back. What I realized while watching her speak out for her friend, believing he would get the Democratic nomination against Senator Kennedy, was that she had a fierce will to fight for what she believed in.

It struck me for the first time in all these years that even though she was a physically mature woman, she loved pretty clothes. She was the keynote speaker, so she must have thought a lot about what she would wear. What we see her wearing is a very feminine cap-sleeve dirndl dress and a small flowered hat with a veil. The bodice of the dress had a rather low scooped neckline and she wore a necklace of what looked like large beads

in different colors. Certainly, the outfit did not flatter her image. In fact, it was really all wrong for her. She should have worn a much slimmer dress with long sleeves. After all, she was a woman with not a particularly good figure, but you just knew by looking at her she must have thought she looked pretty because the clothes themselves

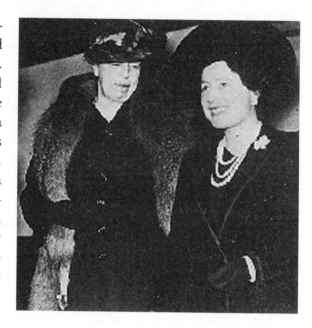

were pretty. Obviously, she just had no one to tell her that she was dressing all wrong and how much better she would have looked if she'd been dressed another way. Regardless of all that, her speech was riveting and the convention floor responded with a standing ovation.

Watching this made me think of all the times I had seen her in other situations not necessarily wearing a color that flattered her or a shape that was good for her figure, sometimes wearing badly chosen prints. But none of that mattered; she was such an icon.

I believe that clothes should help a woman feel good about herself, and in some way, these pretty clothes that should have been worn by a whole other type of woman, made her feel good.

The one time I've seen pictures of Mrs. Roosevelt looking quite smart was when Queen Elizabeth and King George VI came to the United States from England in 1939. The first lady met them wearing a well-tailored dark coat with silver foxes around her shoulders and a jaunty hat slanted over one eye. Though she really looks more stylish in the photos, the lovely Elizabeth does outshine her—dressed in a velvet coat piped in satin, with a matching hat and ropes of those great royal pearls.

I always felt Eleanor Roosevelt was a very feminine person at heart, and

I know that she liked to go into her garden at Val-Kil and cut roses for the guest rooms. This is a very feminine gesture. It's also a gesture of a person who wants to make other people feel welcome. Eleanor Roosevelt always made everyone, no matter what color or what culture, feel welcome. That was her strength and *her* kind of true beauty.

*Pamela Turnure and Bob Timmins's wedding
at Jacqueline Kennedy's Fifth Avenue apartment*

JACQUELINE KENNEDY ONASSIS

The other morning I found myself trying to hail a taxicab on Madison Avenue at Fifty-sixth Street. I glanced over to the southeast corner and remembered another time long ago when I picked up Jacqueline Kennedy Onassis and her daughter at that very spot.

At six-thirty in the evening of Tuesday, June 17, 1969, I left my salon at 26 East Fifty-sixth Street and walked the few steps to Madison Avenue. In those days, traffic on Madison went both up and downtown; it was not the one-way thoroughfare it is now. I was going to a small cocktail party on the Upper East Side off Park Avenue before joining a group of friends attending the opening of the musical *Oh! Calcutta!* The brilliant theater personality and critic Kenneth Tynan was one of the masterminds of the show and, as it had been billed as "an evening of erotic stimulation," everyone was dying to see it.

I love going to opening nights—I think it's really exciting to see a production the very first time it's shown to the public. For me, it's like the opening of a new dress collection, when it all comes together and the audience is wondering what it's going to be like, and you are suddenly a critic. I was looking forward immensely to the evening. The creative team of *Oh! Calcutta!* included Sam Shepard and John Lennon, and the abundance of frontal nudity assured a kind of wild sixties success!

I hailed a cab going downtown and had the driver swing left onto Fifty-sixth Street toward Park Avenue. As the car moved past the south corner of the street, I noticed that Jacqueline Kennedy Onassis and her daughter, Caroline, were standing there trying to get a taxi. Mrs. Onassis was looking every which way to no avail—there were simply no cabs in sight.

I had met Jacqueline Kennedy a few times but got to know her quite well in 1965 at Pamela Turnure's wedding to the heir of a Canadian gold mine fortune, Bob Timmins. Pam Turnure had been Jackie's press secretary through the White House years, and we had become friends when the first lady was deliberating over whether she would have Scaasi clothes in her White House wardrobe. Pam's wedding reception was held in the Kennedy apartment at 1040 Fifth Avenue overlooking the reservoir in Central Park, where Jackie and the children lived after she left Washington. The bride wore a charming Scaasi wedding gown made of white piqué that was short in front and went to the floor in the back, and a little kerchief of reembroidered white lace—very young looking and of the moment.

I remember Mrs. Kennedy unsheathed a silver ceremonial sword that had been given to President Kennedy by King Hassan of Morocco and insisted the young couple cut the wedding cake with it. All the little flower girls gathered around the table, Caroline included, and giggled as the long shiny blade cut into the cake—Jackie was jubilant!

The memorable occasion came flooding back as my cab began to pass the former first lady and, not wanting to make the same mistake I had made with Eleanor Roosevelt, I had the driver stop the car. I rolled down the window and said, "Mrs. Onassis, it's Arnold Scaasi. May I give you and Caroline a lift?" Jackie's face lit up with that famous endearing grin and she said, "Oh, Mr. Scaasi, how kind of you. We're supposed to have been home ages ago." I remember wondering, as I had about Mrs. Roosevelt, why the very recognizable Jacqueline Kennedy Onassis did not have her own chauffeur-driven car. I got out of the cab and Caroline jumped in first, moving over into the corner, then Mrs. Kennedy, and finally me—all in the backseat.

As we traveled uptown, we talked for a moment about our mutual friend, Pamela Timmins, and then Mrs. Onassis asked me what I thought was a very strange question.

"Arnold, you are such a wonderful designer, I've always admired your clothes. In fact, I own many things of yours and have enjoyed them so much. Tell me," she asked in that famously breathy voice, "what would happen if you woke up one morning and you didn't have a new idea? What would you do?" Well, I was taken aback. No one had ever asked me

this question before. And I remember at the time thinking that it was a particularly silly question and very strange to be asking it of a creative person. Perplexed, I stammered, "Well, of course, I would just keep on sketching until a new idea came along." She laughed and said, "That is probably what any fine designer would do."

We continued up Park Avenue and I reached my destination on Seventy-first Street. I said, "Mrs. Onassis, I must leave you," stopping the cab, "but please continue on. I know you're going farther uptown." We made some niceties as I began to leave the cab. Then, of course, the eternal question came to my mind.

After all, Jackie Onassis could certainly afford to pay for the taxi. But, I thought, as a gentleman I must offer. So I said, as I would to any friend, "May I take care of this?" She said, "Oh, no, no, no. You were so kind to pick us up. Please don't even think about it. Absolutely not!" At which point I thought the best thing was just to escape. So I said, "It was wonderful seeing you, again," and I began to leave. As I opened the door, the cabbie suddenly piped up, "Huh, I see you're the last of the big spenders, letting the lady pay, what's the matter with you?" I was shocked and protested vehemently, trying to give the cabman some money. Obviously, he had not recognized the most photographed face of the century. Mrs. Onassis became alarmed. "Oh, no, please, please don't do that—please, you were just so wonderful to pick us up. We'd still be standing at the corner if not for your kindness." Well, I didn't know what to do and Jackie was getting slightly hysterical, while Caroline scrunched down in the corner of the taxi, trying to make herself invisible.

I realized that the best course was to leave the scene. I bade them farewell and hurriedly departed—continuing on my way to an evening of more surprises and much merriment!

FLASHBACK—late one afternoon in 1959, the better-dress buyer from the Bergdorf Goodman salon called me, and in the most excited voice said, "Scaasi, guess who was just here. Jacqueline Kennedy. And she has ordered two of your evening dresses. She just loved them and looked wonderful in them. We are all so excited." I knew that Mrs. Kennedy was the beautiful young wife of the United States senator from Massachusetts and that John F. Kennedy, her husband, was running for the presidency.

One of the dresses Jacqueline Kennedy had chosen was a great favorite

of mine that season. It had a long bell-shaped skirt and long tight sleeves with a bateau neckline. The dress was made of a luxurious ruby-red satin, perfect to set off Mrs. Kennedy's lustrous dark hair and creamy complexion.

For the spring season, amongst other things, Mrs. Kennedy ordered a white raffia lace dress and shawl with a ruffled hemline that was slightly shorter in front and dipped to the floor in back. The simple bodice went straight across in the front. Over the bare back were crisscross wide-ribbon straps ending in two bows. The dress was very beautiful and, I was told, a great favorite of Mrs. Kennedy's. It was certainly a look that was to become the "Jackie Look"—simple, luxurious, and yet with a certain dash of youth that was the quintessence of the future first lady.

Of course, we knew that Mrs. Kennedy loved French couture clothes, primarily from Hubert de Givenchy who had apprenticed with his mentor, the famed Cristobal

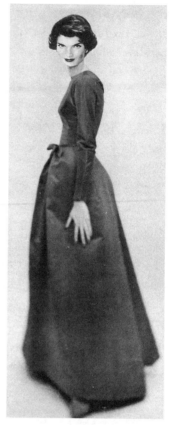

Ruby-red satin dress

Balenciaga. Givenchy created the sleeveless simple look that became synonymous with Audrey Hepburn's style in 1954 in the movie *Sabrina*. Jackie Kennedy also favored François Crahey, the designer for Nina Ricci. She liked clothes from Pierre Cardin and the timeless draped gowns of Madame Grès. I was very flattered that the senator's wife had chosen many of my designs and had told the people at Bergdorf's how much she liked them and how flattering they were.

Early in 1960, my friend from Bergdorf Goodman called again to say, "Jacqueline Kennedy is coming in to fit the pale blue dress of yours that we just received. I'm concerned about the change we made on the bodice. Scaasi, would you mind coming by this afternoon and having a look at the dress on her, just in case something more has to be done?" "No

problem," I replied. "See you at three." As I was in the Stanford White house on Fifty-sixth Street just west of Fifth Avenue, and the entrance to Bergdorf Goodman was on Fifty-seventh Street, it was a snap to get there.

I arrived and was told Mrs. Kennedy was already in the special fitting room put aside for her. I knocked and entered. She had gotten undressed and was wearing the pale blue zibeline silk evening dress. The fitter was on her knees, fussing with the hem. Jacqueline Kennedy was standing patiently, reflected six times over in the three-way mirror. She smiled that broad grin that was to become world famous.

"Mr. Scaasi, I'm so happy to meet you," she said, extending her hand. "I love my dress. Isn't it beautiful!?" I agreed as how it was lovely on her. She continued, "I know we decided to make the sleeves slightly longer than the original, but now they almost come down to my wrist. Do you think it might look better if we shorten them a little, say, to just below the elbow?" Pinning the sleeve up, I viewed the result in the mirror; it *was* a better proportion for the dress.

"I'm sure you'll wear gloves, and it will look great," I assured her. While the fitter was working on the hem of the dress, we talked about her busy schedule campaigning for the future president and the different collections that I was working on at the time. Eventually, the fitting was over and I made my good-byes. I left the store happy, knowing that the senator's wife looked wonderful in yet another dress of mine.

Later, when she was established in the White House, I received a call from her office, asking if I could send that season's sketches from my new collection. I can't tell you how excited I was to think I might be dressing another first lady!

Pamela Turnure and I spoke often, and I suggested, as I was going to Washington to do a fashion show for the specialty store Woodward and Lothrop, perhaps we could send the clothes that Mrs. Kennedy had picked from the sketches over to the White House after the show. It was agreed that we would do this, and someone picked up the garment bags to take to the first lady. I departed Washington that evening, leaving the clothes behind.

I realize today, with all the security around the presidential mansion, it would not be that simple, but this was 1961, and one could almost wander into the historic Pennsylvania Avenue residence at will—and did.

There were often tours all day long, with very few exceptions. The young first lady did such an amazing job of renovating the house after the Eisenhowers, I do think she was very proud of her accomplishment; she wanted everyone possible to see it.

A few days later, the clothes were returned to New York with a note saying how much the first lady liked them. I then spoke to someone in Jacqueline Kennedy's office, going over once again the list of outfits that she liked. The young lady said, "Now, Mr. Scaasi, how long will it take to make these things, and will you come here to do the fittings?" I said I would call back after speaking with my workroom.

"Fine," she said.

"By the way," I continued, "I do want you to know that I will charge Mrs. Kennedy only the lowest wholesale price, as I did with Mrs. Eisenhower. I think that's fair, don't you?" There was a long pause on the phone.

"Oh, Mr. Scaasi, I don't know what we'll do about that—to my knowledge, the first lady does not pay for her clothes. I'll have to get back to you," said the voice on the other end of the phone.

I was in shock. I was in the beautiful, Empire-style office that Valerian Rybar had designed for me, and though it was only six o'clock, being autumn it was already dark outside. Everyone had left the town house, and I really felt alone and completely bewildered. I didn't know what to do—I was in my mid-twenties, and the business was barely four years old. I had made myself a promise that I would never give away a dress for free, and here I was being asked to give away dozens of outfits for God knows how long a period! My business was going well, but I had the mortgage on the town house and other financial demands.

I tormented myself all evening about the subject. In the morning, I called the first lady's office and said, "I'm so sorry—I would love to dress Mrs. Kennedy, but if I do, I'm afraid I must charge her for the clothes at the lowest wholesale prices—I will do my utmost to keep things as inexpensive as possible. Please do try and explain this to the first lady." I never heard from the White House again.

THAT WAS PROBABLY THE DUMBEST DECISION I EVER MADE IN MY LIFE!

It's interesting to note that today the clothes could not be shipped

without an invoice for payment. If they *were* given gratis, the first lady would be obliged to declare the gift and pay a gift tax. The Ethics in Government Act of 1978 requires high-ranking government officials and their spouses to report any gifts worth more than thirty-five dollars. How can we ever forget the flap over Nancy Reagan accepting thousands of dollars' worth of clothes from designers Bill Blass, Adolfo, Oscar de la Renta, Jimmy Galanos, and Jean Louis, and also jewelry, as "gifts." The press had a field day with the first lady's indiscretion, and it proved to be a serious embarrassment to the Reagan administration.

Of course, we all know what happened in 1961. Because of her formidable style and famously charming personality, Jackie Kennedy became the most powerful fashion icon since Marie Antoinette. Oleg Cassini was called her official designer, and though her look during the White House years continued to be based usually on French clothes, Cassini became one of the best-known designers in the world. The first lady gave him full credit for what she wore. I always think this possibly could have happened to me, if only I'd been more experienced in the ways of the world.

In truth, he was an unlikely candidate for the job but had been a friend of Jackie and Jack's long before Kennedy became president. The Cassini workrooms accomplished what had to be done interpreting the French looks for the first lady, and he and Mrs. Kennedy obviously worked well together.

Another explanation might have been what was strongly rumored by the Kennedy inner circle and hinted at in the press. We know the president liked to approve the first lady's choices of evening dresses, and each time they arrived at the White House there were always beautiful models in tow. Supposedly, the young women were sometimes brought in for the benefit of the horny young president waiting upstairs! His recently released medical records prove that the drugs the president was taking for his severe back pain kept him in a state of sexual arousal that had to be satiated often.

Jacqueline Bouvier Kennedy Onassis was not your ordinary woman. One realized this even more after she married Aristotle Onassis in 1968. She changed noticeably; there was a whole other dimension to her than when she was first lady. She became more of an extrovert, possibly

because she had the shadow of Onassis's longtime lover, the extraordinary, world-renowned, and much photographed Maria Callas, hanging over her.

One night in the early seventies, Parker and I were at the nightclub, El Morocco, with Cortie and Tootie Wetherill. It was a fun evening—we gossiped about everyone sitting around us on the zebra-printed banquettes, drank lots of champagne, and danced on the tiny dance floor. About eleven-thirty, we decided to leave. On our way out, we spotted Jackie and Ari and waved to the celebrated couple. Jackie smiled and waved back—she was radiant in a pink satin strapless dress.

We had just seated ourselves in the Wetherills' car as the Onassises exited through the door of the club. The ever-waiting paparazzi flashed their pictures. Jackie laughed, as her husband left her on the front steps. The former first lady said something to the cameramen and then reentered the club, only to emerge again, this time, posing purposely, with broad gestures, for the cameras. We waited and watched, fascinated. It gave one an insight into this amazing woman who had always complained about being photographed too often, but actually didn't seem to mind if she was setting up the shot! Of course, the next day, the photos in the press were perfect—Jackie had staged it like the pro she was!

Diana Vreeland, the flamboyant magazine editor, was a great friend of the young Mrs. Kennedy and had helped her immensely, choosing her wardrobe for the White House years.

Mrs. Vreeland was a study in contrasts. She was probably the most stylish woman in the world, yet quite ugly, with fierce-looking eyes that were too small for her face and a large hawklike nose. She had the most wonderful thick shiny black hair worn in a pageboy. Her mouth was always painted a brilliant red. Though her skin was pale, her cheeks and ears were brightly rouged. Her slim figure was usually dressed in black with a splash of color—she loved red—and large pieces of jewelry that were often fake. When she entered a room, she took over the space. She was highly intelligent, with a deep voice and an unusual varied vocabulary. She made the most banal statement seem amusing, outrageous, or simply full of common sense. As an editor at *Harper's Bazaar* and then as the editor in chief of *Vogue,* she hired the most avant-garde photographers and had them photograph everyday fashion items in the most fantastical

settings. However, in this highly sophisticated body dwelt a being who was completely down-to-earth. And though her extravagances were great, she had a fine businesslike mind.

Wanting to use an enormous bright blue wool-and-mohair coat of mine for a September cover of *Bazaar,* Vreeland telephoned and asked where the fabric had come from. "It was woven in France by the House of Lesur." I answered. She said, "Oh, Arnold, they are so clever—I adore what they do—we're nuts for the coat! However, as it's the Americana issue, do you think you could find an American fabric to make it in? We will use the coat, regardless, but it would be a great help to me if you could make the change." I said I would certainly look into it, and asked my fabric man to work on it immediately. After several tries, he came up with nothing that even remotely resembled the original. I telephoned the flamboyant editor and explained the situation.

"Oh, don't let it worry you, dear boy," she said, "I just had to tell something to the boys upstairs [the men who sold advertising]. We adore the coat, and Dick [Avedon] will photograph it next week."

She often turned words around to make them more palatable to fashion folk; a famous example was when she started to push the product of an important advertiser, Celanese, who produced man-made fibers for fabrics in the fifties that were often unpleasant to the touch. Not knowing just how to promote this undistinguished product in her tony magazine—suddenly her mind clicked. Vreeland entered a meeting, excitedly bellowing, "I've got it! Chella-Nayzee, Chella-Nayzee—we'll get the world to use the stuff, no matter what!" In another original observation after returning from Kashmir, Diana announced, "Pink *is* the navy blue of India!"

Always protective of the girls on the staff she cared about, she was like a mother hen with her chicks. One day, visiting a secretary who had just married and moved into a particularly drab apartment, she was at an unusual loss for words. Trying to think of something nice to say to her protégée, she suddenly spied the telephone.

"Peggy," she said, enthusiastically. "You have a black telephone. *How* original, dear girl!"

After *Harper's Bazaar* and *Vogue,* Mrs. Vreeland became special consultant to the Costume Institute at the Metropolitan Museum of Art in New York. In 1974 she was preparing a show called *Romantic and Glam-*

orous Hollywood Design. She asked many designers to re-create clothes that had been lost from some of the more memorable films. I was particularly enthralled with the costumes that Adrian had designed for Garbo as *Camille,* making the big Swede look so fragile and feminine. I asked if I might work on these dresses specifically. Vreeland was overjoyed at my request. I began to search out fabrics and embroideries that could work for the two or three dresses I wanted to make for the exhibition.

At one point, I had several swatches in hand and went up to the Met to meet with the grande dame in her office. She enthusiastically approved of everything until we came to a swatch of flower-embroidered white organdy. I was so pleased that I had found something that was close to the original fabric used in the 1936 film. She vehemently said the fabric was not correct and had a photograph brought in of the dress.

"Diana," I said, putting the two facsimiles together "Look, they are amazingly alike. I think I should use it." There was a long pause, and in a barely audible guttural whisper under her breath, she said (I believe, to herself), "Boy, you really have balls!" I gathered she was clearly not happy with the fact that I had questioned her otherwise undisputed fashion declaration. I used the fabric, and the dress turned out beautifully, looking to all the world like the original.

I knew that she could swear like a trooper, but deep down inside, she was truly sentimental. For the gala opening of the Hollywood show, I sent her a nosegay of white camellias, the flowers Camille always wore. She carried them with the black velvet off-the-shoulder ball gown she wore that night, looking very much like a romantic character out of the MGM film.

She had an innate kindness that was unusual for a woman in her position. She did special things, like travel to Texas with her assistant, Carrie Donovan, who was all alone and had to have a then-revolutionary heart bypass operation. Diana didn't want Carrie to be on her own at such a critical time.

The flamboyant editor embodied the most trivial fripperies of fashion with the most down-to-earth elegance of a courageous pioneer woman—Diana Vreeland was truly an original from the word go!

In January 1977, I was lunching with Vreeland and Mrs. Onassis at the Colony restaurant. The special consultant had just opened the show *The Glory of Russian Costume* at the Costume Institute at the Metropolitan

Museum. It was astounding! Diana Vreeland and Jackie Onassis had gone to Russia to persuade the Communist government to loan the clothes to New York—an unheard-of feat! The exhibit opened in December 1976 with a great gala. I remember it being the most exciting evening of the season—everyone who was anyone was there, and the Vreeland "magical mystique" was everywhere.

The most amazing object the two formidable Americans fought furiously to obtain (and succeeded) was Catherine the Great's wedding gown made of cloth of gold, studded all over with diamonds. It stood, eerily, on an inanimate mannequin in a long glass case, alone in the middle of one of the galleries. Russian music filled the halls, and there were bowls heaped high with Russian caviar and gallons of chilled vodka—what a night!

When I reached the Colony restaurant that day, I found Diana already seated at the table. I congratulated her on the monumental exhibit and said, "How wonderful the hardcover catalogue, *In the Russian Style,* turned out."

"Do you really think so?" Vreeland asked.

"Yes, I love it—it's so complete—the photographs are beautiful and the text perfect," I answered. "I treasure it."

"Oh, Arnold, do tell Jackie, when she arrives—it's so important, dear, she hears it from you. She edited it and did all the work. It's her first paying job, you know, and she's so unsure of herself. She can't believe that it's really as good as people say. Do make a point of telling her."

Of course, when Mrs. Onassis arrived, I exclaimed how great I thought the book was. She was a little embarrassed, but finally Vreeland and I persuaded her not to be so modest. She relented, smiling happily.

Later, Onassis left Viking Press, publisher of the catalogue, and went on to be very successful in an important editorial job at Doubleday. She worked extremely hard and was an excellent line editor. One could see her at the end of each day, walking home, up Park Avenue, dressed in a simple silk top and pair of slacks, looking for all the world like any working woman, the epitome of New York chic at the time.

Still, to this day, people think of Jacqueline Kennedy as the perfect first lady, exuding charm and grace, with that special aura that we will never forget.

Serena Russell Balfour at Blenheim Palace, 1962

CHAPTER VIII

SPECIAL DEBUTANTES

On Friday, June 6, 2003, Parker Ladd and I went to visit our new chums, the Honourable Peter Ward and his pretty blond wife, Liz.

Their home is *Cornwell Manor,* a great stone edifice, which was first built in the late seventeenth century and added on to each century after that, right up to the twentieth when a very rich American lady refurbished it successfully.

The main building and surrounding ones and what is called the "village," sit in about four thousand acres of beautiful countryside near Chipping Norton in the Cotswolds in Oxfordshire, England.

Parker had complained for years that, although we came to London often, we had never been to an English country weekend house party. Well, Liz Ward, invited us and we had the best time! Liz has decorated the house beautifully. It could have been done in very gloomy chintzy English style, but instead, it's all bright colors. The large entrance hall, or "winter sitting room," is painted in a warm bright red. From then on, each room has a color scheme of its own. The house is filled with pinks and leafy greens, giving the most cheerful effect, making you feel happy from the moment you pass through the enormous front door.

Parker and I had the blue bedroom, which, obviously, has a lot of blue in it with touches of cream. There is a great canopied bed and, best of all, three enormous windows that look out onto the park.

We had met the Wards through our good friend Pauline Pitt in Palm Beach. We had entertained them there and on Long Island, and were delighted that they invited us back for this weekend. There were twelve people in all, and some of the guests included our old friends Lady

85

Jane Spencer-Churchill, one of the really good decorators in England, and her husband, whom I have known for over thirty-five years, Lord Charles Spencer-Churchill, the brother of the present duke of Marlborough.

The countryside of England is really special. All the flowers you've seen in picture books are in the gardens: every kind of rose imaginable, delphiniums, and fields of lavender. The Wards have a great wall of white wisteria and a long hedge of fuchsia and white peonies. It is truly eye-popping!

On Sunday morning, Charles drove us to his ancestral home, Blenheim Palace, which is just twenty minutes away from *Cornwell Manor*. His brother, the eleventh duke of Marlborough, Sonny, gave us a tour. When we entered, I looked around the vast entrance hall, and it brought back one of the most special evenings of my life. It's funny how just being in a room that you haven't seen for forty years can suddenly bring on a flood of memories. It was as if the whole experience was happening again. Let me tell you about it . . .

In 1962 I flew to London for a week, the highlight of which was a most remarkable party at Blenheim Palace. It was the twenty-first birthday celebration of Lord Charles Spencer-Churchill, the son of the tenth duke of Marlborough. It all came about because my friend and special client Lady Sarah Spencer-Churchill Russell had asked if I would do the dress for her daughter Serena Russell's debut, which was also to take place the same night in the palace.

Serena was a stunning, tall blond American beauty of eighteen, and the dress I made for her was a long, strapless gown with a wide flounce at the hem that moved beautifully. The fabric for the dress had come from the embroidery mills in Switzerland and was a wonderful white guipure heavy lace. We made several other things for the time she would be spending in England, as there were to be many gala parties. There would be luncheons and tea parties, and the very special day when she would go to the opening of Ascot and sit with the queen of England and Princess Margaret in the royal enclosure.

For that occasion, I made Serena a powder blue princess-line lightweight wool coat over a matching dress. For Lady Sarah, I did a lime wool coat with wide revers, the fabric having a very fine overcheck of black.

Both women wore white kid gloves, at the time very de rigueur.

Jacqueline Kennedy also wore white kid gloves almost always in the years she was first lady, as did all fashionable women in the early sixties. You also wore black kid gloves at certain times, and even colored gloves that matched your other accessories. It is interesting to note that several years later when women stopped wearing gloves, a whole industry almost went out of business. Fashion can certainly be fickle. Today, I often see young girls in the evening wearing lace mittens with the fingers cut out, the thought being that it looks sexy—and it does.

But back to the festivities surrounding Lord Charles Spencer-Churchill's twenty-first birthday and Serena Russell's debut. I was very pleased to be invited. After all, I was still a social neophyte and had never been to a ball in a real palace! I stayed at the Carlton Towers in Cadogan Place, a very modern hotel. I liked it for three reasons: it was very up-to-date, had the most marvelous steak restaurant in London, and it was not averse to your inviting a guest up to your room. Most of the grand hotels at that time—the Savoy, the Connaught, and Claridges—would only allow you to invite a friend up if you had a suite, which I did not. For these reasons, I was happy staying there.

Besides going to some of the grand parties that surrounded this occasion, I had come to London to work with my friend Bill Poole, who was the creative designer at the fabric house Liberty of London. Liberty's had been in existence for over a hundred years, and Bill had discovered all the old printing rollers of the art deco and art nouveau periods. We had a great time recoloring these old patterns, which had originally been done in muted tones of grays and browns. I, on the other hand, would recolor them into the most luscious tones of peach, apricot, turquoise, or even into the patriotic red, white, and blue. After a few days, I moved to Bill Poole's charming mews house, where we could work more intensely.

Finally, the day arrived when I was to go for the weekend to Oxford, the town near Blenheim Palace. I had talked beforehand to Mitzi Newhouse, the wife of Sam Newhouse, who owned Condé Nast and *Vogue* magazine. Mitzi was a tiny doll-like woman who loved my clothes and wore them constantly. When she heard that I would be going to the ball at Blenheim, she said, "Si and I are coming to stay in Oxford also, and we have hired this wonderful Rolls-Royce. Won't you drive down with

us?" Si Newhouse was Sam and Mitzi's oldest son who is now the irrepressible business head of the Condé Nast empire—a kind of genius!

On the appointed day, they came to pick me up at Bill Poole's tiny two-story mews house. I had to laugh—the Rolls was almost as big as the first story of the house. Mitzi insisted upon getting out of the car and having a tour. She went from room to room, oohing and aahing, and was totally charming, although it was a far cry from the magnificent multiroom duplex that she lived in on Park Avenue.

Finally, we set off in the back of the car, the three of us: Mitzi, Si, and myself, with the very proper British chauffeur up front. I don't remember what we chatted about, but it probably had something to do with fashion. Si seemed very young, though he was then in his thirties, almost as small in stature as his mother, and though he seemed quite shy at times, he had a good sense of humor, and we laughed a lot as we traveled the lush English countryside on the drive to Oxford.

Halfway there, we stopped for lunch. I thought it was strange that neither of them seemed to have any knowledge of English money. Mitzi kept asking me how much she should tip the waiters and the maître d'hôtel. All this coming from the wife of a world-class financial wizard.

When we arrived in Oxford, it turned out we were billeted in the same charming nineteenth-century hotel. My rooms were on the floor below the Newhouses'. At about five-thirty, I began to dress in my white tie and tails. There were several small dinner parties being given around Oxford that started at seven o'clock, and we were not expected at the ball until nine or later.

In the middle of dressing, I received a frantic call from Mitzi.

"Arnold, Arnold, do you know how to tie a bow tie? We are having the most terrible trouble. Could you come up, please, and help us?" Of course, I said, "I'll be right up." I put my trousers on and dashed up the stairs to find Mitzi in her dressing gown, and Si, standing in the middle of the room, looking bewildered, with his arms outstretched in his white starched evening shirt. He had no shoes or trousers on and, with his black-stockinged legs protruding from the shirttail, he made a charmingly comical figure. I helped him get the studs into his shirt, while he grinned sheepishly and then tied the white piqué bow tie. "I thought they would send me a tie that was already made and would just

clip on," he said. That was *not* the style in elegant London Saville Row shops!

Next it was Mitzi's turn. She was perplexed that her beautiful diamond necklace did not already have the acorn-size pearls hanging from it that were supposed to be there. Someone had to hook them on around the base of the necklace. Of course, I was used to helping women get dressed, so there was no problem for me there. Having hooked the pearls onto the necklace, I placed it around Mitzi's neck, and she was happy as a clam, and looked quite marvelous, even in her pink wrapper.

I went back to my room to finish dressing. About twenty minutes later, Mitzi called and said they were ready to leave. I went down to the lobby and watched the Newhouse mother and son descend the staircase. She looked wonderful in a white chiffon dress with the beautiful jewels. Si, a little uncomfortable in his uptight elegant duds, looked quite handsome and could easily have passed for an English gentleman.

We went off to our dinner party, which was upstairs in one of the tonier restaurants of Oxford, given by a Lady So-and-so, whose name I cannot remember. There had to be at least a hundred people present, and everyone was really done up. I remember having a very good time and drinking a lot of champagne.

At about nine o'clock, Mitzi decided we should leave, and we went downstairs and started off in the Rolls-Royce. The approach to Blenheim is quite majestic. As you go through the great gates to the wide drive, there is a small lake with beautiful white and black swans in it. The palace was built in the early 1700s and was given as a gift to the first duke of Marlborough by Queen Anne, the reigning monarch of the time, as thanks for his victory over the French in the Spanish War of Succession, which was fought in a small village in Bavaria called Blenheim. Hence, the name. The palace is enormous and very grand, with well over a hundred rooms in it. The ball we were attending was the first great party given at Blenheim since World War II, and certainly promised to be a night to remember.

As we entered the gates, there were many cars ahead of us, and we waited in line patiently as the footmen helped the beautifully dressed crowd out of their cars. It was a lovely warm night, and as you approach the front entrance there is a bank of enormously wide stone steps lead-

ing up to the entrance terrace. There, in front of the door, was Lady Sarah Spencer-Churchill, sister to the birthday boy, resplendent in her pastel flowing Scaasi dress and sparkling jewels and tiara, beside her tall handsome American husband, Edwin Russell.

As our Rolls inched up the roadway, we were still behind several other cars. Finally, there was only one car ahead of us. Suddenly, everything stopped dead, as we watched the footmen and chauffeur get out of the car. When they opened the rear door Princess Margaret descended, looking radiant in a black satin ball gown with heavy gold embroidery around the neckline and hem. She wore a sparkling tiara and, of course, the wonderful royal jewels, probably borrowed from the Tower of London display. She swept up the staircase to great applause from the crowds on either side. When she reached the top, Lady Sarah came forward and curtsied, while Ed Russell bowed.

We all watched this excitedly from our car when suddenly Mitzi Newhouse let out a small shriek and said, "I'm going in *now*." I said, "Mitzi, I think you must wait until the princess is inside." She said, "Not at all." With that, she flung open the door and ran ahead of the princess's car, up the stairs, and was presented to Princess Margaret, there and then. We watched in disbelief, but the tiny resilient Mrs. Newhouse had made her point. After all, she was, more or less, paying for the party, as Edwin Russell was employed by the Newhouse family, and his principal income probably came from Condé Nast. Obviously, Lady Sarah wanted her daughter Serena to have the most beautiful coming-out party and, indeed, she did, amidst the splendor of her ancestral home, Blenheim Palace.

After Princess Margaret's car had left the drive, the brown Rolls moved up and Si and I got out. We went up the stairs to the entrance of the palace, where Lady Sarah and Ed Russell were standing. I told Sarah how wonderful she looked, Ed congratulated me on the dress, and I entered the Great Hall of the palace. There were hundreds of people inside.

The hall has great carved stone columns, the ceiling being sixty-seven feet high and painted with the image of the first duke of Marlborough kneeling before Britannia and showing her the plan for the Battle of Blenheim. It was painted in 1716 by Sir James Thornhill. Above, around the perimeter, is a balcony, where many men and women stood,

smiling and taking in everything that was going on below. I concluded that they must be some of the staff that ran the palace, there with their friends. After all, this was a momentous night, as the palace had not been used in this way for more than twenty years since the war.

As you can imagine, the atmosphere was very lively. The waiters in livery were passing champagne on silver trays. I was surprised at how many people I knew. There were many Americans who had come over for the occasion. The Americans and many of the Europeans were dressed in the latest fashion, but it was interesting that you could spot some of the British gentry, the women being dressed in quite old-fashioned gowns—some of them, I believe, dating back to the late thirties. What was interesting was that, though they were not too stylishly dressed, they had obviously gone to the family vault and brought out the most extraordinary jewels. Most of the women wore tiaras, as they were asked on the invitation, which stated: "Tiara and White Tie." Most of the Europeans and, of course, the British gentry complied. What was amazing was the incredible parures of jewels that each woman wore. Many of the ladies had a tiara and also an extraordinary necklace, sometimes a stomacher, a long necklace that would go down, as we say, to the stomach, and, perhaps a diamond belt, several bracelets, earrings, and rings: a complete array of the family jewels. The hall was fairly sparkling with diamonds everywhere you looked.

Standing out from the crowd was the Vicomtesse Jacqueline de Ribes. The extraordinary dark-haired beauty wore a shocking pink taffeta dress that was very slim until the knee, and then burst into a flounce, giving the dress an almost flamenco look. Jacqueline was someone I knew from New York, and at this time had not yet started her ready-to-wear business. We wandered together through the reception rooms, hung with ancestral portraits.

At one point, Jacqueline stopped and said, "Look, there's Vivien Leigh." The gorgeous actress who had immortalized Scarlett O'Hara in *Gone With the Wind* was coming straight toward us. She was wearing a green taffeta ball gown, definitely *not* made from the curtains of Tara. She wore a parure of diamonds and emeralds—a sight to remember! Though it was more than twenty years since she had won her Academy Award, she still looked beautiful, supported by an entourage of four handsome

young men. There was a moment when her eyes glazed over and she seemed on the verge of stumbling, and I wondered if the stories about her excess drinking were true. She was so stunning and had become such an electrifying screen legend—it really didn't matter.

I believe there were more than fifteen hundred guests at the ball; many young people, invited for Charles and Serena, and the older set, who were friends of the duke of Marlborough—a great mix of all ages.

A particularly sad note for me were the young men in wheelchairs and on crutches. These men were the casualties of war. Many others had been disfigured and wore what I was told were "silk faces"—masks which were molded to resemble their original facial features, made out of a kind of silk that had a pink tint to it. Growing up in Montreal, I really had no idea of what war meant, but during that evening, I realized first-hand how brave and courageous the British people were.

At midnight, Lady Sarah opened a marvelous tent within walking distance of the palace. This was set up like the most "in" disco, and all the young people, and everyone else who wanted to stop waltzing and dancing the fox-trot, gravitated to the flashing lights and disco beat.

By two a.m., a marquee had been set up and a fabulous English breakfast was served with platters of scrambled eggs, bowls of caviar, Scottish smoked salmon, sausage, bacon, all kinds of rolls and cakes, and whatever else one can think of for a magnificent breakfast. No one can do this quite like the English. I sat with the Vicomtesse de Ribes and other friends from Paris and America. By this time, it was early morning and after drinking more champagne, we decided to leave.

I remember we wandered out a little ways into the meadow just below. It was dawn and the sun had begun to rise, a mist had come up and enveloped the lower part of the palace—it was absolutely breathtaking. Certainly, one was taken back in time, realizing that this was the way Blenheim must have looked at its very inception in the eighteenth century, when the first duke of Marlborough came home at dawn from the wars to his own special palace.

I said good night to my friend the beautiful Jacqueline and then found a lift with some other young people to my hotel in Oxford. As I drove away and looked back at Blenheim, ablaze against the rising sun, I knew this would certainly be a night to remember.

I received a great deal of publicity on both sides of the Atlantic on Serena's wardrobe, especially on her debut dress. So it was natural, about a year and half later, for Serena to bring her friend Gillian Fuller to the salon when it came time for her debut in 1964.

Gillian was lovely looking, with fluffy blond hair and an angelic face. When she was undressed, in her bra and panty hose, I saw that she was a perfect size six and, obviously, anything we made for her would look great. She was the daughter of Geraldine and Andy Fuller and would inherit from her mother the Spreckels sugar fortune.

I had dressed Geraldine Fuller, a stunning blonde, for some time before Serena brought Gillian to the salon. Geraldine Fuller had extraordinary taste and some very wonderful paintings by Kupka, which were given to the Guggenheim Museum.

Gillian, though only seventeen, was very self-assured and knew exactly what she wanted. She picked two very beautiful dresses, as she was going to be presented at two of the most important debutante balls in New York City. For the ball at the Plaza Hotel, we did a dress of white feathers. It moved beautifully, the feather skirt falling from a high-waisted small strapless silk *gazar* bodice. The second dress was a fairy-princess white silk tulle ball gown, sprinkled with tiny silver beads and clear paillettes. Gillian wore this at the Grosvenor Ball, one of the poshest evenings on the debutante circuit.

It sure is a small world—especially the social jet set world of the fifties and early sixties—for who would have guessed that the announcement of Gillian Fuller's wedding to Lord Charles Spencer-Churchill would happen soon after, and that the twenty-first birthday boy from Blenheim would marry the Spreckels sugar heiress in 1965, one year after her white feather dress debut. Gillian's upcoming marriage to a member of the Marlborough family prompted the press to compare it to the marriage of the ninth duke of Marlborough to the Vanderbilt heiress, the dazzling Consuelo in 1895.

As soon as the wedding plans were set, Geraldine Fuller called me to discuss the clothes for the ceremony itself. There were to be about sixteen bridesmaids and several other attendants. It was to take place in the fall. I remember Geraldine and I going to the church on Madison Avenue to look at the beautiful stained glass windows for inspiration for the color

scheme. Because of the fall colors, we decided on a particular shade of russet taffeta for the bridesmaids and, as there was a special shade of royal blue in the church windows, I made Geraldine a royal blue velvet dinner long suit and matching chiffon blouse. The jacket for the ceremony was bordered in Russian sable. The eighteen-year-old bride was to be in virginal white. I immediately ordered one hundred yards of russet silk taffeta from France, where the color had to be specially dyed.

Everything went along swimmingly, and Andrew and Geraldine Fuller went off with their daughter, Gillian, to England in

Gillian Fuller and her father, Andrew

June to attend Ascot and firm up the September wedding plans. Early in July, I received a telegram from London. It said:

> Dear Arnold, Gillian and Charles married this morning. Everyone is very happy. Don't worry about costs for the wedding—you will be reimbursed for everything. Affectionately, Geraldine

Well, of course, I was dumbfounded. But there it was, and I remember thinking what a nice lady Geraldine Fuller was to notify and reassure me before it all came out in the press.

Not long after, Lady Gillian Spencer-Churchill wore her white feather debut dress again, in England. Lord Charles said it was one of the most

beautiful dresses he'd ever seen. She wore it to a very big ball the marquis of Hartington was giving at Chatsworth, his estate in Devonshire. Gillian had put on a little weight since her debut and found, after getting onto the special train taking them there, that her zipper had split open. When she arrived at Chatsworth House, a maid hurriedly sewed up the back of the dress. Still, she was concerned that the dress would not stay on all evening.

After dinner, she was seated next to the prime minister, Harold Macmillan. They got on very well, and he was charmed by the pretty American. At one point, there was a lull in the conversation, and Macmillan dozed off, letting his cigar fall onto the feather skirt—setting it on fire! Gillian shrieked, and after much rushing about, the skirt was heavily doused with water and the flames extinguished.

Her ladyship returned on the train that evening, clutching her soggy feather gown, still fearing it might fall off and reveal all. The next day's papers were full of photos of Gillian and her wet feathers, smiling bravely.

On another note, Gillian's mother took the hundred yards of silk ordered for the bridesmaids and redecorated her living room, the long windows that looked out on Park Avenue framed with draperies of russet silk taffeta.

*With Barbra at the 1969 Academy Awards party, wearing a David Webb
heavy gold necklace, an accessory many men wore in the 1960s*

BARBRA STREISAND

One morning in 1963, Carrie Donovan, then one of Diana Vreeland's special editors at *Vogue,* telephoned all excited about a young girl she'd seen the night before at the Bonsoir in Greenwich Village. "She's *divine,*" she trilled, "and Nicki [de Gunzburg] says she's going to be a tremendous star—you must dress her, my dear—do go and see her—you'll be bowled over!" De Gunzburg was the "editor at large" who worked at *Vogue* very much the way André Leon Talley does today.

I said that it was nice of them to think of me, but that obviously the young singer had no money and I didn't dress people for nothing. One of the business decisions I'd made at the beginning of my career, knowing I knew only how to design clothes—not sing or dance or give cooking lessons—was that I had to be reimbursed for what I *did* know—for *my* specialty. When Judy Garland called in the mid-sixties and asked if I would do her clothes for a big upcoming concert, she was absolutely charming on the phone. I'd seen her onstage at Carnegie Hall in 1961 doing her breathtaking act, singing and dancing with such verve that you thought she had just danced off the soundstage of one of her late-forties movies. Norman Norell and Ray Aghayan had always done her costumes but "this time," she said, giving that special Judy laugh, "I want SCAASI."

I called my friend Freddie Fields, Polly Bergen's husband, to ask what he thought.

"You know, she doesn't have a dime," he informed me, "and she can sometimes be difficult." Freddie knew Garland very well—he had agented the deal for the marvelous weekly *The Judy Garland Show* on tel-

evision. It was rumored that Garland had gone through whatever money she had made and just couldn't pay her bills. Also, I had recently opened the couture salon and was not exactly flush myself. I was unable to make clothes gratis. I had to say no to one of the greatest talents of the twentieth century—Miss Judy Garland. It made me very sad, but the business of being in business is tough sometimes and has to come first.

Because Carrie had urged me to, I went downtown anyway as the Bonsoir was one of my favorite places, a sort of semi-gay music bar with a tiny stage and a little jazz group, the kind of spot with lots of atmosphere, low lights, and a mixed crowd of uptown and downtown people. There was always an interesting vocalist. In the sixties I made Lovey Powell some waist-deep halter-neck slinky dresses of satin with no back and colorful feather boas (very much today's look). I also dressed Kaye Ballard for her appearances in the same club. So I thought—why not?—and off I went to see Miss Streisand. I really thought her voice and singing style were spectacular, but her clothes were so bizarre and not very flattering. I wondered both about her taste and what she was *really* like.

Before I knew it, Barbra Streisand had gone on to her famous rolling-across-the-stage-in-an-office-chair scene from *I Can Get It for You Wholesale* and then to her spectacular success in *Funny Girl* on Broadway. It was *then* that her manager, Marty Erlichman, called me and said he would like me to make some clothes for his young star.

In May 1964, I opened my first made-to-order couture collection to rave reviews. It was not the time for couture clothes, as everyone was on to prêt-à-porter. Couture salons, such as Mainbocher, Chez Ninon, and Bergdorf Goodman, were having a tough time of it and beginning to think about closing. Nonetheless, we had a wonderful opening in the beige damask salon Valerian Rybar had decorated for me on East Fifty-sixth Street. A plethora of New York's then famous young society women attended, among them Jean Vanderbilt, Mrs. William Randolph Hearst Jr. (the ravishing Austine), Brooke Astor, Mrs. Samuel Reed (now Mrs. Oscar de la Renta), Tootie Wetherill, Lady Eileen Guinness, Mary Rockefeller, and many others. Also present were the stars Joan Sutherland and Barbra Streisand. I ended the collection with a tightly hooded long white silk faille monastic wedding gown with a hundred tiny silk but-

tons down the front, looking very much like a nun's fantasy habit out of *The Sound of Music*!

Miss Streisand arrived wearing an oversized black poncho, totally covering (what I was to find out later) her slim, curvaceous body, and a big, floppy black felt hat that hid part of her face. She did *not* look great—sort of out of it in comparison to the swanky society ladies with their chic suits and white kid gloves. But she was this great new star, and only twenty-two! I was thrilled she was there.

About an hour after the show, when everyone had left, my grande dame directress, Molly Macadoo, whom I'd hired away from Chez Ninon, came to me; she knew all the social set and was in her seventies. "Barbra Streisand is on the phone, and she wants to know if the wedding gown can be made in black—how ridiculous! Shall I tell her you've left?"

That's a really *cool* idea, I thought. "Let me speak to her." Well, that was the beginning.

Streisand thought the wedding gown would make a beautiful evening coat and she was right. She mentioned some other clothes she liked and asked about them—a rust-colored, short strapless ribbon-lace number, I remember. I listened, fascinated, to her ideas of variations of what she had seen in the collection and then did something I would continue to do with women I wanted to dress—I asked her to lunch. She accepted with alacrity, and we planned to meet at the "21" Club the next day at twelve forty-five, and then go back to the salon afterwards to try on clothes.

The management at "21" knew me very well and seated me at the best table in the front of the restaurant. I waited and waited and called my office to see if Streisand's plans had changed and perhaps she wasn't coming. At about one-thirty, the waiter said Miss Streisand had just called and that she was delayed but on the way. By two o'clock, there was still no sign of the fledgling diva. Finally, at about two-twenty, after the restaurant had all but emptied, Barbara Streisand arrived!

With a shy smile, she apologized and asked if we could sit farther back in the restaurant, away from the few remaining diners. Of course we moved, and slowly I began to know more about the quirks of the offbeat girl from Brooklyn with this amazing talent. She was genuinely shy and

kept looking around like a doe frightened by headlights of approaching cars. She wore a nondescript pale blue seersucker suit and her hair hung straight down, almost covering both sides of her face. Her nose was prominent, but she had this little girl smile and her figure was very good. To my surprise, she was taller than she appeared in photos—about five foot seven.

I don't remember what we said at the beginning—there was lots of nervous laughter—and suddenly, after we had ordered, she asked if she could use the phone. The waiter indicated the stand of phone booths near our table, and the "21" operator on duty told her how to place the call. In a few moments, she returned to the table astonished.

"You know, they didn't charge me for the phone call. Do you think I could come here and make *all* my calls for nothing?" she asked, incredulously.

"Barbra, your picture is on the cover of *Time* magazine. I think you could make as many calls as you like from now on, and they won't charge you a dime." She just couldn't believe it. (In 1964 a phone call *was* a dime!)

We are both born under the astrological sign of Taurus, so we hit it off right away. She seemed naïve and charming and so vulnerable, but smart, and at times, very, very funny—*naturally* funny. I *did* enjoy her company as lunch went on.

We went back to the salon, and Barbra started trying on the clothes she liked. I realized, seeing her undressed in her bra and half slip, (forty years ago, girls wore slips!) that she was quite thin, maybe a size six. Of course, we put the white silk faille "wedding dress" on first, and although she loved it, I didn't feel that it really worked as an evening coat or for her lifestyle at the time, so I shot it down. I remember she was surprised by my not wanting to make a sale. I think it instilled confidence in her that I would never sell her things that didn't look right. You know, Streisand loves great quality and beautifully made clothing. She would take the dress and turn it inside out to admire the tiny hand stitching around the hemline or the carefully hand-finished seams. I realized she was a perfectionist and bought secondhand clothes (what we now grandly call "vintage") at the beginning of her career because she had very little money and loved the beauty and finish of them, even though they may not have been

fashionable at the time. Interestingly enough, her fans didn't seem to care what she looked like; they just listened to that unique sound and marveled at it. It didn't matter that she wasn't "pretty" in a conventional way—the nose was too long, the eyes too closely set—but so what? She had this unpretentious, winning personality that said "I'm this little girl from Brooklyn and I'm very special!"—you had to like her. She had imagination and that glorious voice. She interpreted old songs we had heard over and over again, making them sound entirely new—no one had done this since the resilient Judy Garland. Yet she didn't sound at all like the MGM star.

Streisand continued to try on different clothes from the collection, some that were very grand, and it was like she was playing dress-up. Her personality changed with each outfit, one moment becoming a Russian princess (in a coat bordered with sable), the next, a giggling young thing in a beaded mini dress. She was obviously a born actor. It was fascinating to watch. When she got an idea into her head, she rarely changed her mind. She finally went back to the rust-colored ribbon lace dress, the one she had originally chosen from the opening day collection. It looked great with her peaches-and-cream complexion. (She had beautiful skin, with maybe a bit of baby fat that only made her look soft and more sensuous.)

We decided on two other outfits, and she left for the theater smiling and happy. After all, she was twenty-two, model size, and the brightest light on Broadway—I was happy, too, knowing I had met a kindred spirit.

After that first meeting, we spoke almost daily on the phone. She would call and ask how the clothes were coming along and suggest subtle changes ("Maybe we should move the bow one and a quarter inch farther to the left?"). I didn't mind this at all—in fact, I enjoyed her interest. Usually, I wouldn't change a thing. As time went on, I would often finish the hemline of a dress with a pretty band of special lace or embroidery that only she would be aware of. Barbra loved these special hidden touches, and I was inspired to come up with them. I was just fascinated that each tiny detail meant so much to her; I hadn't met anyone quite like this before. She just wanted to make everything the best it could possibly be.

Of course, I was to find out later that she was almost maniacal about this quest for perfection, and finally she drove people away who could not

cope with her intensity. *I really didn't mind*, sometimes feeling the same way when I was working on one of my many collections and strove to have everything perfect. My motto (and, I guess, Barbra's, too) is "It takes the same amount of time to do something right as it does to do something wrong, so let's get it right the first time!" However, I do have a little more patience now that I'm older, and I hope I'm not as demanding about the little things as I was thirty years ago—maybe the wonderful Barbra has eased up a little, too?

From that first meeting on, we made great clothes for the star. We became friendly, and I found that much of her insecurity came from her unusual looks. One night Parker and I were walking up Broadway after the theater and supper; it was about midnight. We were surprised to see a tremendous crowd outside the stage door of the theater where *Funny Girl* was playing. We pushed our way through the motley group of young people and gave the guard our names. He called her dressing room, and Barbra asked if we would come up. Elliot Gould, her husband, was with her, and she didn't seem to be doing anything in particular. She was just happy to see us.

"Why are you still here, the show ended over an hour ago?" I asked. "Aren't you tired? Why don't you go home?"

"Arnold, I've been trying to tell her that, but she won't budge," Elliot replied.

"Barbra," I continued, "there's a mob outside the stage door, and I don't think they'll go away until you come down."

"I know, and they're all ugly. Aren't they?" she asked, wistfully.

"Well, they're not the classiest-looking group, but they obviously love you. And besides, you've got to go home sometime," I reasoned. "You can't stay here all night. Now, come on, we'll all go down together, and it won't be so bad. The car and chauffeur are just outside the door."

"All right," she said. "But why are they the *only ones* out there—it's because they identify with me, isn't it? Why aren't the beautiful people ever there?"

In that moment, I understood how serious her insecurity was, and even with her great success, it would take many years of therapy to prove that she was okay—that you didn't have to look like Lana Turner to be beautiful.

I think being well groomed and wearing beautiful clothes, and the fact that Cecil Beaton compared her to the ancient beauty Queen Nefertiti, and that Richard Avedon and every major photographer wanted to photograph her, helped her self-esteem tremendously—every fashion magazine did flattering stories about the star—God knows, that would help anyone! She didn't have to think of herself as unattractive anymore. She had become "the beauty of the decade." All the young girls wanted to emulate her—she gave them hope that they could succeed, also.

Late in 1966, Barbra left for Hollywood (her new home) to make the movies *Funny Girl* and *Hello, Dolly!* Being a Friday, I was on my way to the house on Long Island that evening. I lived on Central Park South, so it was easy for me to pass by her Central Park West duplex to say good-bye. A confirmed New Yorker, she would keep the large apartment for decades. I arrived to find it in disarray, mainly decorated in the Victorian style; there were packing boxes everywhere. Barbra was trying to calm her infant son Jason and say good-bye to her mother who didn't seem to want to leave. The nanny was about sorting something out and the maid was asking all kinds of questions. Elliot was there trying to be as helpful as possible—there was utter chaos! I thought, My God, they certainly don't need me here too. I said my good-byes as quickly as possible and seeing the confusion, asked if I could take Barbra's mother home. She lived on the way to my apartment, where I would pick up Parker and the dogs, our two Irish terriers. Barbra seemed happy and relieved at the prospect of her mother's leave-taking.

A bustling little lady with curly hair, her mother was annoyed to have been pulled out of the fray in Barbra's apartment. As soon as we got into the car, I turned and looked at her.

"Isn't it wonderful what's happened to Barbra? You must be so proud—she's really an amazing talent and now going to be a huge movie star in Hollywood. It's very exciting!" I said enthusiastically.

"Yes, I guess it's all right," she answered glumly. "But you know, my other daughter has a *really* beautiful voice and, of course, I had a lovely voice, too—much better than Barbra's." I was so shocked that I almost had an accident driving home. I couldn't believe my ears. Here was the mother (and a Jewish mother at that) of one of the greatest talents to come down the pike in years and she wasn't lauding her for it. Well, here I had

another insight into what made Miss Streisand so insecure. If you couldn't count on your own mother to say you were great, who could you count on?

Firmly ensconced in the business of making movies, Barbra bought Joan and George Axelrod's palatial home in Beverly Hills. As she had filled her apartment with Victorian antiques in New York, she began collecting art nouveau and art deco furniture and bibelots in earnest for her West Coast residence—the interior would almost have a museum-quality look to it by the end of her fascination with this period. George Axelrod was Arlene Francis's director for *Once More, With Feeling* and also the author of *Goodbye Charlie* with Lauren Bacall, both productions I had worked on—small world.

Barbra returned often to Manhattan and we stayed close, while I continued to make clothes for her personal wardrobe and the many special events she had to attend. I especially enjoyed creating the extraordinary outfits she wore to her movie premieres at that time.

In May 1968, Streisand went to the Los Angeles premiere of *Funny Girl* wearing my long white llama-like shaggy-wool evening coat over a jumpsuit of bright magenta satin. For the premiere in New York, Broadway between Forty-third and Forty-fourth streets was closed so that the opening night crowd could walk across the wide red-carpeted thoroughfare from the theater to the Astor Hotel where a grand supper party was in progress. For her hometown premiere, the *Funny Girl* star wore a floor-length nude tulle gown and cape that shimmered with scattered clear iridescent sequins.

I was in the car with Barbra, Elliot, and her manager, Marty Erlichman, when we arrived for the premiere. The mob was enormous and so eager to catch a glimpse of the superstar that they jumped on the car and began to rock it to and fro. We were all frightened and Barbra shouted, "Drive away, drive away—quickly—let's get *out* of here!" The driver sped away. We finally went in through the back door of the theater. As you can well imagine, the incident was very traumatic and, I believe, was the beginning of Barbra's serious withdrawal from public appearances. Still the night was Streisand's with her extraordinary performance as Fanny Brice. When we walked across Broadway that night, she looked like a fairy princess and was undoubtedly the happiest girl in New York City.

In September 1968, I received a letter from Robert Evans, the head of Paramount Studios, saying that Barbra wanted me to do her modern clothes for the film *On a Clear Day You Can See Forever.* I had known Bob and Charles Evans since my early days in New York when the brothers worked in the Seventh Avenue family sportswear business, Evan-Picone. Bob made a point of saying how pleased he was that I was Barbra's choice. Of course, I was thrilled. Barbra had never clued me in, so it was a surprise. She was on the West Coast and I called her immediately.

"I've just received the letter about your modern clothes for *Clear Day*— how great that you want *me* to design them."

"Silly," she said laughing, "I can't believe you're *too* surprised. Who else

Opening of Funny Girl, *shimmering gown*

would I have do them? They're sending you the script—call me when you've read it."

I was thrilled about this new development in my career and couldn't wait to start the designs. I called my friend and very good theatrical agent Gloria Safier. I knew Gloria had worked with several designers who had done clothes for films and the stage. She also had a roster of actresses who worked on Broadway and in Hollywood. When the contract arrived from Paramount Studios, we went over it together, making the necessary changes, though there weren't too many. As Gloria pointed out, "Barbra Streisand asked for *you*—so they're going to have to be very nice because they don't want their star to be unhappy."

While I was to do the modern clothes in the film, Cecil Beaton was to do the period costumes. Part of the story takes place around 1815, when George IV, the Prince of Wales, was regent of England. The

period was right up Beaton's alley; he had done the same kind of clothes beautifully for other period plays and films. I, on the other hand, was very excited about doing the contemporary clothes, because it had always been my wish to get Barbra out of those period costumes worn in *Funny Girl* and *Hello, Dolly!* For once, I could dress her as a modern, contemporary young woman.

Gloria negotiated the contract and was very pleased with herself when she came back and said to me, "Well, I've gotten you more than any designer that I've ever represented. You're to get twenty-five thousand dollars outright as a design fee [about two hundred thousand dollars today]. Of course, whatever the clothes themselves cost will be extra and you'll charge Paramount directly. Also, when on the coast, you'll stay at the Beverly Hills Hotel [the grandest Hollywood hotel then of its kind] and you'll fly first-class! Arnold, I can't tell you how generous this arrangement is. Barbra must *really* want you."

Later in October 1968, I flew to Los Angeles to discuss the modern-day clothes with Barbra. I had several ideas and they were all to keep the look of the contemporary Daisy Gamble (the screen name of her character) young and pretty.

Boy, was I lucky! The sixties and early seventies were all about change in fashion—well, really change in everything. The political climate changed; the cultural and sexual mores changed; the square mood of the fifties, charming and family-oriented, was gone. Everyone wanted to be hip or a hippie. Skirts were minuscule and patterned stockings took precedence. There were knee-high or thigh-high boots, charming "little girl" shoes. Makeup was wild and exaggerated, following Elizabeth Taylor's Egyptian look as Cleopatra in the multimillion-dollar film epic. Hairstyles were even wilder, with women in the know sometimes wearing three hair extensions to appear "in" and glamorous. All was new and different and people wanted to look and *be* different. It was an exaggerated time—many people smoked pot to get through it all!

I went through the script scene by scene and made a list of the clothes that I thought Barbra should wear and began putting fabric swatches and sketches together. As I knew pretty much the kind of clothes and colors she liked and would look good in onscreen, the ideas came easily.

106

Before actual shooting began on *On a Clear Day You Can See Forever,* I would fit some of the clothes when Barbra was in New York. Later, I would fly to Los Angeles almost every week and we would fit the new things. Usually the head of the Paramount wardrobe department was with us. If the changes weren't too great, we would leave the costumes there to be finished.

Often while filming, I commuted weekly between New York and the coast. I would have my driver make a midnight stop at Pearl's Chinese Restaurant to pick up a goody box to carry on the plane and present to Barbra a few hours later. There was usually a big hullabaloo and cheers when I arrived on the set. She was always happy for this reminder of her hometown, loving the lemon chicken, beef with broccoli, moo shu pork with pancakes, and fortune cookies! She was ecstatic about the food, and I became the most expensive delivery boy in Hollywood!

In the story, Daisy Gamble is first seen in Professor Dr. Chabot's hypnotism class. So those costumes had to look right on a college campus in 1969. (Yves Montand played Chabot.) I did lots of mini-skirt jumpers that buttoned down the front, some with patch pockets. These were paired with textured cotton white shirts. One of my favorites, in fact, the first thing we see Daisy in, is of chocolate brown thin wool. The jumpers were wonderfully cut, always with the idea of making the actress look slim and girlish. One is of a yellow-green-and-red tartan, cut very short with leggings of the same fabric, finished off with a matching beret.

As we go deeper into the screenplay, Daisy becomes more sophisticated and I designed a high-waisted flared taupe wool coat lined in pale pink silk worn over a pale pink wool crepe dress that Barbra wore in a long scene. The matching taupe tights had to be dyed three times to get the exact shade. As with mostly every costume in the movie, Barbra wore monochromatic handbags, gloves, and shoes (usually from Fiorentina). A pivotal costume that we agonized over was the dress she would wear singing the lament "What Did I Have I Don't Have Now?" I felt it had to be a dark dress to emphasize the mood of the song. But as the scene was filmed in Dr. Chabot's paneled office, it couldn't be black or brown. I decided on a deep bottle-green in the shape that was so good for Barbra, with the double-pointed cut under the bust line. It was finished with a white collar and cuffs and black satin soft bow tie (the star's then trademark).

As much of the action takes place on the rooftop garden of Daisy's apartment, I designed many different tops with bell-bottom trousers. In a particular scene with the young Jack Nicholson, the outfit was a bright navy blue. Another scene with the doctor takes place in his office at the end of the day on her way to a dinner date with her fiancé. For this, I designed a short white organdy dress, the fabric embroidered with multicolor flowers. The dress had short sleeves, making it look particularly youthful. When she leaves the office, Daisy puts on a white coat lined in the same flower-embroidered fabric. Barbra insisted upon wearing a white beret with the outfit. The coat and dress would be perfectly at home today, thirty-five years later—the beret looks silly!

A scene, which is near the end of the film, is a flashback to the hero-ine's other life in 1815. As I wanted the two periods 1815 and 1969 to cor-relate, I met with Cecil Beaton in New York and found that he had designed a peach color chiffon gown that was very décolleté for the 1815 sequence. To bring the character back to 1969, I designed a soft short peach silk crepe dress with a neckline yoke and tiny sleeves of dotted white organdy. With this, I gave Streisand a large square of peach chiffon that she was able to work with while going from one period to the other—the prop worked very well.

There is a long montage at the end of the film where Dr. Chabot sings "Come Back To Me," the camera mov-ing in on several locations around New York City, capturing Daisy's "escape." There are at least six scenes in the mon-tage: Daisy in cooking class, wearing a chef's hat and a white apron over a navy-green-and-white check dress; running from the cooking class in a

Wild '70s outfit from On a Clear Day You Can See Forever

108

navy coat trimmed in navy-green-and-white check with a matching hat; escaping from the Fiorentina shop, wearing a smashing bright green side-buttoned suit with a green "train conductor" hat; then a brown coatdress with white collar and cuffs; next, a pink-and-navy plaid high-waisted coatdress and wide-brim navy straw hat; ending in front of the Time-Life Building fountain in a wild fuchsia-and-white zig-zag print silk suit. Streisand looks really fabulous in the entire two-minute montage.

In the final scene in which she leaves Chabot, saying, "See you later, doctor" (meaning, in another life), she wears a psychedelic orange wool crepe dress with a large white hat on the back of her head with orange ribbon streamers. Here, she finally sings the enchanting "On a Clear Day You Can See Forever"—THE END.

The star looked lovely in the Beaton period clothes and absolutely splendid in the modern costumes I designed. Wanda Hale of the *Daily News* wrote, "Arnold Scaasi's contemporary costumes for Miss Streisand have a richly produced look." The press particularly loved a short nightie I did in the same fabric as Daisy's wall covering and bedsheets. The reviews were great and I was happy as a clam! I had accomplished what I set out to do—bring Barbra Streisand into the hip world of the 1970s.

Interestingly, the film is shown in design colleges today the world over to illustrate to students what a young woman's clothes looked like in the early seventies.

One day while filming, we heard that Barbra was nominated for an Academy Award in the best actress category for her role in *Funny Girl*. We were ecstatic! The other nominees were Katharine Hepburn, Patricia Neal, Vanessa Redgrave, and Joanne Woodward—all formidable actresses. Still, Barbra had been extraordinary playing the legendary Fanny Brice.

We began to talk about how the star should look at the Academy Awards. I never knew whose idea it was, but one day I arrived to find Barbra in her dressing room on the set, wearing a voluminous black-taffeta hooded cape that not only hid her curvaceous young figure but also half of her face. The wardrobe woman stood by, smiling encouragingly beside the producer of *Clear Day,* the amiable Howard Koch Sr. Grinning broadly like a cat that had just finished all the cream was Barbra's long-time maid.

"What do you think, Scaasi?" Streisand asked, twirling around to show me how the cape moved.

"Nice," I said, "but I thought you were to be in white in the 1815 ballroom scene in the Brighton Pavilion.

"No, Arnold," Koch said. "This is what we thought Barbra might wear to the Academy Awards." I was visibly horrified. Never being very diplomatic early on, I got right to the point. "You must be kidding," I said. "She looks like a character out of *Gone With the Wind*!" Barbra laughed, but everyone else looked stony-faced.

"I think," I continued, looking at Barbra, "it is *very* important, since the world has only seen you in two films and in both all dressed up in fussy period costumes, that you appear at the awards looking like the contemporary young woman you are [she was barely twenty-five]. We have to do something very modern—really of today—I think the cape thing is all wrong." Everyone but Barbra seemed disappointed. The cape vanished.

I immediately began to work on sketches that were in a contemporary vein. I liked a dress that I had just designed for Polly Bergen's nightclub act. It was of black bobbinet tulle covered in faceted clear sequins the size of a dime. We had lined the dress in nude net over a nude-color silk slip. It really looked wonderful on Polly—very slim-sexy, yet elegant at the same time. Barbra did not have Polly's type of figure; also, Barbra looked about twenty years old. So the outfit had to be a younger version. I did love the shiny black see-through effect, and as bell-bottoms were all the rage, I wondered why Barbra couldn't wear some kind of pants to the awards. It was a thought that kept germinating in my head.

Barbra and I finally agreed on a sketch I had done, using the black net, clear-sequined see-through fabric. The bell-bottom trousers were exaggerated and had many godets flaring out widely from the knee down, almost giving the appearance of a trumpet-shape evening skirt when she stood still. The top was a straight overblouse of the sheer embroidered fabric with two patch pockets covering her breasts. It was finished with the basic white collar and cuffs and black satin bow at the neckline. There was nothing overtly sexual about the outfit. In fact, it was insouciant.

Before going to the awards presentation, Fran and Ray Stark, the producer of *Funny Girl,* gave a large party at their art-filled Hollywood estate.

Because Yves Montand was also staying at the Beverly Hills Hotel, he turned out to be my "date." We went to the Starks', sharing the stretch limousine that the studio sent to pick us up. Barbra arrived last at the party, looking like the model of the moment—Jean Shrimpton. She was the epitome of elegance, carrying white kid gloves and a black satin clutch that matched her evening pumps. Fran Stark, who had been on the best-dressed list several times, whispered in my ear, "Arnold, you are brilliant—she looks ravishing."

We left for the awards ceremony in a kind of motorcade with Barbra and Elliot Gould in the front car and Yves Montand and myself in the second, with the Gallic star worrying all the way about the speech he would have to make *if* the French-nominated movie won the best foreign film award (it didn't, the Italian film did!). Though it was only four in the afternoon in California, there were hundreds of people along the route, hoping to catch a glimpse of their favorite stars on the way to the Dorothy Chandler Pavilion.

When we arrived, a tumultuous cheer for Streisand rose up from the bleachers on either side of the red carpet. You can't imagine the joyous emotion this Jewish boy from Montreal felt at that moment, walking behind the extraordinary star.

After it was announced that Barbra Streisand (at twenty-six) had won the best actress award in a tie with the legendary Katharine Hepburn, the audience went wild—it had never happened before.

Barbra began to go up the steps of the long runway that led from the audience to the stage where the awards were presented. She tripped and almost fell, as hundreds of flashbulbs went off, recording her derriere on film. The young star caught herself and continued on to the podium where she accepted the award. (Katharine Hepburn, who won her second of four Oscars that night, did not attend the ceremonies.) Barbra Streisand, looking lovingly at the statuette, said, "Hello, gorgeous"—her opening line in the film *Funny Girl*. It was a very special moment.

Following the awards, we all went to the Academy Ball at the Beverly Hilton Hotel. Barbra was exuberant and photographed constantly, flashbulbs going off everywhere. Though we had taken every aspect of the sequin outfit into consideration, we did not know that the flashbulbs used by the press would wipe out the flat surface of the black net. The head-

lines the next day proclaimed STREISAND, NUDE UNDER SEE-THROUGH OUTFIT! Of course, she wasn't. Next morning Barbra was on the phone to me, laughing about the whole episode. The headlines helped make the star's outfit the most famous Academy Award costume ever!

I didn't realize *how* absolutely legendary it was until many years later when I was in Paris at Michou's, a well-known nightspot with an extraordinary show of female impersonators. The repertoire consisted of celebrities like Edith Piaf, Judy Garland, Dietrich, Mae West, and, naturally, Barbra Streisand. When the "girl" appeared in an excellent copy of the see-through outfit wearing a wig that could have been Barbra's hair and lip-syncing her recording of "What Did I Have I Don't Have Now?" I was amazed—that's when I knew we were really famous!

Interestingly, in that epoch Yves Saint Laurent had done many *really* see-through clothes (without underpinnings) for his couture collections in Paris—naturally, the world press loved them, photographed them, and no one batted an eye!

1969 was a wild year for both actress and designer. While working on the *Clear Day* costumes, we were also deciding on the Academy Award outfit and, in New York, preparing the beautiful sari dresses for Barbra's stint in Las Vegas.

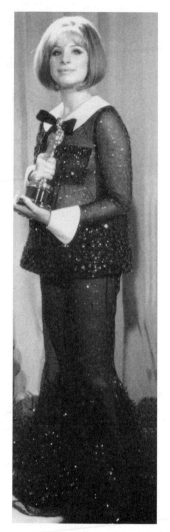

The famous Academy Award outfit

At the beginning of July 1969, Streisand was the headliner for four weeks during the opening festivities of the stupendous new hotel the Las Vegas International. The press was full of the news that she would receive over a million dollars for appearing at the "biggest, most luxurious, new gambling establishment to ever hit Nevada." The main

entertainment room was called the *Internationale* and held sixteen hundred people for the dinner show and nineteen hundred for the late show. Though I don't think she was too wild about performing in front of such a large audience for so long, obviously the enormous (in those days) sum offered could not be turned down by the young star. Going by the current rate of inflation today, her monetary compensation would be at least ten times that amount, not counting a good percentage of the take of the house!

I began to search for fabrics that would be different from the usual glitz one saw on Las Vegas stages. One day the Gil sisters arrived at my salon with the most beautiful and luxuriously beaded saris from their native India. The fabrics were gorgeous in the extreme—four-yard lengths of chiffon (the usual amount of fabric used in a classic sari costume) that had borders on three sides of contrasting color, completely embroidered in gold tiny sequins and beads. Down the center of these marvels ran different designs, also heavily embroidered.

One sari piece was white chiffon with three huge spaced dots, about sixteen inches in diameter, of deep green. The border was red. The white with red and green and all the gold glitter made the whole thing magical. Another was red with a small paisley design of yellow and gold beads all over.

There was one of very fine, almost transparent, linen gauze—a pink-plum color with a gold plaid design that I was to have embroidered with tiny bits of matching glitter. The dress was cut with a very deep décolleté that showed off Barbra's milky-white bosom—very sexy. In fact, I always found the star extremely sensuous. I also designed slim strapless or one-shoulder numbers with a side slit that revealed the slim, curvy Streisand legs when she propped herself up on a stool to sing. We had a tall pillbox made of each fabric that Barbra placed on the back of her head, with her hair swept up underneath. In profile she did look like Queen Nefertiti. The shapes of the gowns were always contemporary, nothing "India" about them—sleeveless small tops with full skirts that were sheer and moved gracefully across the stage. She felt comfortable in them and the dresses were perfect for what was becoming the "Streisand look."

I was not in America when she opened, but I telephoned her the

minute I returned from France. Before she came to the phone, I talked to her longtime maid who was all excited about Vegas. Then, Barbra came on.

"I hear the opening was great and that you're packing them in—are you pleased?" I asked.

"Yes," she said, "and the clothes are really beautiful—why weren't you here for the opening?" I reminded her that I had been in Europe and only just returned.

"So when are you coming?"

"Gosh, I don't know," I answered, "I'm on Long Island, you know, and it's Sunday, three hours later than in Vegas and—"

"So come tomorrow, okay? I want you to see the show, and I'd love to see *you*—so just get in a plane and come. Marty will arrange for the rooms—see you." And she was gone.

Well, I was dead tired from the European trip, but I really wanted to go. I found there was a flight that would get me there the next afternoon in time for the show. The problem was that being on Long Island I had no traveling clothes that I would normally wear. (In those days, one dressed in a shirt, tie, and jacket for travel.) Going through my country closets, I found a white linen suit that I believed would be perfect to wear in sunny Las Vegas. I also had a nice navy jacket to wear on the plane. Parker was joining me the next night and was bringing my navy blue suit from town.

As soon as I arrived in Vegas, I went to the suite that had been reserved, I thought, only for me. I changed into my white suit and went down to see Barbra, thinking I was perfectly dressed and really sophisticated. At that moment, I pictured myself as Humphrey Bogart, all suave and mysterious—I was even smoking a cigarette! I knocked and went into the dressing room. She was overjoyed to see me—then, standing back and looking me over, she said, in that inimitable Streisand twang, "Hey, kid, who you think you are—in the white suit—Charlie Chan?" Well, I laughed a lot—she could always make me laugh. However, my fantasy image sadly disappeared.

Of course, I went up and changed back into my navy jacket. The suite was very big, with an enormous living room and four large bedrooms—all done in white; it felt crispy-new. The air conditioning was so strong

that I was literally freezing. I opened a door to find Pat Newcomb, Streisand's public relations person, wearing a thin printed blouse and white pants—as we were almost the same size, she was thrilled to wear my white jacket. Pat is a small, pretty blond with a great sense of humor and *very* clever—she was Marilyn Monroe's public relations person also, and was able to keep a lot of Marilyn's personal life out of the press.

We went down together to see Barbra's act. Of course it was great and she looked beautiful in the one-shoulder red paisley sari gown and scarf—the gold paillettes shimmering under the spotlights. She used her voice as an instrument, like she was part of the orchestra. When Parker heard her the following evening scolding a musician that he was two notes off, he was amazed.

"How did she know that?" he asked. "How can she hear that one musician when there are so many playing at the same time? She is obviously a great musician herself."

Barbra came back to New York often. She loved the city and I was always happy to see her. We fitted the Las Vegas costumes and I did some additional designs that were not of the sari fabrics. One in particular that I loved was a long silk crepe dress in a navy blue—yellow-and-white art deco print that I had embroidered in flat one-inch squares of navy sequins with tiny rhinestones outlining the pattern. It was cut sort of high-waisted with a seam that had two points going under the bust line and then dipping low to the natural waist in back. It was very flattering and hid the really tiny tummy Barbra was always worried about. Another dress in the same shape with full bishop sleeves was in bright fuchsia satin crepe with one-half-inch square multicolor sequins scattered all over it. These dresses were great fun and not what any other performer was then wearing. We continued to make dresses in this "Streisand cut" often. It was truly flattering to the star.

For the 1970 Academy Awards presentation, as we had made enough waves with the see-through outfit the year before, I decided we would go in a complete opposite direction! I thought Barbra should just wear something flattering and really pretty. She loved pink, so we chose a soft pink silk crepe, again in the Streisand cut. The gown was long with tiny sleeves and a very low U-shape décolleté. Embroidered here and there, scattered all over, were dime-size tiny mirrors encircled with seed pearls.

The obligatory pillbox in pink with mirrors and seed pearls crowned her. Young and pretty, she was ravishing as she presented John Wayne with his Best Actor Oscar statuette—looking the antithesis of 1969. Naturally, the press the next day made clear their shocked reaction to the difference; *Women's Wear Daily* called her outfit "Mother-of-the-Bride." Hollywood had never really cottoned to Barbra, often condemning her for her individuality, perfectionism, and free spirit—not following the Tinseltown norm at all. One bitchy LA fashion journalist wrote,

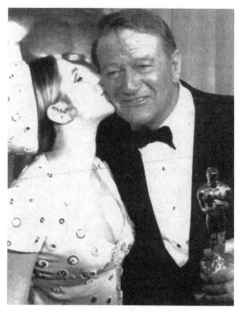

1970 Academy Awards, presenting to John Wayne for Best Actor

"She looked like she was going to her son's Bar Mitzvah."

For the New York opening of *Dolly* in the spring of 1970, we did a thin white leather midi-length coat bordered in fluffy white chicken feathers and bands of Indian embroidery set with tiny mirrors. The always present matching pillbox and white leather knee-high boots looked great.

One night in New York, I said I would come to her apartment to go over some sketches and fabrics for new clothes. I arrived at about nine p.m. to find the star in the upstairs sitting room–library off the bedrooms, wearing an old bathrobe with her head wrapped in a towel, turban-style, and her feet soaking in a tub of water while her extraordinary fingernails were being manicured by a beautician. This was not a pretty sight! Jokingly, I threatened to snap a picture of her and send it to *The New York Times*. Even Barbra laughed at her appearance that night. We looked at the sketches and went back and forth about how the dresses in question should be made.

Suddenly the telephone rang and the maid came in to say that Pierre

Trudeau, the very attractive prime minister of Canada, was on the phone. (Streisand had been separated from Elliot Gould for some time. They divorced in 1971.) Giggling, Barbra picked up the phone. I couldn't know what was being said on the other end, but I did hear Barbra twang, "So how did you get my number?" which I remember thinking was a pretty naïve question to ask the head of a major country that was the United States' next door neighbor! The conversation went on with the star's feet submerged in water and when it ended her beautiful hands flew up in the air in a broad gesture and she said, "Just call me Madame Prime Minister!" We all laughed.

She dated the erudite Trudeau and I think she really had a good time. It must have taken her to another level intellectually. On one visit, she stole the show in Ottawa, the capital of Canada, when she wore a beautiful long white wool crepe evening suit that had a stand-up white mink shawl collar and cuffs. To complete the ensemble, we made a white mink pillbox and a round little-girl mink muff. She looked stunning on the arm of the handsome prime minister at the opening of the ballet. She had worn the outfit to the premiere of *Hello, Dolly!* at Hollywood's Grauman's Chinese Theatre earlier in the month and created an equal furor. For her appearance at Canada's House of Commons, I designed a similar short outfit in a paisley wool challis in shades of brown, with trim and accessories in natural sable! After all, it is freezing in Ottawa in January and we didn't want the superstar to catch cold.

Though I didn't get back to Los Angeles too often, Barbra and I spoke on the phone quite a bit and I would see her when she returned to the New York apartment. In April 1970,

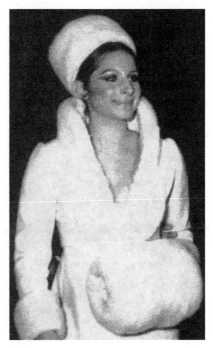

Outfit worn in Ottawa while dating Prime Minister Pierre Trudeau

while she was in town, the Metropolitan Museum of Art was holding a spectacular gala evening celebrating its centennial. Parker Ladd and I were going to the black-tie affair with a group of friends. I suggested Streisand join us.

"Oh, Arnold," she said, "there'll be *so* many people—I'll get lost in the crowd." (Two thousand were expected.)

"Now, don't be silly," I answered. "You'll be with us and we'll have a great time. Besides, it's an historic evening in *your* hometown. You should be there." After some heavy persuading, she acquiesced.

"Okay, okay, but what will I wear?" she wondered.

"Why not one of the Vegas dresses? You look gorgeous in them. How about the pink-plum gauzy one with the gold plaid? It has a full skirt, so you can *eat* all you want!" I teased.

"Now, don't be cheeky," she said, laughing, "I just lost five pounds." Barbra always worried about her weight, though there was no reason to— she really had an almost model-size figure.

She arrived at the gala late; the security people informed me as her car drove up. I went down the impressive stone front steps of the museum with Thomas Hoving, the wildly innovative museum director, to greet her. She looked fabulous, the matching gold-embroidered pillbox on her head and the full dress billowing around her. Smiling sweetly, she surprised us by curtsying—just like in *The King and I*. We all laughed and mounted the steps.

We whisked her into the museum, and naturally one hundred flash-bulbs popped. After preening for the photographers, Barbra wanted to see some of the important exhibits in the museum that were closed that evening to the public. Hoving led us up the grand staircase, and there in the middle of this momentous evening, Miss Streisand had her private view of some of the wonderful treasures in this amazing bastion of art.

For the premiere of *On a Clear Day You Can See Forever,* I designed a high-waisted off-the-shoulder gala dress of white organdy and rosettes of starched white poplin—we called it the "Wedding Cake." It was sophisticated, yet sexy. Also, Barbra finally got to wear a cape, this one of the same white sheer fabric—with a voluminous hood that was pushed back on her head so it framed her face without obscuring it—she made a really grand entrance.

Barbra won a Golden Globe for her role in *On a Clear Day You Can See Forever*. She accepted her trophy wearing a green-velvet long dress and jacket trimmed in sable—a replica of the white gown and jacket she had worn in Canada.

Sometime after *Clear Day* was released, I was having lunch in Hollywood with the talented Vincent Minnelli and Howard Koch, who had produced the film with my friend the wonderful playwright-lyricist Alan J. Lerner. Howard, his wife, Ruth, and their children had become good friends of mine, inviting me often when I was alone to their home for dinner in Beverly Hills. The two men were discussing future projects. At one point, I said, "Howard, what would you think about me designing the costumes for your new film? After all, it does take place in the present."

"Scaasi would be great for it, Howard," Minnelli said. "That's a swell idea." Koch, being a kind, sweet man (unlike many people in his industry), looked at me grinning sheepishly. "You know, Arnold, I have to give it to you straight, you're just too high-priced for us. It worked with Barbra in *Clear Day* because we didn't want to upset her by saying no—and you did a magnificent job, but it cost us a helluva lot of money! I don't think you'll get another major movie too soon. You know, Hollywood is a small town; news travels fast—everyone knows you are the most expensive designer around!"

Well, he was right, no matter how hard Gloria Safier tried, she couldn't make another deal for me to equal the *Clear Day* one. In the end, I didn't really care too much, as my time was fully taken up designing all the collections I was doing in New York. The couture made-to-order salon was flourishing and I was still designing ready-to-wear, a children's collection, sleepwear, and a major fur collection.

Later, I did go back to Hollywood to design the clothes for the film *Loving Couples* that my friend David Susskind was producing. The budget wasn't as big as it had been for *Clear Day*—by then, Hollywood had all but eliminated designer clothes for contemporary films, opting for "shopping" the clothes from stores that were only too happy to give them to producers for an onscreen credit. I enjoyed doing the film, and I was able to see all my friends on the West Coast, but it wasn't as satisfying creatively—and nowhere near as much fun as working with my pal Barbra.

Streisand's time was mainly spent in California. She took up tennis and told me, "I really love it here, the sunny weather and being able to be outdoors so much—you should try it, kid." There was no way; my business had quadrupled and it was impossible for me to go to the coast even for fittings. If I went anywhere, it would have to be to Europe to choose fabrics for my collections.

Barbra went on to make some great movies, such as the wonderful second remake of *A Star Is Born,* which earned her a second Academy Award for the song "Evergreen," which she wrote. I sent sketches of Fortuny-like pleated clothes I was working on and she accepted the Oscar in a finely pleated gown of copper satin crepe. It was made and fitted on the coast and she looked great. In 1983 she directed and starred in the critically acclaimed *Yentl* and later did the same in *The Prince of Tides* in 1991. Her son, Jason, played her movie son in the film and turned out to be both charming and handsome, *and* an accomplished actor.

Late in 1992, I was diagnosed with a disorder in my nervous system and my doctor prescribed Prednisone, a strong steroid that would puff up my face and make me very irritable. Sometimes I would fly off the handle for no explicable reason! The medication worked, eventually curing my illness, and by 1994, I was my old self again—thank God!

In the middle of this ordeal, in September 1993, Barbra called me late one evening when I was on Long Island—I was overjoyed to hear her voice. We chatted for a while, catching up on each other's lives. She then said, "I'm going to do live concerts again, and I want you to design my clothes. I'll be in New York in November, we open New Year's Eve in Las Vegas; I have the old crew back—Marvin [Hamlisch] will do the arrangements and be the musical director." We made a date to meet in early November at my salon on Fifth Avenue. I would be happy to have her back in my life.

Barbra arrived for her appointment and, though I was happy to see her, I was surprised she had brought garment bags of old clothes to refer to. We started by remaking a black satin crepe full-sleeved long dress that I had designed in the seventies and a pink-and-white crepe–and–embroidered organdy evening pajama from the late sixties. We talked a lot about how she wanted to look for the world tour but she was so unsure that I couldn't get a handle on it—it seemed we were both confused. During

fittings, I found I just didn't have the patience anymore to fuss about the shoulder seam being an eighth of an inch more forward or not—it was the overall look I was after—I couldn't go back to the way we had worked thirty years before.

Though I hated to, I suggested Barbra's friend Donna Karan help do the clothes—I just felt that my stamina in 1993 wasn't up to the superstar's demands. Barbra opened to great acclaim and went on to do a world tour starting in London and closing in New York City. The program notes gave the star full credit for costume design.

A few years later, we met at an event one evening in New York City. We embraced and Barbra said to me quite out of the blue, "You know, Arnold, I will always have a very special place in my heart for you," and, of course, I feel the same about her.

We shared many wonderful moments together and I truly loved working with her and knowing her. In a funny way, we sort of grew up together professionally, her beginning as a star in *Funny Girl* and my beginning as a star in couture. I was able to imagine what she wanted to wear, she listened to me, and was exciting to work with—we were on the same wavelength. She was a wonderful patron, a memorable friend, and she certainly looked gorgeous in her Scaasi clothes—to this day, Barbra Streisand remains always—real cool.

P.S. For years I had asked to borrow the famous Academy Award see-through outfit to show at the many retrospectives that have been done on my career at museums across the country—I was always refused. A secretary told me often, "It's in storage somewhere and can't be found." In October 2003, Streisand auctioned many of her personal items on eBay, the money going to the Streisand Foundation. Suddenly it was "found," and after paying several thousand dollars I was able to buy it. Scented with Barbra's personal fragrance—the controversial outfit finally came home to its creator.

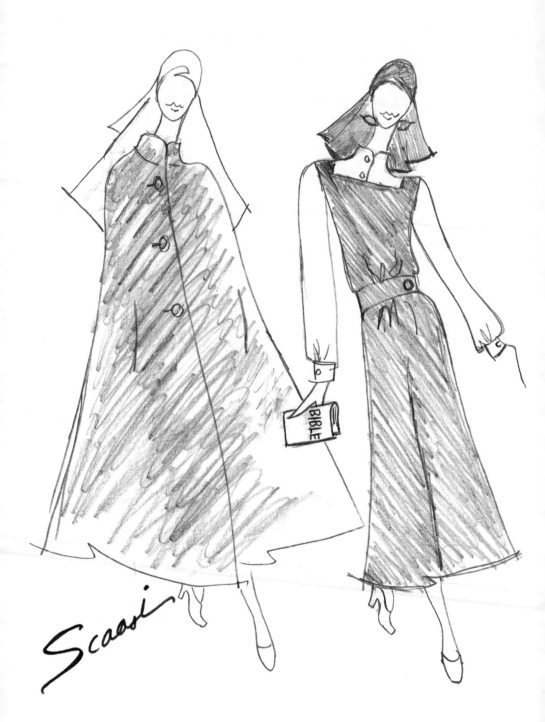

CHAPTER X

THE MOTHER SUPERIOR

I was taken by surprise one spring afternoon, in the mid seventies, when my directress, Marjorie Reed came to me and said, "You know, I've just had the most unusual conversation on the phone. It was with the assistant to the Mother Superior of an order of Catholic nuns in Pennsylvania. The Mother Superior very much wants to meet with you—are you thinking of changing your religion?" She was obviously trying to be funny.

"Absolutely not. I was born Jewish, and I intend to remain Jewish—tell them I'm not interested," I answered with a straight face.

"All right, but I think it would be nice if you called her back yourself, that way there won't be any confusion about your decision. Here's the number."

With that, she handed me a slip of paper that simply said "Mother Superior" with a phone number on it. I called and spoke to the assistant who had telephoned earlier. "Oh, Mr. Scaasi, thank you so much for ringing me back," she said. "I wanted to make an appointment for Mother Superior to come see you. The other night, she saw *On a Clear Day You Can See Forever,* and just loved what you did for Barbra Streisand." I suddenly had this picture of the Mother Superior, fleeing the convent with her black vestments flying every which way, and becoming a nightclub singer dressed in Scaasi drag!

"I'm sorry, but I'm not quite sure why the Mother Superior wants to meet with me."

The assistant explained, "Mother Superior thinks that our habit is very old-fashioned looking, and hopes that you could design something for

123

our order that is more modern. Would that interest you?" Without any hesitation, I said, "Of course, I would like very much to see what we can work out."

The idea did intrigue me. After all, I had grown up in an Orthodox Jewish family and didn't know the first thing about nuns or Mother Superiors. The closest I had ever come to the subject was seeing Ingrid Bergman in the film *The Bells of St. Mary's*. This was really going to be a stretch for the Jewish kid from Montreal—it certainly posed an interesting challenge!

On the appointed day, the Mother Superior arrived at my pale beige salon. Marjorie welcomed her, and she accepted a cup of coffee from Jacqueline, the uniformed maid. She was seated on one of the beige damask-covered banquettes under the stylized mirrors and near the life-size silver swans filled with fresh white flowers. There were small pewter bamboo coffee tables here and there around the room, with Tiffany silver ashtrays on them. The sheer white curtains and plush beige carpet gave the salon a definite feeling of a French boudoir. The large room was topped off with a silver chandelier that my famous decorator, Valerian Rybar, insisted upon. The salon had to be the antithesis of the usual places where nuns hang out!

After I was told the Mother Superior had settled in and was reading an issue of *Harper's Bazaar* (that included photographs of some of my dresses) I went in to say hello. I was met by a smallish round woman with fine skin and twinkling eyes, no makeup, of course, but a cheerful smile and pleasant countenance. She must have been in her sixties. In her voluminous black robes, a black veil set back on her head, and the starched white wimple that went under her chin, it was difficult to guess her age. Only her face showed. Still, there was a definite elegance about her, totally different from the society ladies who usually frequented my establishment. She seemed very much at ease, which helped me be the same. Within a few minutes, I was chatting her up as if she was a longtime client.

I said, "I'm so fascinated that you came to me when there must have been other designers of *your* faith that might have been more appropriate."

"Yes, probably," she answered, "but we all like in particular what *you* do. There's a feeling of newness about your clothes without being too way

out. I felt that you would understand what we needed without making us look too mod!" she said laughing. "Do you think you can do that?" I said I would certainly try, and asked what she and her nuns needed.

"Mr. Scaasi, before we start," she said, seriously, "you must realize something very important—we are not like other women. Therefore, we cannot appear before our congregation looking like other women. We live a life that is totally insular—we *are* different. However, we move about the city a great deal, helping people and doing our duties, it is really difficult for us to carry all this baggage around with us!" Saying that, she rose, and trudged through the room, showing me exactly how difficult it was to get around, wearing all the layers of long, heavy clothing. I understood exactly what she was saying.

"It's easy to design a new habit for you. First of all, we are very lucky that we are in a decade where longer skirts are in style," I said, taking up my sketchpad and beginning to sketch.

"Well," she said, laughing, "I never thought we would be in *style*, but I guess you're the one to do it if anyone can!" I showed her my sketchpad, where I had drawn a figure, wearing a black dress that ended mid-calf, well below the knee yet not to the ankle. "Midi length" was the length of most clothes during the late seventies. I had fitted many clients wearing this length of skirt—so I knew it could work on almost anyone. It all had to do with the overall proportions of the top. If you dropped the skirt length, you had to drop the hipline of the top for it to look right. Just as in the sixties, when mini skirts abounded, you had to raise the waistline to make a smaller top to go with the smaller skirt. It was that simple—*if* you had a good eye!

The dress itself was kind of a jumper that was sleeveless, with a highish square neckline and a soft belt. As there was no waistline seam and the top went down about four inches below the waist, you could put the belt wherever it was good for each person. What was left below the belt became a "hip yoke" that the inverted pleated skirt fell from. It looked great, and the Mother Superior was visibly excited. With this, I sketched a simple white shirt with long sleeves that looked very fine with the black jumper.

"Is that difficult to make?" the older woman asked. I said it was comparatively easy if you had a good pattern. Why did she ask?

"Because, you know, we make our own clothes." Well, I didn't know—but thinking about this problem, I answered, "As I said, if you have a *good* pattern, and you have some experience making your own dresses, which I'm sure your girls have, it can certainly be done. Tell me, where do you get your fabric from, and can you get it in different weights—so that it's not too heavy?"

"The fabric is given to us by different mills, and I'm sure we can ask for one that's not too heavy—but won't we be cold?" she asked.

"No," I explained. "I'll design a cape for you in the same type of fabric that goes over everything. You know, like the Salvation Army girls have, but not as big and bulky. Also, you would use a much lighter fabric for the summer dresses than for the winter ones." I couldn't believe it—she actually clapped her hands for joy!

"That's perfect—oh, Mr. Scaasi, thank you. May I ask you one more question? Would you be a dear and make us the first pattern? We'd be willing to pay for it, of course. Then we'd be sure it would turn out well," she smiled sweetly. I thought, Lady, do you ever have chutzpah! but I didn't say it. I simply said, "Yes, I think my people can do that for you. Now, what should they wear on their head? Do you think it could be a kind of babushka-scarf that was longer and tied under the back of the head—sort of what Jackie Onassis wore when she visited Capri? It would not be as long as a veil, but still have a different look from other women and act as a veil."

"Oh, Jackie Onassis, I don't know," she wondered.

"Well, you know she wore this scarf that covered all of her head and it looked very nice. Of course, in black it could be appropriate," I assured her.

Suddenly, I realized I had to ask an embarrassing question, probably for both of us—certainly for me to be asking it of a devout Mother Superior! But, it had to be done. She could slap my face and leave, I thought, or answer me and stay and talk about it. It would certainly help the order of nuns and help my design as well.

"I'm sorry to have to ask this, as I don't mean in any way to offend you, but what *do* you wear when you're undressed—under all those layers? Perhaps I can simplify that also."

"Well," she said, hesitantly and blushing only slightly, "I do want this

to be right—it's just that I never discussed this before—certainly not with a man!"

I went straight on, "My mother always wore a boned corset when I was a child, and I wonder whether you wore the same?"

"Yes, that is it, exactly," she said, simply.

"And, because of this, Mother had to wear stockings and garters and a brassiere and underpants and a slip," I continued, trying to get it all out as quickly as possible to stem the embarrassment—in essence, I *was* undressing this holy person. The nice lady fidgeted and looked away, and I thought I'd had it for sure. But no, she was not called Mother Superior for nothing. She looked me straight in the eye and said, "Yes, that's it—the whole lot of it—now may I have a glass of water?" Our maid, Jacqueline, brought us *each* a cool glass of water.

Refreshed, I said, boldly, "You know, today it's not really necessary for anyone to wear all that. Remember, Mother Superior, I work with many women and, of course, all the models who show my collections, so I really have experience with this kind of thing. I think you should all wear panty hose—black, of course. That would make life much easier for everyone. It will eliminate stockings, garters, corsets, and other underwear. Yes," I continued, decisively, "that's what the nuns in your order will wear with their new habit I designed for you. Of course, they may still wear a bra and, possibly, a slip, if they choose" (though it *was* said that across the country women were burning their bras in defiance!).

"Well," she said, "I came for something different, and you've certainly given it to me."

"And while we're at it," I continued, "we have to change the shoes. No wonder you all have trouble getting around, wearing those heavy clunky shoes. I think a low-heel, simple black leather pump that is really comfortable would be the best. I asked Marjorie to bring me a pair of the new low-heel pumps that we had just received from Italy, and also a pair of black panty hose. The poor Mother Superior, by this time, was beginning to fade, but I doggedly went on.

"You'll see, Mother Superior, every girl in town will want to join your order!" I said, laughing, but really thinking I had gone too far.

"Now tell me, dear lady, what are we going to do about the wimple? That won't do at all with the new habit!"

"Oh, no, Mr. Scaasi," she said, vehemently, "we *can't* change that. You surely don't want to see all the chins and wrinkles that are behind this wimple. No, no, *I'm* not taking this off!"

Well, I thought, I'd gone far enough for one day, so I said, "You know, you're right, let me think about it and come up with a simpler alternative—I promise, I won't make you go without your precious wimple!" I did think that somewhere in the Bible I had read that vanity was a sin, but I didn't say anything.

We made the paper patterns in three sizes: small, medium, and large. One day in the fall, Mother Superior came back with a nun to show me how successful the new habit had turned out. The young woman was very pleased, indeed, and said so. Though outwardly Mother Superior had not changed her basic look, she did have on new shoes, and implied that she had changed her undergarments as well!

We corresponded often, and I was pleased that I had made so many women happy—looking and feeling good about themselves. After all, that's what I'm here for!

JOAN SUTHERLAND

A major change took place for New York opera lovers in the early sixties. The old Metropolitan Opera House, opened originally in 1883 at Thirty-ninth Street and Seventh Avenue, was to be torn down and the venerable opera company was moving to its shiny new digs at Lincoln Center, to reopen in 1966—when a new era for opera fans would begin.

With Dame Joan Sutherland and Richard Bonynge, 1961

The closing night November 1960 gala was an extraordinarily festive evening. The old stage was set with a grand staircase, maybe twenty feet high and almost the width of the proscenium. Each famous opera singer would appear at the top and descend the stairs dramatically to the stage.

When the tiny, pert, world-renowned French coloratura soprano Lily Pons appeared, the throng thundered their approval. I had made a most beautiful candy-pink satin evening cloak for the popular diva. Her dark eyes sparkling, she descended the staircase to the orchestration of "The Bell Song" from *Lakmé,* which she had made famous in her time at the Met. Lily was joined halfway down by two tall extras in guardsmen's uniforms who accompanied the prima donna. When she reached the stage, she glanced at the audience in her fiery way and flung the coat open to reveal a lining of white ostrich feathers, which formed a background for the beautiful pink satin strapless ball gown underneath.

Her voice was in great form that evening and she accomplished the difficult trills that are so necessary for an exciting rendition of the *Lakmé* aria—the audience went wild!

Later, in 1961, Joan Sutherland's manager made an appointment for the young diva to come to my 550 Seventh Avenue showroom. I had seen the redheaded opera singer when I was a teenager at a concert in Melbourne, Australia. She was very young at the time, and I was awestruck by her magnificent voice, as the whole world was by the early nineteen sixties.

Miss Sutherland and her husband, the conductor Richard Bonynge, arrived at my draped coral-silk mirrored salon. I came in to welcome them, and was impressed by her presence. As we said hello, her six-foot frame towered over me. She had a delightful smile and a twinkle in her eye, and her bright red hair was a wonderful frame for her creamy white skin.

We began to chat about when and where she would perform. I learned that she was making her first appearance on the New York stage at a concert at Lincoln Center with Leonard Bernstein conducting. She wanted a gown designed for that very special night—I was excited that this uniquely talented woman had chosen me.

"That's wonderful! But how did you happen to come to me?" I asked.

"We just loved what you did for Lily Pons for the closing gala at the Met," she enthused.

I was really flabbergasted. Here was this tall, redheaded Brunhilde-type girl standing beside me, and she had loved what I had done for the tiny French diva Miss Pons.

"What would you like me to design for you?"

"A black dress with a neckline not too low and long sleeves and, you know, just nice, simple and black," Sutherland replied.

"But you have such extraordinary coloring. Why would you want me to do a boring black dress?"

"Well, because it would make me look thinner, smaller, you know, not so big," she responded.

"But you're enormous! I could never make you look smaller. No, we will make you look bigger, grander, bolder. We will make you look stupendous!"

You can tell I was very brash and young at the time, or I never would have dared say such a thing. Sutherland and Bonynge laughed. And I laughed, embarrassed by my boldness. But still, I found she had a great sense of humor. And that quality was wonderful, made her easier to work with, and such fun for a young designer—we were both really at the start of our long careers.

From that moment on, we proceeded to make her some marvelous clothes, always with the idea that she was a glamorous diva with flaming red hair. I immediately sent her to Kenneth, the hairdresser of the moment, and he did a fantastic, great bouffant hairdo. She had peaches-and-cream skin, as I've said, and appeared quite marvelous onstage. Her size on the enormous stages at Lincoln Center looked quite normal—the stage sometimes even dwarfed her! I found in taking her measurements that though she was very tall and probably about a size eighteen, her chest was quite flat for a person her size. We immediately began to make a type of corset that I put into my evening clothes at the time (and still do). These boned corsets indeed pulled in her waist and supported her back. We padded her bust line so that her bosom was bigger and in proper proportion to her size. We made her wonderful clothes, and I never thought of her as anything but glamorous. Sort of like Mae West, but younger and classier!

We made day clothes, such as a gray tweed suit with a bright yellow top and wool crepe dresses for daytime meetings at the Met. I never saw her as being too big, because she was always in proportion—that's the secret, of course, and what you can accomplish in couture—make the clothes in perfect proportion to the size of the client. We made grand clothes and simple clothes. One dress I remember, in particular, was black lace over black satin, it was strapless and had a little fishtail train. Imagine making a strapless gown for a girl who was over six feet tall and a healthy, large size! She called it her "Diamond Lil" gown and loved wearing it—she was glamour personified in that dress!

For her first public appearance in New York, we made a gown of printed apricot roses with green leaves on a black background and a huge cloak that went off the shoulders of bright tangerine silk lined in the same flowered print. When she appeared on the stage of Philharmonic Hall, the audience let out an audible gasp and then applauded wildly. Maestro Bernstein jumped off the podium to greet her, saw this flame streaking across the stage toward him, and was visibly shocked—he looked so tiny in comparison. He jumped back onto his podium and simply bowed and smiled at the diva. Sutherland suddenly had the most wonderful composure, and, just like Lily Pons, stood with this great tangerine cloak around her shoulders, grinning at the audience—it was a breathtaking moment. The music swelled and she opened the coat with a flourish (we had rehearsed this many times) and again the audience gasped as the flowered gown was revealed. And then that glorious voice—Sutherland sang like an angel and looked amazing. She was totally transformed from the insecure Australian girl who had come to my showroom a few months before.

What a night—I cried, and afterward backstage she hugged me and said, "Thank you, Arnold. I have never felt pretty in my life. Tonight I feel really pretty. Thank you. Thank you."

As time went on, Joan Sutherland became more ensconced at the Metropolitan Opera and also did concerts in other cities. She and Bonynge had a wonderful house on Madison Avenue near Ninetieth Street. They were really becoming Manhattanites and felt at home in the city—after all, they were a celebrated couple in a town that loves stars.

My Central Park South aerie was well suited to entertaining and I

decided to give a black-tie supper-dance for my friends, the Bonynges. I could seat forty people around the twenty-two-foot-high living room that had huge windows facing Central Park. Valerian Rybar had designed unique stainless steel banquettes cushioned in brown velvet that circled the room. On the dark mahogany floor, there was an enormous square rug of twenty-four beige wolf skins that the furrier Ben Kahn, for whom I designed collections, whipped up for me. With a Fernand Léger on each side of the fireplace and the Empire crystal chandelier hanging from a velvet rope in the middle of the chalk-white room, it was quite the glamorous spot!

Joan, Ricky, and I planned a guest list that was a mix of New York pals and colleagues from the opera world. Naturally, my then new friend, Parker Ladd, was invited. Also, Arlene Francis and her husband, Martin Gabel, Diahann Carroll, Nancy and Henry Ittelson, Ahmet Ertegun, Alfred and Jean Vanderbilt, William Randolph Hearst Jr. and his beautiful wife, Austine, the vivacious Aileen Mehle (gossip journalist "Suzy"), Leland and Pamela Hayward, my model pal Gillis McGill Addison and her husband, Bruce, Andy Warhol, and John McHugh and Trumbull Barton, friends of the Bonynges, who were a same-gender society couple (rare at that time) with a landmark house and a grand weekend estate. Rudolf Bing, head of the Met, and his wife were included. Joan had sung often with the glorious Marilyn Horne, who was invited along with the popular television host David Susskind and his pretty blond wife, Joyce, who later became a television host herself. Leonard Bernstein was invited, as were Alicia Markova, the grand dame of ballet, and the formidable critic John Gruen, whom we all liked a lot.

Guests arrived on the twelfth floor, dropped their coats in the wall-to-wall mirrored bedroom and descended the narrow red-lacquer stairwell with the railing of Lucite posts set into stainless steel. (Rybar had a fetish for metal!) I had hired a five-piece orchestra, which was seated in the open balcony room that overlooked the downstairs living room. The tiny balcony room had a wall of French doors looking out onto Central Park; the two remaining walls were covered in yellow and white Fortuny fabric. Treelike plants framing all the enormous windows of the apartment gave the feeling that you were sitting in Central Park. There were masses of white calla lilies and candles in every room, creating a really festive

atmosphere. Sutherland arrived in a sparkling green long dress I had made for her and was in great spirits, greeting everyone who came down the stairway. At one point, a handsome man dressed in black tie came over to me.

"I'm John Gruen," he said. I was speechless—the man standing in front of me did not resemble the inimitable John Gruen we knew.

"I realized when I got the invitation there had been a mistake," he continued. "But I am such a fan of Joan Sutherland that I could not *not* come. If I might just meet her for one minute—then I'll leave immediately." I led the other Mr. Gruen over to Joan and explained the mishap. After speaking to the imposter for a couple of minutes, they found that they had mutual friends, as her fan was in the music business.

"He seems very nice and he did get all dressed up, why not let him stay for supper?" Joan whispered in my ear—she was a most compassionate lady.

I planned to serve two of my favorite dishes that evening—my decision had come about quite naturally. After the theater or opera, we would always go to the Oak Room restaurant in the Plaza Hotel, just down the street from my apartment. Mario, the maître d'hôtel, always seated us at a prime table where we could watch the celebrities arriving after their performances on Broadway or at Lincoln Center. Parker and I always settled on one of two of our late-night favorites—the chicken hash that the Plaza made so well, or caviar served with tiny blinis. When planning the menu for our supper party, I decided to serve the chicken dish from the Plaza and the finest caviar with little homemade blinis. I'd spoken to Mario about ordering this for some forty people.

"Mr. Scaasi, of course we'll do it for you," he said. "Just remind me the day before and I'll be happy to have it for you the next afternoon. Please make sure whoever picks it up has a container large enough."

I had hired a very competent staff for the gala party. A wonderful Swedish gentleman, who was famous in New York at that time, known as "Rudy the Omelet Man," could make the most delicious blinis! I hired three pretty waitresses, all done up in little black uniforms with white collars and cuffs and frilly white aprons, an accomplished bartender, and Michael, who I thought was the best butler in town. When he arrived at about six o'clock that evening, I sent him down the street to collect the

chicken hash from the Plaza Hotel. I thought I had given him a large enough container but soon the efficient maître d'hôtel telephoned.

"Mr. Scaasi, the container you sent is nowhere near large enough to hold the chicken hash." By that time, I was fussing with all the last-minute details that were needed to make the party perfect for my grand diva.

"Mario, just put it into whatever will hold it properly, I don't care what it looks like, we'll transfer it into the proper dishes here. Please, Mario, just do the best you can, I know it will be fine." Fifteen minutes later, the hapless butler arrived at the apartment door carrying two metal pails that one would use to wash floors with containing our delicious chicken hash! No matter, it all turned out fine, and we had the most marvelous supper, accompanied by magnums of champagne. The music played on and we danced well into the night—the party was a dazzling success!

(Individualists take note: Some years later, after the obliging Mario had left the Plaza, I tried to do the same thing and was told by the new management that it was against the New York Health Department regulations to take food out of the hotel. What has become of our freedom for sociability?)

About this time, I had decided to give up the Seventh Avenue ready-to-wear showrooms and move to East Fifty-sixth Street, where Valerian did his usual magic at the new salon. This is where I would open my first professional couture, made-to-order business. During the interim of moving, we would have to finish what we were making at that time for Sutherland. For want of another place to fit, she came to the Central Park South apartment. We did our fittings in the small balcony room with the wonderful views of the park. One day while looking out the windows, Joan suddenly turned to me.

"Arnold, look at all those young people bicycling—isn't it wonderful? You know, Ricky and I used to bicycle all the time in Australia—we had such fun. Now, of course, there just isn't time for any of that sort of thing anymore, is there?" Her voice was so sad and I realized that no matter how successful you become, and God knows, she was one of the great operatic voices of our time, you always lose something along the way.

"Oh, well," she sighed. "Let's get on with the fitting, dear boy—we certainly don't have time to bicycle today!"

We made many wonderful clothes for Joan. I remember a grand dark brown satin floor-length dressing gown with a wide, thickly quilted border lined in pink toweling—made especially for her to wear in her dressing room when she received people who came backstage after the performance. You understand, the diva might be a little sweaty after being under the hot stage lights for three or more hours. We made evening pajamas and cocktail dresses and a coq feather-trimmed dark green midi-length satin coat—it was divine! We made gowns for her to wear in concert, usually with a floor-length cloak covering them so she could come out and shock the audience when she opened the coat and revealed the gown underneath, obviously, a throwback to the outfit I'd done for her first New York performance. Mainly, I think, we made Joan Sutherland feel happy about herself and secure in the way she looked.

As with Streisand, who moved to California, it was impossible for me to continue to fit Sutherland once she moved to London, as she was seldom in New York. Of course I would see her when she came to town, but that was mainly during the Met season.

One time in the late sixties, Parker and I were visiting London, and we were asked to lunch at Joan and Ricky's home. It was a charming English house, surrounded by sumptuous trees and a lovely garden. One arrived on the parlor floor and then went downstairs to the dining room off the kitchen and the garden, all being at street level. As I remember it, Dame Sutherland did the cooking, and the meal was perfect. She wore a simple skirt and a cashmere sweater set with a strand of small pearls— definitely the suburban British housewife. Parker and I had great fun with them, their son, and some other friends that day in London, a memory we truly cherish.

Fast forward—on Monday, September 29, 2003, our good friend Peter Wolff invited us to the opening night of the Metropolitan Opera in New York City—very fancy and black tie. Renée Fleming was making her debut in *La Traviata,* the production designed and directed by the great Italian Franco Zeffirelli. At 6:30 p.m. sharp, the majestic gold curtain went up, and for the first time we saw the young diva as the emotionally distraught Violetta—she was stunning. Near model size, with a lovely face and a flawless voice, she is obviously a fine actress. All the

emotion of the character came across the footlights beautifully—her performance was perfection.

Sitting in my third row seat, my mind went back to when I first heard Joan Sutherland sing the role thirty-five years before. I still get chills up my spine when I remember—in her beautiful gown with her shining red hair, she was an arresting presence, standing totally still onstage, just letting that extraordinary, gorgeous voice boom out into the opera house over the audience and far, far beyond—clear, clear as a bell. Wow! She was not called "La Stupenda" for nothing!

Mary Sanford with Rose Kennedy and her young son Edward

CHAPTER XII

ROSE KENNEDY

I met Rose Kennedy in Palm Beach through my dear friend Mary Sanford, a spectacular woman, who was very spontaneous and outgoing. She had been on the New York stage when she was very young, and known at that time as "the devilishly beautiful" Mary Duncan; and then on to Hollywood, where the millionaire polo-playing playboy Laddie Sanford met her and swooped her up and married her. They were the glamorous couple of the thirties and forties—Laddie often flying his own plane—and also great racing people with their stables and a horse farm in Sanford, Florida. They had a marvelous mansion called Los Incas in Palm Beach. When I went there in 1967, Mary Sanford was known as the "Queen of Palm Beach," and she held that position until she was well into her eighties.

Laddie Sanford's father had built the racetrack in Saratoga at the turn of the century. Mary and Laddie also had a smaller house in Saratoga where they would go for the summer. It abutted the beautiful golf course, which people thought was part of her garden—she never corrected anyone who complimented her on the land, thinking it was funny. "If the damn fools don't know the difference, why should I tell them!" she would say, laughing uproariously. The Sanford box at the racetrack was the primary place to be, right smack over the finish line. Mary was a hoot, with a great sense of humor about herself and the life she lived. After all, she *was* an actress and could become very grand "upper class" if she wanted to, dropping her voice an octave and calling everyone "dah-ling" when she liked you, and, of course, acting the opposite if she didn't.

She loved making an entrance and we made her some extraordinary clothes, many with sequins and beads and feathers—she was anything but a wallflower. In those days, there were lots of costume parties in Palm Beach—one night she might go as a fantastic-looking geisha, the next perhaps as Scarlett O'Hara. For a fabulous Indian motif party, I designed a beautiful purple-and-red chiffon sari embroidered in gold with sparkling gold beads all over it. She wore a gold-and-ruby necklace as a choker and then an emerald-and-diamond gold necklace below, forming this massive six-inch collar of jewels. Mary and Laddie Sanford had been to India often to shoot with the Maharaja of Jaipur, staying in his palace. During one stay, she told me, the Maharaja invited Laddie into the "Jewel Room," a place with displays set up like any grand jewelry shop. Mr. Sanford *purchased* the two wonderful necklaces at that time. Mary always laughed when women said they had received their jewelry from the monarch as if it was a personal gift—Mrs. Sanford knew better! On that particular evening, I went to the Indian party with Mary, who entered leading a live baby leopard on a diamond leash—naturally, she caused a sensation!

The Kennedy compound in Palm Beach is famous, and Rose was a longtime friend of Mary Sanford's. We would all go to parties together, and Mrs. Kennedy and I became very friendly. Rose Kennedy was a petite woman, extremely chic and well dressed, always by the Paris couture. Even though we might be walking through the soggy grounds of one of the estates—perhaps Patrick Lannan's—at lunch, Mrs. Kennedy always wore very high stiletto heel shoes. Often she sank down into the ground and got stuck—she would laugh and say, "Oh, Mr. Scaasi, please help me out of all this—I *must* get some of those awful flat shoes," but, of course, she never did.

I had made a few things for Rose Kennedy in the past. She telephoned one day.

"You know, Scaasi, I need an evening coat, and I think you're the only one to make it for me. I don't have time to go to Paris. You've made so many beautiful things for Mary Sanford, I'm sure you could make me a wonderful one." Well, we did. We made her a long white-silk serge double-breasted coat, which she wore and wore and absolutely loved, and finally replaced with the same style made in a very, very pale pink. She

was a charming, funny Irish woman who really didn't care about what she said. Whatever popped into her mind she said immediately, and it was usually either amusing or very down-to-earth, very direct.

When Sargent Shriver, married to Eunice, Rose's daughter, was running for vice president in 1972, Mrs. Kennedy called.

"I'd like you to do some clothes for Eunice. Could we come to the salon at eight-thirty on Thursday?" she asked. We never opened the salon until about ten, when the social ladies of the day were ready to come in for fittings and order clothes.

"Well, Mrs. Kennedy, that's terribly early for us."

"I know, Arnold, but wouldn't you please do me this favor because Eunice has a terribly busy day? If I could bring her in early that would be wonderful." Of course, I relented. I mean, here you were, talking to Rose Kennedy, mother of a past president of the United States. She was so charming and persistent, you couldn't say no to her.

She arrived at eight-thirty in the morning, as planned, on the day of Eunice's appointment. I was there, under great duress, as was the fitter, Margaret, the head of the workroom, and everyone else who could be there to make her time with us pleasant. That is the idea of couture: great service to the client, something that a woman cannot get buying ready-to-wear clothes in stores. When she arrived, I thought she looked absolutely great, and I told her so.

"Really? I can't believe it. You know, Arnold, I put my makeup on at five-thirty this morning and then went off to six-thirty mass. I've had the taxi driver driving me around until eight-thirty so that I wouldn't be too early for you. I must look absolutely terrible." She opened a beautiful compact and reapplied her lipstick.

"Now let's see the clothes. What are we going to show Eunice?"

We went into the models' room where all the clothes were hanging and we looked through the collection. Because I knew Eunice had to travel across the nation with Sargent Shriver in his vice presidential campaign, I suggested some suits and perhaps a coat and some short dinner dresses that she could wear in different cities and feel comfortable in. We also picked a wonderful slim long dress that I knew would suit Mrs. Shriver's tall, thin good looks and that she could wear for more formal occasions. After we got through choosing these things, Mrs. Kennedy

and I went back into the salon and had some coffee while waiting for her daughter.

"Now remember, Arnold, you should show Eunice all the clothes we looked at and that we put aside, but please never tell her that *I* chose them for her because she would be very upset, and absolutely turn them all down—you know the way daughters are, they never want their mothers to choose anything for them. They only want their own say. If you show her the clothes and say that you liked them for her, I'm sure that she will accept that and order most of the things we picked."

Well, this was a revelation to me because my mother had done the same thing with my sister, Isobel, through the years when I was growing up in Montreal. I realized that all mothers really were sort of Jewish-mother types, mother hens that take care of their little chicks. Here was Rose Kennedy, this formidable woman who had lived an extraordinary life and whose son had been president and whose husband had been the American ambassador to the Court of Saint James's in London, telling me the same thing that my mother had told salespeople about *her* daughter. I was amazed.

She was loved by her children and would often call her son John F. Kennedy from Paris. They would chat about what she'd been doing, what collections she had seen, and then she would explain in detail the clothes that she had ordered from the couture, mainly Givenchy after Balanciaga had closed. If Bobby was nearby, he would listen in also and chat with his mother. That gave me a special insight into Rose Kennedy, who cared what her children thought—she was so proud of them and what they had accomplished—and a wonderful insight into President Kennedy, who took time out of his busy schedule to listen to his mother; he obviously cared a great deal for her. I don't think she was ever given very much credit for her impact on the president, but I believe Rose Kennedy had great influence on all her children, and they loved her for it.

We had a charming relationship, and I saw her often. I certainly always enjoyed her company and think she enjoyed mine because whenever she saw me, especially in Palm Beach, she would gravitate to me.

One time I remember, in particular, Parker and I were in Palm Beach at an art gallery vernissage on Worth Avenue and in came Mrs. Kennedy—she came straight over to us.

"Oh, Scaasi, please do speak English to me. Say anything you want, but just do it in English, PLEASE," she said anxiously.

"Well, Mrs. Kennedy, of course, what would you like to talk about?"

"Oh, I don't much care—I have just spent the whole day with a Japanese delegation, and I have been going absolutely wild. I just can't wait to have a drink and speak to someone in my own language." Parker brought her a drink and we looked at the paintings together and began a conversation. It was in the seventies and the feminist movement was in full swing; I was interested to find out her reaction.

With Pauline Pitt and Parker at Indian gala in Palm Beach

"Tell me, Mrs. Kennedy, what do you think of the feminist movement? Are you for it or are you against it?"

"Oh, my dear, I am absolutely for it. Of course, it's taken too long in coming, but you know, I really believe that early in the twenty-first century there will be a major change in America—we will have a black lesbian nun in the White House as president. Mark my words, it *will* happen. The way things are going now, I am so excited by what women are doing that I just know that all this will come to pass." Of course, Parker and I laughed, and she sort of giggled. We were shocked at what the "First Grandmother" had said, but she seemed really quite serious about it. I was amazed that this thought and this statement would come out of this tiny woman who had been brought up so strictly in Catholic Boston and had become a world figure on the international stage.

I liked her very much, and, you know, I miss women like that. They seemed to be a product of the sixties and the seventies when life really changed, and our vision of living changed, as did our vision of what people were. It all suddenly became something else. The uptight fifties vanished, and these ladies who were prominent and strong and had a place in history said whatever they thought. There were no holds barred at that moment—Rose Kennedy was certainly one of these visionary women.

Mary Lou Whitney, also of Palm Beach, Saratoga, and Kentucky, was married to Sonny Whitney, one of the richest men in America, who helped produce *Gone With the Wind*. The Whitney clan is old stock, arriving on these shores early in the nineteenth century. Mary Lou loves to have fun, and for over forty years gave her husband a grand time. She is a vivacious, always blond curly-haired southerner, whom I believe thinks of herself as a fairy princess. She owns great horses and in her mid-seventies has given over the management of her stables and properties to her new husband, handsome John Hendrickson, some thirty years younger than she. Being of the Rose Kennedy–Mary Sanford ilk, Mary Lou loves to shock also. One time at her beautiful home in Lexington, Kentucky, we were on our way to the Kentucky Derby in the bus she always hires for fifty of her fancy friends. I complimented her on how great she looked in her new navy-and-white check Scaasi outfit and big straw hat.

"How young you look today, Mary Lou—did you have a little facelift, by chance?" I teased. "You don't have a line on your face!"

"Not at all, Scaasi," she said, laughing, "I just use Premarin Vaginal Cream. If it tightens everything down there, why shouldn't it work up here?" she said, pointing!

Later, after Sonny had died, I gave a dinner party for her in my Beekman Place duplex overlooking the East River—guests were invited for 8:15 p.m. At 7:45 the doorbell rang and I told my housekeeper Glendina to go down and see who had arrived so early. She came back upstairs.

"Who is it?" I asked.

"She says she's Mrs. Whitney, but this lady looks much too young to be her!" Of course, Mary Lou had had a facelift and was thrilled with Glendina's reaction—it was just what she wanted to hear. We've made her

many beautiful dresses, either big white frilly affairs or slinky clothes fit for the siren she is. Believe me, when Mary Lou glides into the room in her newest Scaasi and the Whitney diamonds every other woman there pales beside her!

Through Mary Sanford, I met all the stylish and social women in Palm Beach. One was Therese Anderson, the wife of a prominent banker. A southern beauty with red hair and a smile that made you love her on sight, she became a dear friend and ordered wonderful clothes, either very ethnic-looking saris or the complete opposite—southern-belle white or pink embroidered organdy. The thing that struck me about Therese was that she had the first breast implants that I had ever seen. They were quite large, but not as large as Pamela Anderson's (no relation)! She looked marvelous, but when you danced with her two hard globes pressed against your chest, and you just knew they were not entirely genetic. There were many other wonderful ladies who became my friends, and I and my designs became an integral part of the social life of the island.

My love affair with Palm Beach continues. I have a perfect small house with a wonderful garden that's about one hundred yards' walking distance from the ocean. Parker and I have lots of friends and many clients who became good friends like the very pretty, much respected mayor, Lesly Smith, who first bought my clothes in the sixties. Also, Diana Wister, the thoughtful and charming Campbell soup heiress, for whom I've made a couple of wedding dresses and many outfits during the last

Jonathan Becker

With Parker in our lush Palm Beach Garden

145

thirty-five years. Of course, there's our friend Liz Gillet, another heiress (this time it's steel!). I've created so many clothes for her I can't remember them all. Also, the decorous decorator Pauline Pitt—she's something else!—wonderful company and really the most gregarious blond in P.B. She gives the best parties in her *beautiful* lakeside home—and Terry Kramer, the Tony-winning Broadway producer, whose father, Charles Allen, started the prominent investment house Allen and Company gives *the biggest* best parties at her grand oceanside estate, usually on special occasions like Thanksgiving or during Christmas week. We *love* the Fanjuls (sugar)—the really attractive Emilia and Pepe—who always entertain with old-world style. They help make Palm Beach special and we're happy to have them as good friends.

I make wonderful clothes for Betty Scripps (publishing and natural gas), a lovely blond lady who dresses mainly in red, pink, pale blue, or ivory—chiffon, lace, or silk crepe, with the occasional suit in red or beige tweed. She has great taste (and jewelry) and a wonderful sense of humor. Betty is a most generous philanthropist, especially of the arts, being the chairman of the Washington Opera Ball and several other good causes.

Audrey and Martin Gruss moved into their "Italian" palazzo about five years ago and have become very much a part of Palm Beach. Martin played polo at Wellington for years before a bad fall—he's in great shape today. Veronica Hearst, the exotic, dark-haired, extremely rich, willowy widow of Randolph Hearst, has *the* most extraordinary "castle" facing three hundred feet of oceanfront! The great philanthropist

Mort Kaye

Rose Kennedy
with Dame Celia Lipton Farris

146

Dame Celia Lipton Farris has clothes of mine that go back to the seventies. Celia is great looking and creative—was an actress in England and is also a fine artist. She remained a very close friend of Rose Kennedy through the years. It was amusing to see the tall, cool blond Celia and the tiny, cheerful Rose together—one with a strong British accent, the other pure Brahmin. There were so many people who loved the direct openness and cheerful countenance of this grand little Irish lady. Though she came from Boston, Rose Kennedy was a true Palm Beach icon.

Claudette's eightieth birthday in my Central Park South duplex

CHAPTER XIII

CLAUDETTE COLBERT

Parker had been bugging me for ages to go to Barbados for a vacation. I always put it off because I thought it was filled with stuffy older Brits, and I really thought we'd have a terrible time. However, in the spring of 1971 at a lunch with Charlotte Curtis, the special editor of the women's page of *The New York Times,* I changed my mind completely. She said it was so beautiful; Sandy Lane, the hotel right on the beach, extraordinary; and the water, in the seventies; the air, in the eighties; and the cool breezes at night, just marvelous—certainly the most beautiful, romantic place. "Arnold," she said, "you must go and see for yourselves."

When Parker got home from his job at Charles Scribner's Sons, the publishing house where he worked, I sprang the surprise. Of course, he was incredulous. "But you told me you never wanted to go to Barbados," he said.

I said, "Well, Charlotte Curtis, who knows *everything,* tells me that it's absolutely wonderful and that we should go. Let's see how we like it. It's only for ten days—if we hate it, we can always leave!"

When I told our friend Dena Kaye, the actor Danny Kaye's daughter, she said, "You must look up my godmother. She's a perfectly wonderful person." I said, "Great. We'd love to know someone there. Who *is* your godmother?" "Claudette Colbert," she announced. "And she has the most beautiful house right on the beach. Please, promise me you'll call her, and I'll let her know you're coming."

Parker and I arrived in Barbados and fell in love with the island at first sight. After a couple of days, we got up our courage to call Miss Colbert,

149

whom we had always heard was a very formidable lady. The housekeeper answered the phone and asked my name, then went away. In a few minutes, this wonderful, famous voice with a lilt to it came on and said, "Hello, this is Claudette. Is this Arnold Scaasi?" I said, "Yes, I'm calling at the suggestion of Dena Kaye." We chatted for a moment and then she asked, "Would you come to tea tomorrow?" I said, yes, absolutely, I'd love to, and that I was with my friend, Parker Ladd. She said, "I know, I'll expect both of you at four-thirty tomorrow. Now tell me how Dena is." We chatted for a few minutes about her godchild, and there we were— with a date for tea with the silver-screen legend Claudette Colbert.

The next day was sunny, as most days are during "the season" in Barbados. We tore ourselves away from the beautiful pink beach and went upstairs to dress for teatime with Claudette. We decided to be casual, wearing open-necked shirts and linen trousers—no socks, of course (in the tropics), with our espadrilles.

We took off in our little rented British car, driving on the left side of the road as they do in England. Claudette was about fifteen minutes away from the Sandy Lane Hotel, and when you reached her driveway there were wonderful gates between stone pillars with the sign *Bellerive.* The gates were open; obviously Miss Colbert was expecting us.

We were greeted by Beulah, who, I found out later, was the house-keeper-cook, one of many island natives who took care of *Bellerive.* She wore a short-sleeved pink-checked gingham uniform with white collar and cuffs, a little white starched coronet on her head, and a starched white apron. In a typical Bajan twang, she allowed as how "Miss Colbert will be out in a minute. Please do come in."

Claudette's home was a wonderful plantation house built by a sugar-cane baron in the early 1800s. It was completely made of wood with a slanting tin roof typical of grand houses of the period. We went up a small outside staircase and arrived in the front hall, which had a zebra-skin rug on the black lacquer floor. To the right was the formal dining room, to the left the living room. Large glassless picture windows, like in so many tropical island homes, looked out to the sea and the verdant jungle gardens. It was enchanting! Claudette had been in the house since the nineteen fifties, when she and her husband, Dr. Joel Pressman, acquired the place.

beautifully, like a scene out of a movie. It was obvious the "direc-
Iiss Colbert, was a superb showman and daunting perfectionist.
totally charmed us, having the earmark of a great hostess by ask-
many questions about us as she would give answers about herself.
:nuinely liked her and in a short time we became friends.

ing the island so much, like any good Taurean (an earth sign), I
·diately wanted to look at houses to buy. We had been introduced
eal estate agent and great gent, Ian McGregor. Though no one
:d to show their house over the Easter holidays, they graciously
:d us to many parties—we found we fitted right in and had a
lerful time.

: one dinner, I was seated next to a large, jolly lady wearing a
ntly colored caftan (a resort-wear *must* in the seventies). She had
ish-blond hair, rosy cheeks, a mischievous laugh and was great fun!
name was Verna Hull, an heiress to the Sears Roebuck fortune. We
·long very well and after several rum punches, the preferred Island
k (Bajan rum is famous), she extended an invitation to lunch at her
e the next day.

Ve arrived at a rather simple house on the sea, smack next door to
idette Colbert! Verna Hull was an artist, doing fantastical abstract
itings. She lived alone and was rumored to be a celebrated lesbian. We
yed her company very much and were interested to discover that the
t-door neighbors didn't speak. Though they had been dear friends, a
in their friendship had evidently taken place just before Joel Press-
n's death, and Claudette had built a wall between their two properties.
bert referred to her as "the Monster," while Verna kept a telescope
ined on the film star's house, monitoring her every move and con-
ntly bemoaning the end of their close relationship. It became known
us that we had done a shocking thing by seeing Miss Hull, after mak-
z friends with Miss Colbert! Well, at that moment, we didn't really care
out gossip on the provincial island, as we were leaving in a few days for
ew York.

We went back to Barbados often after that first time, made lots of
iends, and had lunch or dinner at least once with Claudette during each
ip. We got to know her very well and learned both the charms and idio-
yncrasies of our famous friend.

As I looked around the living room, I spott
famous French impressionist Maurice Utrillo—I
not the art most movie stars collected. (They
pink Renoirs.) The room was filled with comfc
chintz-covered easy chairs and sofas. A backgam
corner. It was a lovely room, very upmarket "Brit
taste. (No surprises here, like a splash of red or pu
Miss Colbert painted, but I could not pick anyth
done by the lady of the house.

In a few minutes, we heard that unique magical
down the hallway—"I'll just be a moment"—and
"Where is that darn shoe?" A minute later, Claude
into the room, laughing the famous laugh, eyes
broadly, with the same brown reddish bangs and fli
seen for decades on the screen—it was amazing. Sh
enty, yet she looked no more than fifty—she seeme

"I'm so sorry to keep you waiting. I couldn't fir
guess I'm just falling apart. [She sure didn't look it.
drink or shall we have tea?" Not waiting for an answe
lah, we'll have tea now—let's go out to the gazebo
complete command of the situation, I was to find out.
appeared to be exactly offscreen as she had been onscr
ago with that flirtatious smile and complaisant way a

We went outside into the garden, all swaying palms
ness, with the turquoise sea just steps away. The movi
a Chinese-style pavilion, a large white gazebo-like stru
panels holding up a double-layer pagoda-shape roof that
white umbrella from the outside, but let the tropical bree
were underneath. We sat at a red lacquer table with matc
chairs. This is where we had tea—and what a tea party it
platters of tiny cucumber-and-watercress sandwiches, pi
and two enormous cakes so decorative one hated to cut
served by two young island girls dressed, like Beulah
When the young ladies were through serving, they retrea
chairs behind the trellised panels, and stayed out of sight u
tress summoned them by ringing a small silver bell. The wl

151

Late one snowy afternoon in 1979, I was in the kitchen of our Long Island house making spaghetti carbonara when the phone rang—it was Claudette Colbert.

"Helen and I are sitting on the terrace in Barbados. It's a beautiful sunny day and we've just come out of the sea. We suddenly wondered why you and Parker are not here with us," she said, laughing. "I would love to have you both down to *Bellerive* to stay with me—do you think you could come in a couple of weeks, maybe for about ten days?" Helen O'Hagan was Claudette's great friend, often accompanying her to Barbados, and sometimes sharing her apartment in New York. For years, she had been a close business pal of mine—a vice president of public relations at Saks Fifth Avenue, where my clothes were sold. She is a petite, good-looking, very bright and loving person. Claudette was always in a good mood when Helen was on board.

Before we left on the trip, our longtime friend Ellin Saltzman, the chic, glamorous-looking senior vice president, fashion director of Saks Fifth Avenue, told us, "Now be sure to take some videotapes with you, as there's nothing much to do in the evening and Claudette doesn't like going out or you leaving her alone." We took a stack of movies! Arriving for our little holiday, I was surprised to find that we were the only guests. Still, Claudette was in a great mood, and we soon found that the three of us got along famously. Miss Colbert would have people in to dinner, or we would all go out to friends' houses. It seemed that we had so much to say to each other we never got to bed till after midnight and never *did* have time to watch those videos!

There was a certain routine to the day: Miss Colbert would appear at eleven-thirty each morning in a black jersey short leotard (showcasing her legendary legs) with long sleeves and a low round neck, wearing an old-fashioned bathing cap made of rubber with little waves stenciled into it that completely covered her hair—the cap had a chin strap, keeping it on her head. With no hair around her fully made-up face, you could see the famous jawline, which was still firm, though the lady was in her mid-seventies. (She *did* reveal to us one night when we were alone that she had had "a tiny face lift, *years* ago.") Claudette never wanted to go into the ocean alone, though she was a good swimmer, mostly doing a mean back-stroke. We would help her into the sea and watch as she quickly swam

away. Emerging afterward, in this unique bathing costume and full makeup, she *did* look every bit the movie queen.

When we were through swimming, we would go to our rooms to change, returning promptly by twelve-thirty for Beulah's delicious rum punch, served on the patio by the sea. Lunch was at one-fifteen sharp in the gazebo—no one was to be late. If by chance, you *were* late, then the routine simply went on without you!

It was a wonderful week and we enjoyed our hostess immensely. Over coffee after dinner, Claudette would tell us stories about her beginnings: how she was married for six years to one of her first costars, Norman Foster, before marrying Dr. Pressman in 1935. One night she told us, unceremoniously, that along the way she had had an abortion. Her ambitious mother agreed when the studio heads felt a child, at that point, would spoil her career and screen image as a "love goddess." Evidently, Norman Foster was unhappy about the decision as he wanted children, but his wife's career came first. Sadly, this occurrence was perpetrated on many film actresses during the twenties and thirties—though they were to appear sexy on screen, they were supposed to be virginal in real life! It was widely rumored at the time that both Joan Crawford and Bette Davis succumbed to this unreasonable pressure also.

She showed us her paintings, mostly of flowers, which were very well done, and revealed that the two Utrillos we admired were fake, copied from the originals she had sold years before. In other words, that week we got to know Claudette Colbert very well, and she became a *real* person to us and a good friend—the movie-queen image faded away before our eyes.

In 1989 Claudette was to be part of the Kennedy Center Honors: A Celebration of the Performing Arts in Washington. She was to receive her award along with the ballet legend Alexandra Danilova and the stars Harry Belafonte and Mary Martin. My old friend the advertising genius Peter Rogers, who had conceived the *Me and My Scaasi* ads, was a close friend of Claudette's. He had created the brilliant *What Becomes a Legend Most?* ad campaign in which she had appeared. Knowing herself very well after being in films for sixty-odd years, she was the only star photographed who did not approve of her picture. She asked that it be reshot, changing the lighting and angle of the camera. The second time around

she went home happy with a beautiful Maximillian-designed Blackglama mink coat.

Peter had seen a dress I had designed for the fall collection that he liked very much. It had a black velvet top with sharp white camellias around the neck and wrists. The long skirt of many layers of black silk tulle was quite full and moved beautifully.

"It's absolutely Claudette," he said. "I want to buy it for her for Christmas and she can wear it when she gets her award at the Kennedy Center." Though Claudette was dubious, never having had a Scaasi before, Peter brought her to the salon and she loved the dress. We proceeded and after only two fittings, the gown was ready.

"I can't believe it, I never had a dress made in Hollywood with less than four or five fittings—they must have worked all night!"

"Claudette, dear, after taking sixty-five measurements," I explained, "we create a dressmaker dummy that is exactly like you—only without your head! Nobody wants to spend time fitting these days—that's what real couture is all about." She hugged me and allowed us to take a snapshot of her in the gown, even though she was "not made up or anything" (you could have fooled me). She wore the dress in Washington to great acclaim—I was really happy for her.

We returned to stay with Claudette at *Bellerive* a few more times until I began renting houses myself on the island or Parker and I would go to Acapulco or Palm Beach—anywhere in the sun to get away from the cold winter weather I had known as a child in Montreal. I must admit, the thought of luxuriating in a warm climate when the north was freezing exhilarated me!

One time in 1990, we arrived at Claudette's to be part of a wonderful holiday house party. Helen O'Hagan

Dress for Kennedy Center Honors

was there with Ellin and her well-known decorator husband, Renny Saltzman, the Academy Award–winning actress Claire Trevor, and the glamorous Marty Stevens, whose father had been the head of Metro Goldwyn Mayer Studios for years. All very good friends—we had a grand time. Parker and I noticed that Claudette was always in a fine mood when there were more women than men around. I think she felt relaxed and could talk "girl talk" to them. It was the height of the season and we went out a lot and many people came to visit—Claudette was glowing.

One day I was taking pictures of the group, carefully avoiding our hostess, who, I was warned, did not like having her picture taken. While photographing Renny and Ellin sitting near Claudette, the star suddenly spoke up, "Why don't you ever take *my* picture—don't you think I'm photogenic enough?" From then on, I included her in every group photo and took some wonderful ones of Claudette on her own.

The following year, Parker and I were staying in the guest cottage, separated by a few yards from the main house. It was decorated in pinks and leafy greens with frilly white curtains—very feminine. We enjoyed it because it gave us a certain amount of privacy that allowed us to call our offices when necessary. Bobby Short, the inimitable supper club singer, was there also, staying in the big house. It was just the four of us. We would travel around in Claudette's little car with Parker driving and visit the wonderful botanical gardens or go to the rougher west coast beaches for a picnic—Beulah would make a great lunch. We laughed a lot, though we could tell Claudette missed not having Helen or some other ladies there—sometimes she would get a little cranky, which was not her style at all.

One morning Parker and Bobby went off to Bridgetown to shop while I stayed home on the phone talking to my staff in New York. Suddenly, the door to the cottage flew open and there stood Miss Colbert in her bathing regalia looking absolutely furious.

"Where is everyone?" she fumed. "It's eleven-thirty—I want to go swimming, and there's absolutely *no one* around!" I said not to worry, I'd meet her at the beach in two minutes. I put on my swimsuit and ran to the beach just as the star was beginning to go into the water. I took her arm and we eased into the surf together.

"I don't know where you people think you are—this is not a hotel,"

she said defiantly. "I'm an *old* woman and you're all here to help take care of me—how could everyone have gone and left me all alone?"

"Claudette," I said pointedly, "they'll be back any minute and, after all I'm here and we *are* in the sea. Besides, you don't *act* like an old woman and you don't *look* like an old woman, so how on earth do you expect us to treat you as an old woman?" Well, I'd got her there—knowing I spoke the truth, she just glared at me and swam away doing her backstroke—smiling up at the blue sky.

It gave us an insight into the psyche of the legendary actress, who, like the character in *Sunset Boulevard,* believed that "no one ever walks away from a STAR!" After that, we stayed near the house, fussing over Miss Colbert—she loved it!

For one of her early films, the 1934 comedy *It Happened One Night,* Claudette received an Oscar. She starred in sixty-four films, during a career that spanned almost seven decades.

One of her last roles was in 1986, playing the fictional character based on Elsie Woodward, the famous social grande dame in Dominick Dunne's *The Two Mrs. Grenvilles,* the television film about the fatal shooting of her son, Bill Woodward, by his wife, Anne. In Dunne's book, the family name was changed to Grenville. Claudette was great in the role, not looking a day over sixty-five through the sharp lens of the television cameras—in fact, she was eighty-three at the time! Still *later,* she appeared with Rex Harrison in *Aren't We All?* on Broadway. *People* magazine praised the octogenarian actors, "not so much for their performances, as for the mere fact that they were still mobile enough to pull them off so well."

Claudette Colbert died at ninety-three in 1996—in full makeup. To the end she was "directing" the activities at *Bellerive.* The consummate film star, she is greatly missed by all her friends—she *was* amazing!

Louise Nevelson in her Scaasi finery

CHAPTER XIV

LOUISE NEVELSON

I met Louise Nevelson through her dealer Arne Glimcher, the head of
the Pace Wildenstein Gallery. It was the late sixties, and Mrs. Nevel-
son, already a very, very famous and respected sculptor, was setting up her
retrospective at the Whitney Museum. It was important that I meet with
Glimcher's star artist, as she was about to embark on a series of lectures
at universities throughout the United States. He wanted Nevelson to
look really pulled together, as the press would be covering her, and asked
if I would make some clothes for her.

She was well known for wearing these bits and pieces, odd belts, shoes,
and strange headgear, also for the way she mixed up items of clothing. She
always wore something on her head, usually a jockey cap or a babushka,
but sometimes, a huge black shiny garden-party straw hat or a cowboy
Stetson—whenever the fancy took her. She had very thin hair that she
mostly wanted covered. Her extraordinary face was like a sculpture of its
own. She wore three pairs of false eyelashes, all fluttering at once. So, there
was her wonderful face with these black-fringed eyes, always moving
and full of curiosity. I met Arne at the Whitney, and amidst the chaos of
setting up a monumental retrospective of her work was—Louise Nevelson!

My first impression of her was a great surprise, because here was this
very distinguished, very famous woman who was completely unique in
the art world—she was an original. I was terribly impressed to see her
wandering around the galleries, telling people where to place the different
pieces—wonderful objects that were painted either white or black or
gold. Some pieces were complete wall constructions, from as small as
three by five feet to as large as eight by fourteen feet in size. Others were

159

simply floating masses of mixed objects in the middle of a wall. These powerful works of art were constructed mainly from "found objects"—pieces of wood that Louise picked up all over town, odd shapes of wood, maybe from a construction site—old bedposts or windowsills. One wall had the slatted back of a kitchen chair mixed in with other objects, all in the same piece. When painted black, the image was haunting.

"Mrs. Nevelson," I said, "this is absolutely extraordinary. I've never seen anything to equal it! There are so many magical things here, and some of them go far, far back in time—it's just amazing that you accomplished all this."

"Oh, this is *nothing,* dear," she replied, "I have so *much* to do—I just don't have time to die!"

That day Nevelson wore a man's denim work shirt and a pair of khaki pants. She was quite tall—taller than I had imagined her—and on her head was a pointed wizard's hat made of some kind of terrible reddish-brown fake fur. A sable coat completed her outfit! She was flying around with the coat swishing behind her, telling people what to do and pointing to her painted wooden constructions with her marvelous, long bony fingers. Of course, I was totally mesmerized. She looked like a cross between an eccentric dyke and a very elegant aging hippie! She was terribly low-key when we met and said how pleased she was to meet me and that she knew of my work and admired what I did. About an hour later, we left the museum together and started downtown to my salon on Fifth Avenue.

We made chitchat on the way, and when we got to the salon, I began to show her some clothes. I thought, here's a woman in her seventies and I guess Arne Glimcher wants her to look distinguished and sort of ladylike. So I began showing her little black suits and a black coat and maybe something in brown, but very low-key, very elegant things I thought she would look attractive in while lecturing her students during the day. She looked at everything and then said to me, patting the gray silk banquette she was sitting on, "Now, dear, that's all very nice. Come and sit by me." I sat down and she took my hand and said, "You know, I've seen all these clothes and I know that you're very talented, but I must tell you something—I'M JUST NOT A SCARSDALE MATRON!" I was taken aback, but I immediately got what she was say-

ing. And I said, "Louise, you are absolutely right," looking at her intensely. "You certainly are not a Scarsdale matron. YOU ARE THE EMPRESS OF ART—we will dress you as an empress!"

From that moment on, we began. We picked extraordinary brocades, one of enormous gold birds flying across an azure sky, and cut velvets in the most beautiful colors, though one *was* black velvet abstract shapes against black satin, matching a Nevelson construction; also the most wonderful giant checks (a long voluminous double-wool cape in black and bright red) and things that were really luxurious and dramatic, like a gray-and-caramel wool paisley long-skirted suit, the jacket bordered in sable. I did a one-piece jumpsuit, like long underwear, of deep green silk jersey to go under a green-and-plum velour lace poncho. She wore the jersey one-piece under everything, and even slept in it! She loved it so much she ordered more in other colors.

"Well, now, dear, that's more like it," she cried enthusiastically, after spending a couple of hours with me that first day. "That's what Miss America needs." (She often referred to herself as Miss America.) We designed clothes for her that were unusual and had great punch—she adored getting dressed up. Nothing was ever too far out. She loved sumptuous, flamboyant designs. Of course, the look mirrored the grand scale of her art. The clothes I designed for her were life imitating art—her art. I couldn't have been more thrilled.

By the time I met Nevelson, she was world famous and, I believe, quite rich. She certainly was not a struggling artist. She called me one day and said, "Darling, Miss America is cold, cold, cold. I'm absolutely freezing in my studio. I need something really warm to wear while I'm working." (The studio was immense; the lower part of her two houses had been joined together on Spring Street.) She said, "I need a wonderful coat, and I think it should be lined in chinchilla. What do you think of that, dear?" Of course, I was bowled over. I had made chinchilla- and sable-lined coats before for regular clients who were traveling around the world in the winter and wanted to be particularly warm. So I understood it. But I didn't really figure on someone wearing such a luxurious coat to work in. However, Louise was *not* your regular kind of person!

I began to talk to the furrier about what it would be like to make a chinchilla-lined coat. We didn't want anything ordinary for the outside

The artist in her chinchilla-lined paisley coat in front of her sculpture on Park Avenue

of the coat and I came up with the idea of using some Persian woolen shawls that she had brought to me saying that one day we might use them to make a dress or a suit. I said, "Why don't we make a marvelous coat from the paisley shawls? Then we can line it in the chinchilla and we can border the whole coat on the outside and cuff it in chinchilla." Well, of course, she loved the idea, and she did wear it indeed a great deal, both outside and also in her studio. This was very Louise Nevelson. We must remember that she had been born in Russia, and I think the feeling of being really cold all the time, even on cool nights in summer, was a throwback to her early years in that subzero country.

Louise loved nothing better than getting all dressed up in one of her most dramatic outfits and being taken to what she called "one of your fancy-schmancy parties!" I would pick her up in the chauffeur-driven car, and she would come down the stairs of her old house with her associate, Diana McKown, holding the door open. Louise would sweep into the car like a queen. We might be going to a big party the mayor was giving, or to the opening of the ballet, or perhaps the "Party of the Year" at the Metropolitan Museum. We would enter the event together and the flashbulbs would go off, and Nevelson would smile, looking like some extraordinary exotic bird—she loved it!

Remember that this success had not happened until she was in her seventies. All the years before, she had struggled to make people recognize her talent, to little avail. One day Arne Glimcher literally picked her up off the pavement, sobered her up, and had her enthusiastically working again, and *then* the world applauded! "Where were they, all those years, when I needed them?" she would ask, plaintively.

One evening Nevelson, dressed to the nines, was being honored by a prestigious college of the arts. She was standing in the receiving line with the dean, and she asked me to stay by her side. Of course, she was being charming and conciliatory as everyone passed and shook hands or embraced her.

Suddenly, a man came up to her and gushed, "Oh, Louise, you look wonderful. It's been so many years, and we were so close—you remember—I'm Bernie Allaine and *this* is my new wife. Remember, we were such good friends." Nevelson, all of a sudden, became very aloof. She looked down at the little man, and countered, "Did we ever sleep

together?" The man blushed and stammered, not knowing what to say. "If we didn't sleep together, then we just weren't that close!" Louise said, and turned to the next person waiting in line to congratulate her.

Soon after, we moved away, as the receiving line broke up. Shocked, I asked, "Louise, how could you say that to that nice little man?" "Nice, my foot," she answered. "Where was he when I needed him? Now that I'm famous, he rushes up to me to impress his wife. Well, fuck him! He didn't marry *me*, did he?" she said incredulously, her eyes flashing in anger. Louise was notoriously famous for having had a multitude of lovers throughout her life. I never did find out if Bernie was the *special* one—it sure seemed that way that night!

The renowned artist was always very outspoken. She didn't pull any punches, and always said exactly what was on her mind, frequently using graphic four-letter words. One afternoon she was part of a panel that included three prominent male New Yorkers and two women. During the discussion, one of the men said, "Well, of course, I'm not afraid to ask the chairman of my company for anything I want—I've got the balls to do it!" The audience laughed. Miss America, not to be outdone, rose majestically from the speakers' table. "I've got balls, too—and they're *bigger* than yours!" she exclaimed—clutching her pendulous breasts. The audience whooped and applauded wildly.

In 1977 Diana Vreeland called out of the blue and said, "Arnold, our next show [at the Metropolitan Museum, where she was special consultant to the Costume Institute] is called *Vanity Fair*. We're showing clothes of famous people through the ages. I have some wonderful things, but it wouldn't be complete without something of yours from Louise Nevelson. Could you be a dear and see if she would give us one of those wonderful outfits—she's *so* fascinating! I would love to meet her—can you arrange it? Please, Arnold, do try." Well, I was amazed, I always felt that Diana didn't think much of Nevelson, either as an artist or of the way she dressed.

All that aside, I called Louise and told her the story, and we decided to give the museum a long black point d'esprit dress with a fluffy sheer coat of the same fabric spattered in black sequins. With this, Nevelson always wore a tight cotton babushka under a black cowboy Stetson. She also decided to give a necklace she had made of painted-black blocks and

gold beads, a small version of one of her constructions. She usually wore this jewelry with the outfit.

I arranged for the two formidable septuagenarians to meet at the museum to discuss the multipieces of the costume. I couldn't imagine how they would get on, but they both seemed excited about their forthcoming meeting.

Curiosity got the better of me, and I couldn't wait for Louise to telephone—I called *her*.

"Well, tell me, Miss America—how did it all go—your meeting with the famous fashion icon?" I asked.

"You know, dear, she's very nice, and the show will be lovely," she said in an unusually quiet, tentative voice, "but I think it's quite amazing that she went so far in life and is so famous—I mean, dear, let's face it— she *is* very ugly!"

I realized in a flash that Nevelson's idea of beauty was Dietrich or Garbo. Still, I had to laugh, picturing the image of these two strong characters in profile, facing each other, with their prominent noses and exaggerated coifs, one with three pair of eyelashes, the other with brightly rouged ears—two aging famous femme fatales—what could I say?

Vanity Fair was a huge success, and I believe Nevelson was thrilled to be included in a show of such fashionable people. I know Vreeland was thrilled to have her there.

Often we would phone each other, and she would speak to me like a mother, and vice versa. If it wasn't the best day, I might say, "Louise, you know, I'm just not too happy today." She would go ballistic. "Happy! Happy? That's not a word. Who told you there was such a word? No one ever promised you LIFE would be happy. Just do the best you can, dear, and that's enough. Listen to Miss America, *she* knows." And I would calm down—the great sage had spoken! You see, besides having this extraordinary talent, she was intelligent, very well read, and, after all she had been through—a kind of philosopher.

In 1979, Nevelson and Diana McKown came to stay for the weekend in our then newly acquired Long Island house—a big old shingled place, built in 1910 as a summer house. It has a beautiful garden and sits between a bay and a canal, so there is water on two sides. Parker and I

moved in after a year of many alterations and painted the outside taupe, the color of the shingles, to camouflage the partial rebuilding.

The ladies arrived and examined the house from top to bottom. As we were having our lobster lunch outside on the terrace—Nevelson loved lobster as she had grown up in Maine—Louise suddenly looked up at the structure and proclaimed, "You know, dear, you really should paint this house black. It would be *so* distinguished." Well, I have always disliked natural shingle houses, so I thought this was a stroke of genius. The very next week we had the house painted black, and it's been that way ever since, and it does look great. Miss America was right on!

Strangely enough to Parker and me, Louise arrived for the weekend without any luggage. When I questioned her, she said, "Oh, don't worry, dear. I'll find lots of things to wear." True to her word, she would rummage through our closets and come down to lunch or dinner wearing a mix of our Carnaby Street seventies clothes—obviously looking like a Nevelson collage that was always original and wondrous!

Sometimes we would go to a favorite Italian restaurant of Louise's around the corner from her house. Diana McKown would be with us. Diana is a cheerful blond woman, and we would laugh a great deal during these dinners. Suddenly, Diana would turn around and say, "You know, there's Mister G." or "There's Mister M. Wave to him, Louise."

And, indeed, Louise would turn and wave to one of the swarthy men sitting at a nearby table. I soon found out, as the house she lived in was near Little Italy, that these men were part of the Mafia. Louise said, "Darling, they're so wonderful to me. They really take care of me, and I'm so happy that they're on my side!" Of course, she loved anyone who was different and unique, and she found these men, who were so kind to her, exactly up her alley.

On these evening forays to one of the many SoHo restaurants we would

Stepping out with Louise

go to, I would come from Central Park South, where I lived at the time. I always had my car and driver go way downtown to Louise's house on Spring Street, where we would pick her up for the evening. As the Bohemian-reared Nevelson loved gossip and her tumblers of scotch (which, she claimed, gave her indomitable strength), these nights out became very late. Laughing a lot, we would stagger back to the car, and begin to drive her home through the silenced neighborhood. Invariably, Mrs. Nevelson would make the driver stop and open the trunk. In all her Scaasi finery, she would leave us and begin picking up random pieces of wood, broken up chairs, and, sometimes, damaged orange crates, or whatever caught her fancy from the piles of junk on the curb. As much as possible was stuffed by the chauffeur into the trunk and then ferried back to Spring Street to be used in a future Nevelson work of art.

Louise Nevelson's work was shown the world over, and there were many exhibits in Europe. One in particular was a retrospective in Berlin. She was very excited about the fact that the work of a Jewish artist would be exhibited there, and she wanted something very special to wear to the opening. We made her a long black lace dress and over it a big black-dotted net coat that was generously sprinkled with multicolored sequins. The coat had ruffles of the same fabric all around the border and the sleeves.

When she made her entrance into the museum that night, the director rushed up to her as she descended the grand staircase of the marble hall. "Mrs. Nevelson, Mrs. Nevelson," he exclaimed. "You look magnificent—you have brought back the glamour of Berlin of the twenties—thank you, thank you—you are extraordinary!"

Of course, this is what Louise Nevelson wanted to hear. She smiled her Giaconda smile. Miss America loved glamour and loved that that night she was *the* glamour girl of Berlin. Batting those false eyelashes at the world, she knew in her heart, however, that she *was* the glamour girl of whatever city she happened to be in at the moment! She *was* extraordinary, an original, the likes of which we won't see again. Every now and then, I hear a little gossip that I know she would love, and then I remember Miss America isn't here anymore. I look at the wall or the ceiling she created for me and I can see her in all her glory—my own special friend, whom I miss a lot.

Violet-sprinkled white gown made for the launch of the fragrance Passion

CHAPTER XV

ELIZABETH TAYLOR

I had met Parker Ladd late in July 1962, and by Christmastime, we had
decided to spend the holidays together at the then unspoiled, beau-
tiful beach resort of Puerto Vallerta in Mexico.

Having just transferred from California to the New York City pub-
lisher Charles Scribner and Son, Parker knew the sleepy Mexican holiday
town very well, as it was easily accessible from his former home in Los
Angeles. He said I would love it, and I did.

We stayed at the charming Hotel Tropicana, directly on the glorious
wide white sandy beach—it was perfect. To go to the tiny village at night
for dinner, you walked along the beach for about one mile until you came
to a rickety wooden "bridge" over a dried-out ravine—"Gringo Gulch."
This route was fine when going *into* town, when it was still light, but very
precarious going home in the dark after several margaritas! Also, in my
tipsy state, I was sure there were iguanas everywhere, and insisted upon
moving slowly, guided by my trusty flashlight.

The subject of iguanas had come up as soon as we arrived, when we
were told excitedly by everyone that Richard Burton was in Vallerta,
filming the stage hit *Night of the Iguana* and that his gorgeous paramour,
Elizabeth Taylor, was with him.

Each night we would go into town to one of the two restaurants. The
first was a kind of taverna; the other was more classic. Both resembled
something out of a Mexican western. We were always on the lookout for
the Hollywood couple.

Ever in the midst of a collection or two, I generally traveled with a

folder of sketches and swatches, renting a room adjoining our suite that I could work in.

Late one afternoon, Parker and I were walking on the sand along the almost empty coastline, going back to the hotel so I could sketch. We came around a bend and there, lying in all her glory under a shady tree, was Elizabeth Taylor, looking ravishing! I remember she was quite sun-tanned, wearing a skimpy swimsuit, and reading a book. We tried to pass unnoticed so as not to disturb her, but the beach was too narrow at that point. As we walked closer, she smiled and said, "Hi," which we acknowledged, saying, "Hello," and grinning like two nuts. What fun, we had really seen the star in the flesh and couldn't wait to get back and tell our pals.

Later in the week, we went with Martha and Fred Murphy, who had grown up in Vermont with Parker and were on their honeymoon, and two other pals from California to the larger restaurant to celebrate New Year's Eve. It was all very festive with paper hats, noisemakers, and the lot. The restaurant was decorated with hundreds of flowers and paper lanterns. The place being quite small, there might have been forty customers at most. It was easy to spot Miss Taylor and Mr. Burton at a corner table—they looked so much in love, no one wanted to disturb them.

At about fifteen minutes before midnight, Richard Burton got up to pay the check and the most amazing thing happened—Elizabeth Taylor began to circle the small room, smiling and shaking people's hands, wishing them a happy New Year! She was very tiny—petite and really slim. I remember vividly she wore a colorfully printed Pucci dress in shades of violet, purple, and rose, with long sleeves and a low neckline—and that glorious face, smiling all the way.

When she reached our table, she approached Parker and me and said, "I saw *both* of you on the beach, but you didn't stop." Martha gushed, "Oh, Miss Taylor, we just love you!" Elizabeth said, laughing that melodious laugh, "Well, I hope you all have a *wonderful* New Year." Then she and Burton were out the door—and, I thought sadly, out of our lives forever.

Fast forward—one Saturday afternoon in April 1986, I was working at my salon on Fifth Avenue when the phone rang. We were preparing the collection, so there was a small crowd—the model, the mannequin, and

my assistants. Surrounded by a plethora of fabrics, I was draping away, creating the new collection.

My secretary said, "There's a phone call for you. It's Mr. Christian, you know, the hairdresser, and he's on the phone, and he said it's very urgent."

"Well, I don't think I can be disturbed now."

"But he says it's *really* important that you come to the phone." So I picked up.

"Yes, Christian, what is it?"

I heard his French accent. "You know, Elizabeth Taylor is in town and I'm doing her hair for this evening and she very much wants to meet you. She needs some clothes. She's going to do the *Bob Hope Show*—it's a big television event—and she very much wants to . . ."

I interrupted, "But Christian, I'm in the middle of the collection—I just don't know. It's Saturday and everyone's here working very hard and—"

"At least just talk to her, Arnold," he said. So I waited and waited, I waited for at least two or three full minutes. And I thought, What the hell is this? What am I doing, with all this work to do? Suddenly there was a silence like the beginning of a scene in a movie and this wonderful purring voice came over the phone, "HELLO. THIS IS ELIZABETH TAYLOR."

I almost fell off my chair, because I thought, of all the things that I've done in my life and all the people I've dressed, I never thought I would be talking again to Elizabeth Taylor. She purred on, "Oh, Mr. Scaasi, could you please help me out? I love your designs and I really need some wonderful clothes. I'm doing the *Bob Hope Show* in a couple of weeks. May I come to your salon in the next hour or so and explain what I need?" What do you say to the most beautiful woman in the world, whom anybody would have given their eyeteeth to dress? "I'll be there very soon," she stated flatly. Well, I found out as time went on that Elizabeth Taylor's idea of very soon meant sort of, whatever, three, four hours, or maybe the next day.

She arrived at the salon much later that day with her assistant Liz, and I must say, she *was* ravishing. Everything I had ever thought about her— the way she looked in films and all—was absolutely true. She was prob-

ably more beautiful in life. She *did* have extraordinary violet eyes and a lovely way of speaking. We looked at a lot of clothes. Of course, after she arrived, nobody wanted to work on the collection—everything stopped dead, and we were all her slaves!

Taylor began by explaining what kinds of looks were needed for the Bob Hope television show, which was to be taped in about three weeks. We showed her many things, and she would laugh and say, "Oh, that's grand, just perfect," or "No, not that, not good for Elizabeth." (My friend Liz Smith, who knew the star very well, had told me, "You must *never* call her Liz.") You couldn't help but like her, she was so natural and really nice, not at all what you'd expect from the Star of Stars. She chose a V-neck, long sleeve, short silk crepe cocktail dress with a wide flounce at the hemline, and a blue-and-black animal-printed, draped, off-the-shoulder, sexy short dress, also, a yellow-and-black tartan jacket and top with a black skirt.

We tried on lots of clothes, and I found out that she could be squeezed into the size-four model dresses, only that her bosom was bigger. *Naturally,* it was bigger; most girl models are built like boys in the chest department! Elizabeth is very feminine, with a good sense of humor about herself and other people.

On this, our first meeting, she was all sweetness and light, and, of course, I liked her immediately. I think that she realized I knew what I was doing, that I had dressed great stars before, and besides, she seemed to love the clothes, which was a nice compliment, as she owned clothes from every major designer in Europe.

After I zeroed in on her personality, I realized there was a young girlishness about her. I brought out a short red organza dress that was appliquéd all over in a flower design of white piqué. It had puffy short sleeves (very eighties) and Elizabeth flipped over it. She looked adorable in the doll-like dress, if a fifty-four year old woman can still look adorable! She is obviously ageless.

You know, when you're working with a new client, you have to make sure there's a good rapport. The job is so personal, you really must feel what the person wants and needs, and how to do it best to bring out her personality, the finer points of her figure, and still keep the client happy. If you don't hit it off, then there's no way the outcome will be suc-

cessful. Thank goodness, Elizabeth Taylor and I hit it off immediately and still have a very good rapport.

We set up a fitting on the new clothes for the following week, only five days from when she first came to the salon. We were very rushed, but I knew it could be done, as the workrooms were staying overtime anyway to work on the collection. Also, the fitter was so excited about doing clothes for Elizabeth Taylor that she would have stayed all night if I'd asked her to!

Elizabeth and Liz arrived a little later than the appointed time the following week, and we began our fitting. Elizabeth's hair had just been styled by Christian and was quite short in the back, almost like a duck-tail cut but very full on top, high and feathery. The color was black, with fine strands of silver throughout. It suited her totally and she looked wonderful.

As we were fitting the pretty little dresses for the *Bob Hope Show,* I suddenly had an inspiration while scrutinizing the star in the mirror. "Elizabeth, I have the most perfect dress for you to wear when you receive your tribute from the Film Society of Lincoln Center next month—it's absolutely perfect!" I said. "Well, show it to me, darling. Don't just stand there," she replied.

The dress I visualized on her was long, made of gray, black, and white organza petals, sparkling with silver and jet baguettes. It was strapless, but had a little stole of the same petals that could be wrapped around her to cover her upper arms. I brought the dress into the fitting room, and she squealed, "Oh, it's beautiful. Let me try it on!"

The dress was perfect for her, obvi-

ously too small over the bosom, but it matched her hair exactly and was very grand-entrancelike. "I love it!" she said, as I enthused along with her. I told her how we could make little sleeves so that she wouldn't have to bother with the stole, and it would look just as beautiful with an off-the-shoulder neckline. It was wild—it was as if I had made the dress especially for her. Of course, I realized that it had to be perfect, as her pictures would appear in every newspaper and magazine around the world and that her image would be on every television newscast within hours of the event. This was too good to be true.

THEN, MISS TAYLOR DROPPED HER BOMBSHELL!

"I love it, but I can't afford it. If you really want me to wear it, why don't you just give it to me? Now, come on, you know how right it is for me"—she giggled and tickled me in the ribs to make her point.

In that split second, I remembered the Jackie Kennedy and Judy Garland incidents and went completely against all my principles about not giving clothes away. "Okay, you can have it if you wear it on May third and tell everyone who designed it for you." "Of course, silly," she answered, and the deal was done.

I had to alter the model dress to her measurements, as it would have been impossible to receive the embroidered fabric from Switzerland in time for the big night in just two weeks.

The workroom virtually took most of the dress apart, and we were fitting it on Elizabeth within days in her large duplex suite at the Hotel Plaza Athénée. It was at that moment that I realized what a perfectionist she was. The dress fit perfectly; we had taken sixty-five measurements and sculpted a dressmaker dummy exactly to her shape. I brought along some extra petals, and the fitter and I began pinning them on where we felt it was necessary. "Here, give some petals to me—you see, you need a black one here and a gray one there and a white one here," she said, placing the odd petals exactly where she wanted them to be for the most flattering effect. We had three more fittings very much in the manner of the first one, right up until the morning of May 3, with Elizabeth "playing" with the petals. I think she was like any great woman; after all, this was her big New York night, and she wanted to feel very secure in what she was wearing.

On the Monday evening of May 3, 1986, I went to the hotel, dressed in my dinner jacket, wearing the ruby-and-diamond studs I had treated myself to just a month before in honor of my thirty years in business. When I arrived in the suite, an old friend was there already, the always tanned George Hamilton, who had come to escort Elizabeth to Lincoln Center. We chatted until Elizabeth came down the stairway, and then we applauded—she looked exquisite! She had on the most startling diamond chandelier earrings, and her enormous diamond ring that Richard Burton had given her. We had some champagne and then left in the limo for the Tavern on the Green, where the dinner took place beforehand.

When we arrived an hour and a half late at the crystal chandelier-decorated restaurant in the middle of Central Park, the mob was enormous. As Elizabeth got out of the car, they went wild—there was an audible appreciative gasp and then much applause and cheering. She moved through the cordoned-off crowd like a queen, waving and smiling, as the paparazzi descended, flashbulbs lighting her way. Seeing me in her entourage, several friends of mine from the press shouted, "Arnold, what a beautiful dress, bravo, bravo!" Through misty eyes, I knew it was one of the most rewarding moments for this Jewish kid from Montreal.

After dinner the ceremony at Avery Fisher Hall was very moving. Over an hour's worth of film clips were shown, depicting Elizabeth's forty years on the silver screen. Some twenty-seven hundred people filled the auditorium, applauding throughout the program.

For several months afterward, Elizabeth Taylor's photo appeared in the Scaasi petal dress in a multitude of publications. Obviously, I was pleased that I had made the gift.

From then on, we designed lots of clothes for Elizabeth; we laughed a lot, and enjoyed working together very much. However, the actress does have one eccentricity—she loves to bargain. Of course, we always ended up working out the price, but I think it's fun for her to do this—just part of the game, so I go along with it. One time, I remember, after going back and forth on the cost of a particular dress she really wanted, she blurted out, "Now, Scaasi, you know, I'm Jewish *too*. So you better give

in!" Miss Taylor had joined the Jewish faith when she married Eddie Fisher in 1959.

The dress in question was a beautiful short black chiffon number that was totally covered in tiny leaves and flowers with diamanté clusters. It had a low V-neck, showing off her *belle poitrine*. She wore it to the Kennedy Center awards with her great friend Franco Zeffirelli in 1987.

Also in 1987, Elizabeth Taylor launched her first perfume: *Passion*. The deep violet cut-glass bottle and stopper was, obviously, a nod to the color of her beautiful eyes. The year the launch happened, the Fragrance Foundation nominated *Passion* for one of their "FiFi" Awards for best new fragrance. Elizabeth needed a dress. She called, and we talked a lot about what it should look like. I had just received some embroidery that I designed in Switzerland, which was white organza with tiny sprigs of violet and green thistle scattered all over. I sent sketches and swatches of the fabric to Beverly Hills. We both agreed that it complemented the violet bottle of the fragrance and was perfect for the awards presentation.

A few weeks later, Elizabeth arrived in New York, and I went to her suite in the Plaza Athénée to fit the dress. It was absolutely great—she was so happy. I had done a princess line–shaped long dress with an off-the-shoulder puffy collar of ruching. Here and there in the collar, I put little violet satin bows, the streamers coming down from underneath the collar to the hipline of the dress, as if the bows had been made and then pulled through the top. The dress had a freshness to it; it was charming. By this time, the silver streaks had been removed from Elizabeth's hair. Her head was a mop of black ringlets and curls, giving her the appearance of a young woman in a Gainsborough painting.

Late in the afternoon of the awards ceremony, the fitter and I brought the dress to the hotel to make sure everything was perfect for the evening. Elizabeth was in a jovial mood. After all, it was almost a certainty that she would win the "FiFi." I asked, "What jewelry are you going to wear tonight?" She answered, excitedly, "Oh, Arnold, I have the most perfect earrings. Wait till you see them." With that, her assistant disappeared, and returned soon after holding a black jewelry

case. Elizabeth took out a pair of loopy-looking amethyst pendant earrings, and said, "Look, Scaasi, aren't these grand!" I said, "Oh, Elizabeth, they're beautiful. Did Van Cleef and Arpels send them over?" (I knew that Van Cleef and Arpels was loaning jewelry to the participants of the show.) "No," she said, solemnly. "Richard gave me these—he had such great taste—he said they matched my eyes." There was a sadness at that moment in her voice that made me realize how much she missed him.

Elizabeth Taylor's *Passion* won the award that night for best new fragrance of the year. Everyone agreed that the star looked lovely.

During the eighties, Elizabeth was doing her press promotions for the fragrance and, also, her wonderful work for amfAR, the American Foundation for AIDS Research that was started by Dr. Mathilde Krim. After Elizabeth found out that her great friend Rock Hudson had AIDS, she traveled, unceasingly, to raise money for AIDS awareness and the critical research that was needed so badly. She raised hundreds of millions of dollars and was always available to help. I designed suits and coat and dress ensembles for many of her travels.

In August 1989, Malcolm Forbes invited about three hundred people to celebrate his seventieth birthday in Tangiers, Morocco. We were all flown over in either Malcolm's private plane or several 747s that had been chartered for the event. It was the most amazing trip. I went with my friend and client the beautiful Gayfryd Steinberg, and we had a wonderful time. Robert and Blaine Trump were there, and the Gettys and Liz Smith and Iris Love and Barbara Walters, Calvin Klein and Diane von Furstenberg, Katharine Graham, who owned the *Washington Post,* and other captains of industry and their wives, and, of course, all the Forbes children and their spouses, and many, many more people whom I can't recall this minute. Elizabeth Taylor was the official hostess.

One day we were having lunch on Malcolm's yacht, and there was Elizabeth in a sheer caftan. We embraced, and I said, "Elizabeth, why haven't I heard from you? We should have done something special for this occasion." She said, "Arnold, look at me. You know—I've put on weight—I will never come to you unless I'm thin. Don't worry, dear, it'll be off Elizabeth soon, and I'll be back to look at the new clothes."

Less than a year later, Miss Taylor arrived in New York. "Elizabeth needs some clothes desperately. Could you please bring up a few things to the hotel?" her assistant Liz asked. Consequently, we arrived at the Plaza Athénée with about twenty dresses. I could hear Elizabeth upstairs in the suite, looking through the clothes—oohing and aahing. Suddenly, there was dead silence. Then she shrieked, "Scaasi, what is this? *I* would never wear this—*this* is for Joan Collins!" With that, she flung the froufrou dress down the stairs. Miss Taylor *could* be wickedly bitchy about other actresses. She has a great sense of humor but at the same time can be cryptic.

I went up the stairs to suggest other things I thought might be right for her, and was struck dumb—there was Elizabeth Taylor, undressed, standing in front of me, in a tiny bra and bikini panties, and she was no more than a model size four! It was awe-inspiring; the last time I had seen the star in Morocco, only seven months before, she was a full size fourteen. I looked for scars from plastic surgery or liposuction, but there were none. She was absolutely perfect.

That day she chose a pale blue diamanté embroidered top gown with a skirt the color of ripe peaches, and two short dresses, one violet chiffon with white dots, and another that was pink with tiny carnations embroidered all over it.

The next time we met, it was time for the launch of Elizabeth Taylor's *White Diamonds* perfume. I sketched a spectacular white satin ball gown with a rhinestone design of arches over the entire dress. I designed a long black velvet cape to go over it—it was fab—and, yes, she won her second "FiFi"!

There were many other wonderful dresses that we made for the great star. A coral and turquoise petunia printed silk short dress with a cape coat in turquoise cashmere was one of my favorites, and the gown of white ribbons that had pale pink silk roses wherever the ribbons crossed all over the dress. She wore it to the Academy Awards, and then I saw her in it again at Barbara Davis's Carousel of Hope Ball.

Elizabeth Taylor has a great sense of style and is intelligent, a lovely, loving person. She is truly a joy to work with because whenever there was something beautiful that she loved, she was exceedingly complimentary—what fun we had!

ELIZABETH TAYLOR

You know, she is the most extraordinary superstar of all time. So that was a marvelous experience for me—that purring voice with the high girlish laughter, and the flirty, sparkling violet eyes. How can anyone resist her?

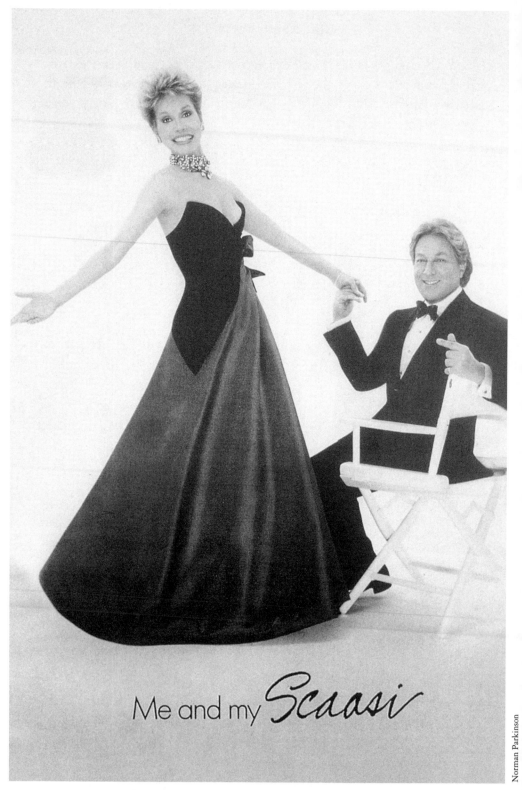

Norman Parkinson

With Mary Tyler Moore in the Me and My Scaasi *ad*

CHAPTER XVI

HOLLYWOOD GIRLS

I'd like to tell you about some of my other "Hollywood Girls." Almost from the time that my career really took off in the late fifties, I have dressed ladies from Hollywood. Sometimes they were society girls like Dominick Dunne's wife, the beautiful, charming Lenny, who had great style. Also Betsy Bloomingdale, and, of course, Fran Stark, the daughter of Fanny Brice, who was very chic and was consistently on the best-dressed lists.

Another client was Barbara Davis, the blond dynamo married to the Hollywood zillionaire Marvin Davis. She has raised hundreds of millions of dollars for the Children's Diabetes Foundation. Mrs. Davis loves pink, and many of her gowns were that color, a great backdrop for her spectacular jewels. If Barbara Davis loved a dress very much she would also order it for her two daughters, Nancy and Patty, with slight changes and maybe in another color. That's what I call a good mother! There is a charming *Me and My Scaasi* ad in which Barbara Davis, in a silvered-rose ball gown, and I are happily dancing.

Mary Tyler Moore and I appear in another *Me and My Scaasi* ad—she in a deep blue satin and velvet strapless gown, looking glamorous. I made lots of clothes for Mary, never for *The Mary Tyler Moore Show,* but for her private life and some of her public appearances. We did glamorous dresses for the actress, who was usually perceived as a typically casual— the all-American girl. One dress of satin and taffeta, combining three unlikely colors—white, pink and green—is short on one side, and dips long on the other. She wore this at a Golden Globe Awards evening and looked great—the next day her picture appeared everywhere. Another

dazzler is a short dress and jacket completely paved in tiny sequins in a colorful flower design on a green background. One of my favorites is the slinky, curvy long brown velvet number with cutouts on the bodice, veiled in see-through brown chiffon done for a special television appearance. Mary and her husband, Dr. Robert Levine, are an inimitable couple who make their home in New York City. Still I think of the ebullient actress as a Hollywood Girl.

I created lots of clothes for the personal wardrobe of Polly Bergen and some dazzling gowns for her very successful nightclub act. I designed many outfits for the screen star Diana Lynn, who became Mrs. Mortimer Hall and moved to a glorious house in New York.

I made great things for Candice Bergen's mother, Frances, in the sixties, and got to know Candice—then at the beginning of her film career. She was absolutely magnetic and looked very much like her charming, glamorous blond mom. Edgar Bergen, the ventriloquist, was the creator of Charlie McCarthy, the puppet he spoke through. Bergen (and Charlie) were an enormous hit in the thirties through the fifties and he was rumored to be very, very wealthy. I always thought it strange that he would telephone me each time Frances ordered something and ask for a discount.

Edgar and Frances's daughter, Candice, wore a few things of mine in the seventies. One dress in particular, I remember, she wore to the Academy Awards when she was a presenter. The outfit was a paisley printed satin crepe full midi-length skirt with the design etched in multicolored sequins. With this, I created a matching large triangular sequined shawl bordered in heavy silk fringe. To complete the outfit, she wore colored suede boots! All very seventies, and she looked terrific—she still does! Candice is truly one of the nicest, civilized people in a tough, sometimes neurotically propelled industry.

Other social types who lived in Hollywood that I designed for included the Honorable Leonore Annenberg, the pretty blond wife of the financier and great philanthropist Walter Annenberg, who was our ambassador to the Court of St. James's. Also Joanna Carson, Johnny's second-to-the-last wife. A beautiful woman, she started out as a client and became a really good friend; Mrs. Bob (Delores) Hope; the Academy Award–winning actress Claire Trevor; and Mrs. Frank (Barbara) Sina-

tra—I did all her clothes for Ronald Reagan's inaugural week and then some.

Let's not forget another Academy Award winner, the vivacious Ginger Rogers. One day, after she was undressed, I began fitting a sheer nude-color chiffon dress covered in glistening clear sequins on Fred Astaire's much admired dance partner when I commented that we had brought the low back of the gown in toward the center to make her back look narrower. Immediately on the defensive, she explained, "Oh, yes, I do have an unusually wide back; it's because of all the tennis I play." I had no idea that great stars like Miss Rogers felt so insecure. At the same fitting, she dance-stepped around the salon, just as she had done in so many hit movies, to show me how well the skirt moved.

The gorgeous Kim Novak arrived at the salon in 1959 and was stunned when I pointed out that she should not wear a particularly high-collar dress because her neck was too short! Though I said it not to be mean but simply to advise her professionally that a V neck might be more flattering—she almost burst into tears. The star kept looking at her neck in the mirror while touching it. She finally left, quite flushed, without placing an order.

We made clothes for the stunning Paulette Goddard, after she moved to her Park Avenue penthouse in New York; some beautiful simple designs to complement the extraordinary jewels she received from her famous husband, Erich Maria Remarque, author of the bestselling classic *All Quiet on the Western Front*. I was eager to meet Miss Goddard, as through the years I had heard stories of her sometimes unusual sexual exploits in Hollywood. Seated next to a studio head at the Mocambo nightclub one evening, she tried desperately to persuade him to give her the lead in an important upcoming film. When he resisted, Paulette supposedly ducked under the cloth-covered table and sexually assaulted him. The smile on the mogul's face made it clear he was more than satisfied. The next day the young starlet was screen-tested and got the role!

From the stories one hears, it's obvious that the heyday of Hollywood was like ancient Babylon—a veritable sin-city compared to what it is today—a multitude of gyms and health-oriented young stars.

Known as a sex symbol in the twenties, Gloria Swanson was the notorious mistress of Joseph P. Kennedy, father of the United States pres-

ident. We designed black chiffon outfits (her favorite look) for the ex–silent film star, who had a triumphant comeback in Billy Wilder's film *Sunset Boulevard*. We would go to nightclubs together. She was always mobbed by autograph fans, the film was such a sensation. Swanson was tiny but came across bigger than life on screen. She was great fun and reveled in her success. She was nominated for an Academy Award for that role and probably should have won—unfortunately, she never did another film to equal that spellbinding performance.

When I first met Arlene Francis, she was not a Hollywood Girl, but she had been one before, first starring in the film *Murders in the Rue Morgue* in 1932. She appeared in several other movies, including *Stage Door Canteen* in 1943 and *One, Two, Three* in 1961, opposite Jimmy Cagney, for which I did her wardrobe. Miss Francis wanted a specific look and asked me to design her clothes for the film, which would be shot in California. However, she wanted the clothes fitted in New York. It worked out very well; I could use my own workrooms, and I didn't have to go to the West Coast.

This was not the norm; a New York dress designer seldom created clothes for a film or stage play. The clothes were almost always designed by a professional *costume designer* who did all the clothes for the entire production. For decades in Hollywood, every major studio had its own workrooms and its own celebrated designers. Adrian reigned supreme at MGM doing gorgeous clothes for such films as *The Women, Ziegfeld Girl,* and all of Greta Garbo's epics. I think he was the most creative in this field. Edith Head was the design queen at Twentieth Century Fox and Paramount Studios. She was a great favorite of Bette Davis (*All About Eve*), Elizabeth Taylor (*A Place in the Sun*), and also Grace Kelly (*To Catch a Thief*). Irene (who was successful enough to be known by one name only, like Adrian) was very popular, designing for most of Claudette Colbert's and Barbara Stanwyck's films. Another favorite was Jean Louis, who worked for Columbia Pictures. He created the famous "Put the Blame on Mame," sexy black dress Rita Hayworth wore in *Gilda*, and the see-through nude gowns for Marlene Dietrich's nightclub act. Travis Banton did all of Dietrich's clothes for her early films (*Shanghai Express* and *Destry Rides Again*). Like me, he loved feathers and used them constantly. Also, he did fantastic clothes for Mae West, as did the wild, cre-

ative French couturier Elsa Schiaparelli. For big musicals with a lot of dancing, Irene Sharaff (who used both her names) was usually brought in. With her long experience for designing costumes for several ballet companies across the world, she knew better than anyone how a costume should move. There were many others: Howard Shoup and Helen Rose were excellent, both working at many studios, as was Walter Plunkett, who designed the marvelous costumes for *Gone With the Wind.*

This all changed during the sixties, when most studios could no longer afford to keep their workrooms and high-salaried head designers working year-round. For modern-day movies, a trend began in which a secondary designer would shop for the clothes in stores, present them to the director, and usually to the star, and then buy them at the wholesale cost or less. This did not make the most creative costuming for films or plays, but it did save millions of dollars for the studios and Broadway producers.

If the star was big enough, requesting a special New York designer was no problem. From the beginning of my career, I turned out to be one of those lucky designers. It sure made work extremely fulfilling and much more fun!

Though Sophia Loren was not a Hollywood Girl when I first met her, she became one a few years later. I had opened my own business in May 1956, and I was designing luxurious ready-to-wear that no one else was doing, excepting for maybe Norman Norell, who did very sharp, sophisticated graphic clothes; I did wild, colorful, very feminine things.

Late in 1957, my publicist phoned to say that Carlo Ponti, Sophia Loren's future husband, wanted to bring the Italian star to see the collection for a photo shoot for *Vogue.* Of course, I was very excited, as Sophia had been an instant success in her first film and was considered very beautiful—everyone wanted to dress her.

I had seen only headshots of the couple in magazines, so I was very surprised to find that Ponti was a short little man with gray hair and Sophia a tall, statuesque young girl with a head of dark curls. They were both charming in an Italian way, and it was obvious that the actress was very young (in her early twenties), not very sophisticated, but very enthusiastic and full of fun. When she got undressed, I saw that she had a big bosom, very small waist, and really big hips—she had the most beautiful face,

full of expression, with large flashing eyes. You liked her immediately for her honest approach and very un-American film-star, naïve quality.

She loved the clothes, but because of her hips we had to choose things with full skirts, which was fine, as that was the fashion in the fifties. We decided on a red-butterfly warp-printed taffeta short evening dress that was draped off the shoulders and fell into "wings" down the back. The skirt was full and bouncy, and she looked great in it. Also for the photo we did a navy blue damask short dress with a very full skirt, starting from a low hip yoke. The dress had long sleeves and a low-scooped décolleté. She looked gorgeous in it, and it made a beautiful picture.

She wore quite a few things of mine in that period, and many pictures of her in fabulous furs I designed appeared in *Life* magazine.

We would see each other now and then through the years, but though she always smiled and said hello, I never thought she really recognized me. Then in 1998, I was invited with my pals, Liz Smith and Parker Ladd, to *Time* magazine's seventy-fifth anniversary party at Radio City Music Hall. It was spectacular! They had taken out all the seats, and the theater was turned into a grand dining hall with about a hundred tables set for ten people each. At a long head table near the stage was Sophia Loren. She was seated next to Mikhail Gorbachev, who supposedly spoke no English. I realized she was in an awkward position.

I remembered our first meeting, almost forty years before, and decided to go up and speak directly to the legendary actress. After I pushed through the crowded hall and approached, I knelt beside her. She looked at me quizzically for a moment, and I said, "Hi, I'm Arnold Scaasi, and I did some clothes for you many years ago." She smiled and said, "Of course, I remember, a beautiful dark damask dress, and all those furs. How are you?" Well, so she did remember! We chatted for a moment about her life and her son, who was sitting on the other side of her. She asked a lot about what I was doing all these years later. She said, "It's lovely seeing you again, and please be sure and call me if you ever come to Santa Barbara." She gave me her phone number. I was floored by her charm and great beauty—she had remained a really nice human being.

Returning to my table, I thought I had died and gone to heaven! How lucky I am to have the talent for designing clothes that beautiful women like. I left the hall fairly floating, and though there were many celebri-

ties there that night, the only one that mattered for me was the beautiful Sophia.

In the late fifties, when every-thing seemed to be happening to me, and I was up to my eyeballs in work, my publicity agent Muriel Maxwell called and asked," Do you have time to design something for Marilyn Monroe?" "Are you kidding?" I answered. "Of course I do. She's the greatest. I just saw *Some Like It Hot*—she was fabulous, Muriel. I think she should get an Acad-emy Award. I'd love to do some-thing for her."

"Well, she needs a very sexy gown to wear to this Christmas party she's giving," Muriel con-

tinued. "She is going to be photographed, and has nothing to wear. Now you know she's quite small but she has this big bust—what do you have?"

As it happened, I had a new dress that was very slinky in pale flesh-colored satin crepe, draped up the front, with a slight train in the back and a very low sweetheart neckline. It was sprinkled all over with tiny rhinestones and had two rhinestone straps to hold it up! "Well, you'll have to bring it over to her today, as the party is tomorrow night."

I had last seen Monroe appear at one of Eleanor Lambert's fashion shows at the Waldorf-Astoria Hotel—I'll never forget it! She didn't say a word, just smiled and waved from the stage, and the crowd went wild.

Marilyn Monroe had a New York apartment at Two Sutton Place with an entrance on East Fifty-seventh Street. When I arrived, the doorman let me in and I went upstairs. The door to her apartment was ajar. I rang the bell and then heard that unmistakable whispery voice, "Please come in." I entered a sparsely decorated room that was filled with vases of flow-

ers. I was shocked to see all the windows were open and it was freezing! It was thirty degrees outside, and Fifty-seventh Street near the East River being particularly windy made it seem even colder. Her hair was tousled and she had on no makeup, but she looked beautiful—soft and natural, almost childlike. She was wearing a fake fur "teddy bear" overcoat! I said, "Miss Monroe, aren't you cold up here? Why do you have all the windows open? It's freezing. Can I shut some of them for you? You'll catch a terrible cold."

"Oh, no, no, no, Mr. Scaasi," she said, with her breath almost visible. "All the flowers will die and they have to be beautiful for tomorrow night." I was amazed, but she was adamant.

I kept my topcoat on and unzipped the garment bag the gown was in. "Oh, it's beautiful," she exclaimed. "May I try it on later when the maid comes back?" "Absolutely," I said, looking forward to getting back to the warm limo waiting downstairs. I took one last look at this amazing woman, this talented original movie icon, and left the apartment in a daze.

The gown came back two days later with a big bouquet of flowers, obviously left over from the party, accompanied by a thank-you note. I never knew whether she wore the dress or not. There were no photos in the papers, and I couldn't find anyone who had seen her in it. Being as mercurial as she was, perhaps the party never happened. It didn't matter really, I was a great fan and happy to have just seen her again in the flesh—and what *great* flesh!

Ironically, I had heard while discussing Oscar clothes with some Hollywood stylists, that Renée Zellweger was looking for a Marilyn Monroe–type gown to wear at the 2003 Academy Awards ceremony. Evidently, she's a great fan of the fabulous Marilyn. Renée was a smash in the film production of the stage hit *Chicago* and was nominated in the Best Actress category. Already in the same year, she had won a Golden Globe Award for Best Actress in a musical, so everyone was rooting for her to receive the Oscar. I had met the actress earlier at a noisy event in New York and was charmed by her down-to-earth bright demeanor. She is terribly pretty and does have a "Marilyn" quality. Consequently, we sent a few things to her agent on the coast; one of the dresses being almost identical to the dress I had left with Monroe all those years ago. It's always interesting to me that young actresses today

have such an affinity for many of the stars that came before them—Renée Zellweger could certainly be our next Marilyn Monroe!

Patrice Munsel was one of the first modern-day opera divas appearing on the stage of the Metropolitan Opera House. She was model size, the total opposite of the stereotypic idea of an opera star with the usual mammoth proportions. She also did Hollywood films, but really hit her stride with *The Patrice Munsel Show* on television in the late fifties. She was something people had never seen before—sleek, beautiful, and with a superlative operatic voice. I designed all her clothes for the weekly variety extravaganza. Though she had a wonderful sense of humor, which came across on the small screen, the main thrust was on how glamorous she looked. We made some amazing clothes for her, sexy, exciting showstoppers—about six outfits for every show—the Scaasi workrooms were kept very busy!

From the sixties on, I designed personal wardrobes for the adorable

Natalie Wood. She was not only pretty and bright, but also a very good actress. She loved dressing up, and I did clothes for her to wear in Europe and also for her personal appearances at premieres and press parties. One dress we made of black tulle with little black taffeta bows scattered all over it was very short and bare—she said it was "the sexiest dress ever!" She had been nominated three times for the Academy Award, and I think she was just coming into her own at her untimely death in 1981.

In the mid-1970s, I designed all the clothes for Shirley MacLaine, Susan Sarandon, James Coburn, Stephen Collins, and Sally Kellerman in *Loving Couples,* a film about doctors and their escapades in and around Beverly Hills. It was fun to do, though the budget was smaller than *On a Clear Day You*

Natalie Wood

Can See Forever. The ensemble cast was interesting and I learned a lot about the machinations of the movie world—and about the Hollywood drug culture!

Of course, coming from the big city New York, I knew that drugs existed, certainly at Studio 54 and many other clubs around town. However, I am a social drinker, and have enjoyed the taste and sociability of drinking with friends since I was a teenager at my uncle Sam Wynn's vineyards in Australia. Therefore, I never went in for drugs. After Australia, there were boilermakers (Canadian whiskey shots with a cold beer chaser) in Montreal; next, a lovely green Pernod or sparkling champagne on school nights in Paris; later, very dry gin martinis with olives in New York at the then semi-gay, sophisticated Oak Room bar in the Plaza Hotel, often frequented by semi-straight men still in the closet! Now I'm into the oh-so-cool vodka Cosmopolitan—I tell you this to explain why I never did drugs.

When I arrived in Hollywood to work on *Loving Couples,* some dear friends invited me to stay at their charming house in the Hollywood Hills. The first morning while I was dressing to go to the studio for my initial meeting, my host said, "What are you taking this morning to pep you up?"

"Well, I'd love some toast with my orange juice and coffee, but that's it. My car will be here any minute."

"No, no," he said, "you can't go to your meeting without taking an upper—everyone there will be on something and they'll take complete advantage of you. Let me give you a *small* pill—and what's with the tie and jacket? You're in Hollywood now—you better get with it!"

"Sorry, I'm from New York and this is how we dress. Besides, I've never had to take speed to get me through a meeting."

At that moment, the doorbell chimed and my driver was there to take me to the studio. Off I went, leaving my chums dumbfounded. By the way, I had a very good meeting and continued to have them, undrugged, all through the filming.

I had seen cocaine and marijuana passed around at big Hollywood parties as if they were hors d'oeuvres, but *I* just kept sipping my cool champagne. One night I was with about a hundred people at Rock Hudson's beautiful home. The house was full of wonderful antiques, and a band was

playing out by the pool. Hudson was charming, the party was smashing, and the sweet fragrance of pot permeated the air—it seemed as though many Hollywood people couldn't get through the extraordinarily difficult sixties and seventies without a little help. It was a totally different time from the family-oriented peaceful fifties.

As the film got under way, I'd stay in Hollywood for maybe ten days at a time and I went out on the town quite a bit. One evening, I was taken to Peter Sellers's amazing estate—just like a movie set. A big party for about two hundred was in full swing. The men were mostly casually dressed; you could spot the New York bigwigs wearing suits and ties. The women, on the other hand, had made a great effort and there were some beautiful dresses on some really beautiful girls—I counted at least six Scaasi outfits in the crowd, so I was happy. Once again, the silver bowls on silver trays with little silver spoons were passed containing the expensive white powder—my pals were shocked that I wouldn't take any.

Maybe I'm old-fashioned, but what Dorothy Parker wrote all those years ago seems to apply perfectly—"Candy's dandy, but liquor's quicker!" The old girl certainly knew what she was saying.

Through all the years, the two Hollywood Girls that I remain close friends with are Diahann Carroll, who, dressed or undressed, is one of the most beautiful women I've ever met, and a lovely Hungarian blonde, the vivacious Mitzi Gaynor. Both of these women became my good friends and though completely different from each other, they both possess an intelligence and integrity that does not come along too frequently in Hollywood.

I first saw Diahann Carroll in Truman Capote's *House of Flowers* in 1954. Though the musical was mainly dominated by Pearl Bailey, the very young Miss Carroll stood out, singing the Harold Arlen song "A Sleepin' Bee" in a sweet yet strong voice. The role was not a particularly big one, but it did bring the actress in front of an important New York audience, and she received fine reviews.

Later, I learned that the composer Richard Rodgers had also seen Diahann in *House of Flowers* and was so impressed with her talents and beauty that he decided he had to do a musical especially for her. The show was *No Strings,* and it was the story of a beautiful black fashion model in Paris who falls in love with a white American journalist. The theme was

unusual for Broadway at that time, and I don't believe it had been tackled in quite this way before.

In 1961 I had already left the Stanford White house on Fifty-sixth Street and moved down to 550 Seventh Avenue, the toniest building for ready-to-wear businesses. I had found that though the house was very beautiful, working on the first three floors and living on the top two floors, I just never got away from the business. The head of my sales department, Virginia, said that the new salon was "just perfect, as we will do much better ready-to-wear business downtown than we did uptown."

Fortunately, I discovered a wonderful small duplex apartment on Central Park South with windows that went right up to the top of the twenty-two-foot-high ceiling of the living room and afforded me the most spectacular views of Central Park.

Of course, my private clients for whom I did special clothes came to 550 Seventh Avenue. Valerian Rybar had decorated the showroom with all the furniture, sconces, and silk that the uptown salon had, and once people stepped off the elevators, you could not tell the difference. Arlene Francis, the Gabors and Lucille Ball, Nanette Fabray, Joan Sutherland, and Lady Sarah Spencer-Churchill and her daughter Serena, and every other private client I dressed loved coming to Seventh Avenue. I think everyone thought they would get clothes wholesale! Of course, this was true of the ready-to-wear, but never for the clothes we made to order.

Late in 1961, I received a call from Diahann Carroll's agent, saying the she would like to come in and see the collection. I was very excited, and had hopes that she would ask me to do her clothes for *No Strings*.

When she arrived, Virginia greeted her and then came back to me and said, "Did you know she's colored?" I said, "Of course I do—so what? She's very beautiful." And with that, I went through the door to greet Miss Carroll.

She was dressed in an elegant dark gray suit and was sitting very primly on one of the fake French chairs. At first, I thought she was a little shy, but soon we were talking a mile a minute, having a great time. I showed her a lot of beautiful clothes, and she said she hoped I would do her costumes for the musical. I was delighted!

We said good-bye, and I walked to the back room to tell Virginia the good news. She immediately said, "Of course, you can't do it." I was

stunned, and asked her why. She answered, "We run a ready-to-wear business, and if you do the clothes for a black actress, all of our southern stores will stop buying from us." I told her that didn't make sense, that Diahann was talented and beautiful, but to no avail. She just went on and on about the southern stores, of which we had many, and if we lost them she would have to resign her position as head of sales. Well, I was furious. We were in the middle of a season, so I was sort of stuck. After the civil rights movement, Seventh Avenue stopped worrying about the "southern stores"—thank God!

In the end, it turned out all right, because Richard Rodgers had been approached by Donald Brooks, a well-known Seventh Avenue sportswear designer, and had decided "he should do Diahann's clothes to keep them within the show's budget," Mr. Rodgers told me. Donald did a great job, and went on to be a very successful stage and film costume designer. Miss Carroll looked lovely—still, I was really very disappointed.

In 1962 I created something revolutionary: a white brass-buttoned, double-breasted gabardine suit with a short skirt; the jacket was very shaped and tightly fitted in a time of loose-fitting clothes. Diahann loved it and wore it to Arthur and Dr. Mathilde Krim's house the famous night that Marilyn Monroe sang "Happy Birthday, Mr. President" to President Kennedy. He was there when Diahann walked in wearing the curvy suit with a white headband; she looked stunning, and the president was noticeably dazzled.

Years later, Dr. Mathilde Krim would become the founder of amfAR (American Foundation for Aids Research) helping to save millions of lives. Elizabeth Taylor was originally the spokesperson for amfAR, but afterward, Madonna took over. One night at a cocktail fund-raiser, I met the pop diva. I found her very much like Streisand at the beginning of her career, a little shy. She said, "I adore your clothes and Mathilde has told me so much about you. Can I come in to your shop?" We talked a lot and I found her charming and really pretty—more real than she appears in her sex-driven music videos.

After *No Strings* opened, Diahann and I became good friends, and I continued to make clothes for her privately, as well as gala things for her concert tours. She has the best taste and always chooses clothes that are elegant and suit her beauty and intellectual personality. Sometimes,

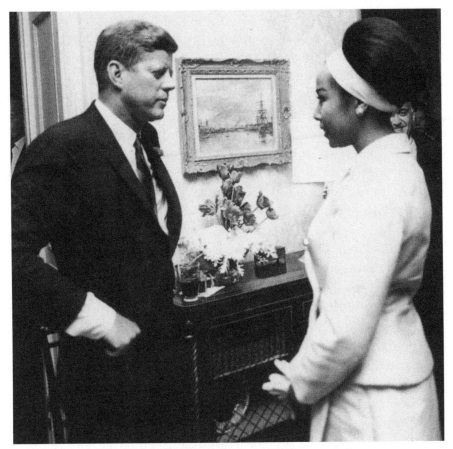

President Kennedy dazzled by Diahann, 1962

though, we did go wild. In 1967, I did a wonderful beaded feather dress for her to wear to the Academy Awards; she looked delicious.

In 1984 Diahann was to appear at the Golden Globe Awards, singing the beautiful love song from Streisand's hit movie *Yentl*. She telephoned me, "Arnold, what on earth am I going to wear? Everyone looks the same in those skinny beaded dresses with their boobs hanging out or those ridiculous huge padded-shoulder outfits. I'm desperate. Please think of something, and remember, I don't want to wear black!" I went to the models' room and reviewed the collection hanging in front of me. One of my talents throughout my career has been being able to choose clothes that absolutely complement and intensify the personality of

the wearer. But here we had a major problem. The dress had to be different yet elegant, and look great on camera before an enormous television audience. Suddenly, I spotted the taupe satin ball gown with a high-waisted navy blue satin strapless bodice. A stole of navy satin lined in brilliant purple went with the dress. I knew at once that the colors would look divine on the *divine* Miss Carroll.

Diahann was in New York, and I telephoned her and said, "Come over quickly. I have a great idea." When she arrived, I showed her the full-skirted taupe satin ball gown.

"Oh, my, do you really think that would work? I love it," she said, giggling like a kid, "but how will it look on me, and how will it look on camera?"

"Great," I said. "Try it on." She went into the fitting room and reappeared in the dress with the navy satin stole, showing a wide cuff of purple around her shoulders—it was perfect for her!

The night of the Golden Globes was truly a night Diahann would remember always. She looked fabulous, and totally different from anyone else on the show. After her song, there was great applause. She left the stage triumphant! She was in such a joyful mood that she decided to *crash* Aaron Spelling's gala party at his huge Hollywood estate. Spelling, the producer of the hit television show *Dynasty,* approached her. "Diahann, welcome, welcome. You're just gorgeous—*unbelievable!* I'd like to put you into *Dynasty.*" The actress laughed. "Great, then I'll be the *first black bitch* on television!" She telephoned me late that night to tell me the news, "Can you believe it?" she said. "And it's all because you made me wear that bloody beautiful dress. Thank you, darling. I love you." Diahann remained on the successful TV series, always out-bitching the very bitchy Joan Collins.

I was so happy for her when she became engaged to the world-renowned television interviewer David Frost. We did a great trousseau, which included a gray flannel pantsuit that had a three-quarter coat with a huge collar of Russian sable. The coat was also lined in sable—it looked smashing on her when she flew to London with the resilient, *now* Sir David.

For the wedding, we copied a short dress I had done for her in black satin crepe. It was finely pleated and spiraled around the body like a fan. We made it in a beautiful shade of peach.

Later, she cancelled the wedding to Frost. Some months afterward, she called me and said, "Now, Arnold, I want you to be perfectly frank with me. I've decided to get married again," she announced with a sigh, "and I want to know if you think it would bring me bad luck if I was to wear the peach pleated crepe dress for *this* wedding?" I said I thought it would be fine, as the dress had already brought her good luck by not letting her marry someone she had decided against before, now I thought it would be lucky for her to wear it to the *right* wedding.

She wore the dress and stayed very happily married, until sadly her husband was in a fatal car crash—so who knows what's lucky? She is still my dear friend, and I love her just the way she is—a beautiful, witty, intelligent, complicated woman!

Mitzi Gaynor and I met in the most amusing way. It was 1958, and I was doing a big charity fashion show in the convention hall in Las Vegas. I had just arrived in the hall, and all the fashion-show planners and owners from the stores that were sponsoring the show were greeting me. Everyone was talking at once and being very complimentary about the clothes. I had just won my Coty award and opened the Stanford White house in New York, and life was really great and exciting!

Suddenly, someone called "Here comes Mitzi!" and pointed to the ceiling of this enormous rotunda, and way up there was this beautiful blond girl. She came sliding down diagonally across the whole width of the hall on a high wire in a pink chiffon dress of mine—floating through the air, and landing right in front of me!

"Hi, I'm Mitzi Gaynor," she said in that lilting voice of hers—what an entrance, I was dumbfounded. I just stood there laughing and hugging her, and we became great friends forever. As it happened, Mitzi had been to the grand black-tie opening of my 1958 fall collection in the Stanford White house. She evidently swooned at the beauty of the clothes. She told me afterward, "I had never seen clothes like that before, and I wanted everything in the collection, especially the spectacular gray chiffon shirt worn with the Norwegian blue fox chaps." These were gray silk pants that were very wide at the hem with two full strips of blue fox going down the sides inspired by cowboy chaps. The outfit was indeed spectacular and was photographed a great deal by the press.

I have made many beautiful clothes for Mitzi Gaynor through the

years, some really wonderful things that were the epitome of the sixties. Included is a brown, gray, and black printed gold brocade mini coat bordered in sable, with a matching short dress. Then there was the red matte sequin mini dress that had a sleeveless knee-length vest of ostrich feathers that started in bright red at the neckline and went through the spectrum to orange feathers at the hem. We did a lot of coats and suits for her. It has always surprised me how Hollywood movie stars who are dressed in so much glitz throughout their careers come to my salon and order the most elegant clothes that my New York society ladies also choose.

In 1966 Mitzi was asked by the Motion Picture Academy to perform the Oscar-nominated song "Georgy Girl" at the Academy Awards ceremony. It was a great honor to be asked, since she would appear before millions of people on worldwide television. Mitzi Gaynor was at the top of her career. She had received wonderful reviews for *Les Girls* with Gene Kelly, and also for her portrayal of Nellie Forbush in the movie version of *South Pacific*. She wanted an outstanding dress to wear to the academy ball after the Oscars were televised. At that time, the ball was the most prestigious post-Oscar party you could be invited to. We picked a dress from the collection that was made of transparent nude tulle. It had a high halter-front neckline and then fell to the hemline just above the knees. The dress then swooped to the floor in the back, creating a wonderful effect when she moved. Over this was a matching transparent cape that followed the hemline of the gown. The ensemble was covered in shimmering embroidery of iridescent sequins in the shape of tiny shells and scattered rhinestones done in a very airy, open fireworks-spray effect. She looked dazzling, and the crowd applauded when she came into the ballroom—her performance onstage had been superlative.

Mitzi Gaynor is one of the most energetic and prolific entertainers I've ever met. When she was not doing a film, she would tour with her own variety show—*The Mitzi Gaynor Show*. For this extravaganza, she traveled with eight male dancers, and all the lead players to complement a full orchestra. The show was produced by her charming longtime husband, Jack Bean. Jack is a wonderful guy with a very good head for business. There were about eight or ten production numbers in her show in which Mitzi sang and danced through the entire length of the mini-

musical. She has toured successfully in nightclubs and theaters for several decades, as well as starring in her own TV specials.

Whenever the couple comes to New York, Parker and I love to see them. One night, some years ago, Jerry Zipkin, "the social moth," gave a dinner party for the Beans at the Côte Basque restaurant for about twenty friends. We were seated facing the guest of honor, which gave us a wonderful opportunity to chat and catch up. Mitzi was wearing a chic, very New York Scaasi black suit, and on her left shoulder a huge diamond pin, which measured about two inches in diameter. Staring, I said, "Mitzi, your pin is fabulous, how did you get *that?*" She looked straight at me and smiled mischievously. "Fucking!" In all the years I've known her, I had never heard this all-American girl next door use the "F-word." "Really?" I said. "Where, when, tell us."

"Well, when I first came to Hollywood in the early fifties, everyone knew that Howard Hughes had taken a great shine to me, it was in all the columns—I was very young and my mother was most upset. Howard squired me around a lot to all the in places in town. One night, around midnight, when he was taking me home, the gray Rolls-Royce stopped in front of Cartier, and Howard said 'Come on, let's go window-shopping.' As we arrived at the shop's front door, suddenly all the lights inside went on. I was speechless! We went in and he said, 'Now, Mitzi, just walk around and pick out something pretty for yourself.' I picked out this beautiful *big* diamond pin. Hey, whoever said Mitzi Gaynor was a dumb blonde?" We laughed a lot, and Parker and I adored her even more for her wonderful candor.

Howard Hughes always had a string of starlets around him, usually romancing four at a time. A handsome, eccentric billionaire, he formed his own aircraft corporation and owned Trans World Airways. He was a perspicacious film producer and eventually gained control of RKO Studios.

Mitzi and her husband of many, many moons live in a lovely house in Beverly Hills. It has a splendid garden that one can see from her kitchen. Oh, yes, I forgot to say that this extraordinarily talented, beautiful woman is also a great cook and thinks nothing of turning out a delicious Hungarian goulash for all her pals on a moment's notice. Is it any wonder Mitzi Gaynor has remained one of my *most favorite* Hollywood Girls?

*With First Lady Barbara Bush on our way
to the New York Public Library* Literary Lions Gala, *1990*

BARBARA BUSH

Much to my surprise, late in 1986, a very formal invitation arrived with the presidential gold seal atop, asking me to attend a state dinner at the Reagan White House. The guest of honor was the president of Iceland. I couldn't imagine why I had been included on this particular evening, as I had previously never been a guest during the Reagan administration. Nancy Reagan's favorite designer was, of course, Jimmy Galanos, and I don't believe many other designers were invited to the White House during the Reagan's time there. The only reason I could imagine I had been asked to attend this particular dinner was because very often the name Scaasi, having two *a*'s, is considered Scandinavian. I thought they believed my background is Scandinavian and I was invited to honor my countryman! I accepted with pleasure, as I was curious to see what Mrs. Reagan had done to this wonderful historic place.

Well, I got out my best tuxedo and went off to Washington. I arrived at the White House; all the pomp that went on was absolutely extraordinary. I got out of my car under the portico of the West Wing, and then went up the stairs where I was greeted by an intern in a dashing militaryish uniform who led me along the hallways, hung with portraits of past presidents and first ladies, to the East Room where a reception was being held. Before entering, I gave my name to another uniformed man and he announced loudly to the throng—"Mr. Arnold Scaasi"—then I went in and joined a gathering of about one hundred people. Champagne and hors d'oeuvres were passed. There was then an announcement that President and Mrs. Reagan were arriving. The Marine Band played

"Hail to the Chief" and everybody stood looking toward the East Room entrance. Suddenly, there they were, the president of the United States, the first lady, and their state guests. It was very impressive. We all fell into an informal line and moved toward the Reagans and their distinguished guests from Iceland. On this particular night, Mrs. Reagan was dressed in a beautiful red-crepe long evening dress. She was professionally made up and coiffed. Wearing a sparkling diamond necklace, earrings, and an impressive diamond ring—she looked very stylish, indeed. I had never met the first lady before and I was aware of how quiet her voice was and how warmly she greeted me. She did not seem at all like the tough lady the press wrote about.

It was wonderful for me. Though I'd been to the White House before, it was the first time I had been to a state dinner, and I was very impressed and almost giddy with the idea that I was really there for this most festive evening, which was so beautifully presented. There was a great mix of people—all famous in their own walks of life and fascinating to watch and be a part of.

When we went into the State Dining Room, I was seated at Maureen Reagan's table next to that of Nancy Reagan—I realized I had a very good *placement*. Maureen, the vivacious, extremely bright daughter of Ronald Reagan and the actress Jane Wyman, was charming and very animated. The State Dining Room is wonderfully decorated and Nancy Reagan was known to be a great hostess. The flowers were glorious and, of course, the silver and glassware and the glittering crowd made this truly a moment to remember. The food was beautifully presented and tasted even better. Björn Borg, the famous Scandinavian tennis player, was seated one guest away from me and we had a lot of fun talking about Sweden (where I had visited) and the new clothing business he was starting in his homeland.

After dinner, as we were leaving the dining room to go into the Blue Room for coffee and liqueurs with the president and the first lady, I literally bumped into the vice president's wife, Barbara Bush. That was our first meeting and the beginning of what has become a very long and happy association. Mrs. Bush has a wonderful look and great presence—she is tall and her white, fluffy hair and smile make her appear very special. That evening she stood out from the crowd. She was wearing a

kind of flowing caftan of printed chiffon and I remember wondering why she covered herself up so much when she was really lovely looking. As we walked on, side by side, I said, "Mrs. Bush, I'm Arnold Scaasi and, you know, many of our mutual friends think I should be doing clothes for you." She laughed and said, "Well, then you better tell me how I can get hold of you to see your collection." So, not being shy, I took out my card and said, "Please, won't you call me and we'll make an appointment." Of course, I never expected to hear from her, because I really felt that if she wanted me to do her clothes she would have called me before.

Still, about two weeks later, my secretary came in and said, "The vice president's wife is on the phone." We made an appointment to meet one morning at my salon on Fifth Avenue. I was very excited about this meeting because there had been persistent rumors that George Bush would run for the presidency after Reagan's last term and there was a good possibility that he would be elected. As I rode across town in my taxi, I realized that I might very well be meeting with and making clothes for the next first lady of the United States.

Naturally, I was more than a little nervous; traffic was terribly heavy and I didn't want to be late for our first meeting.

By the time I arrived, I knew Barbara Bush was there. There were three sedan cars and lots of Secret Service men standing around. After going up in the elevator, I found another Secret Service man in the foyer outside of my salon. I walked in, apologized profusely to Mrs. Bush, and said, "You know, I couldn't believe how much traffic there was this morning, I'm so sorry to be late." She said, "You're right. There was a lot of traffic. But, you know—*we* have a siren!" We both laughed; it gave me an insight into her character and strength. Of course they had a siren, and, wanting to get to the appointment on time, if necessary they would use it. I knew, there and then, this lady was very self-assured with a great sense of humor, and I liked her for it.

We began to show her the collection and I brought out clothes that I thought she would look nice in. I realized quite quickly that Barbara Bush liked pretty clothes and that, even though she mainly dressed to cover herself up, underneath all that was someone who, like most women, loved looking attractive. She began to try things on and, of course, the clothes didn't fit very well, being model size. Still, Mrs. Bush

chose three dresses; one, a long black dress, one in purple, and one in blue.

After deciding on the first dresses, we began to take measurements. When she got undressed, I saw that she was wearing a full slip. This was very rare, because by the eighties most of my clients didn't wear any slip! I thought, That's sort of a nice old-fashioned touch. We took the measurements and I was surprised to find Mrs. Bush was not overweight and not really large-large, that she was quite well proportioned. She was about five feet eight and her size was somewhere between a twelve and a fourteen, whereas in photographs she always looked like a good size sixteen. I realized it was just that her clothes were not being fitted properly, that she was simply wearing loose clothes off the rack and that we could make her look a great deal better. We could flatter her figure and make her look trimmer and more modern.

At the time, I felt she dressed in a rather dowdy, old-lady way. But she was not an old lady and she had great flair and a wonderful personality that good clothes would enhance. Her look before 1987, I'm sure, originated from earlier years, maybe even from the time she and the vice president were in China. My main concern was to get her out of those boring clothes and into some that were pretty and glamorous, that showed her off to her best advantage.

So we began. The next time she came in for a fitting, I showed her more glamorous, distinguished clothes, and she liked them very much. By this time, George Bush was running for president and he had a very good chance of winning against Mr. Dukakis. Also, of course, everyone loved Barbara Bush. She was one of the most admired women in America—direct, intelligent, and with a great sense of humor about herself. She was indeed a super asset to her husband. So I had to think about dressing her as an important public figure because, even though she had been the vice president's wife, there was no way she had been seen as much as she would be if George Bush was elected.

It was around this time that I began to show her dresses that in the back of my mind I thought might be candidates for her inaugural ball gown—probably the most widely photographed dress during the post-election year. One was the blue satin and velvet dress that Barbara did finally wear. I found she was superstitious—still is to this day—and

would not choose a dress until her husband had actually won. So we were sort of on tenterhooks about that particular gown. However, she did choose many other evening clothes. There was a white satin-topped dress that was covered in a design of brilliants with a long black satin skirt. Very chic, very elegant. It looked beautiful with her white hair. There was a marvelous red-and-black cut-velvet top that I put with a side-draped A-line white satin skirt that looked wonderful on her. She chose all kinds of clothes, including a hot pink chiffon gown with a top all beaded with stones and pearls. She loved them all. She picked very, very glamorous clothes totally different from those I had seen her wearing in her role as the wife of the vice president.

Also at that time, I had a great ally in Laurie Firestone, who was Mrs. Bush's social secretary and a good friend. She's a wonderful, vivacious woman, a good-looking petite blonde who is extremely bright and loves pretty clothes. It made her especially happy that Barbara was getting dressed up—she was very loyal to Mrs. Bush and wanted me to do really fashionable clothes for her.

It's an interesting bit that Barbara Bush chose the blue satin and velvet dress as *one* of the evening dresses she would wear during inauguration week. Even though the gown looked smashing on her, I was slightly worried—I knew of three other women who had bought the dress and worn it already. One of them was the venerable Brooke Astor. Another was Mrs. William Hearst Jr., who lived in San Francisco. So I thought, My God, what are we going to do if Barbara decides to wear this to the Inaugural Ball? However, as she would not tell me what she *was* going to wear to the balls and didn't want anyone else to know, we were in the dark. She would not let us release sketches of any of the dresses; I don't believe even Laurie Firestone knew what she would wear and when. So we were a bit anxious the whole time, waiting to see what her choice would be. I thought, when that time comes around, if it is the blue dress, I'll just have to decide what to do about the others. We went on that way for quite a while until, finally, about ten days before the inaugural balls, I was having lunch at the vice president's house with Barbara and Laurie.

"You know, we have a terrible problem," I announced. "The press is calling every day, asking which dress you're going to wear to the Inaugural Ball. Barbara, dear, I really feel kind of stupid, because, after all,

we're not kids and I think we really have to say which dress you've decided on and let them do a story about it."

In her usual intelligent way, she looked at me and then at Laurie, and said, "I guess Arnold is right. I will have to tell them but it's really such fun keeping it a secret." That day she told me she would wear the blue velvet and satin dress. I was overjoyed, because she just looked so marvelous in the dress, it did everything I wanted her gown to do for her. First, it established the color blue, which became *Barbara Blue*. She let me do a neckline lower than she usually wore which showed off the three strands of pearls that became her trademark, and the boned "underbodice" made her waist smaller. It was just the most perfect dress for an elegant lady who was about to become first lady—I was thrilled!

I got back to New York and went to our house on Long Island. It was late Friday afternoon. I told Parker, "I'm going to tell the two most important people in the fashion press, it's so late today already, it won't come out until the Monday papers anyway." I called my friend Etta Froio, who was then the head of *Women's Wear Daily*.

"Etta, dear, I can tell you now what Barbara Bush is going to wear to the inaugural balls," and I described the dress to her.

"Now is this an exclusive, Arnold?" she asked.

"Yes, it is. You're the first person I've told," I answered. That was absolutely true. Since it was Friday night, I perceived that nothing would come out in *Women's Wear* until sometime on Monday. Then I called one of my best and oldest friends in the newspaper world, Bernadine Morris, who was a fashion critic for *The New York Times* and whom I had known for over thirty years. As we were chatting away, I said, "Oh, I've had the most wonderful day in Washington and I'm so excited because Barbara has told me what dress she's going to wear to the inaugural balls."

"Oh, tell me, which one is it?" Bernadine enthused.

"Well, I'm telling *you,* but no one is to know," I said, "This is a big secret, Bernadine. However, since it's *you*—it's the most, gorgeous sapphire-blue velvet and blue satin-skirted gown. And she looks absolutely spectacular in it." We chatted on a bit longer and then hung up. I was certain that Bernadine could not get anything into *The Times* until Tuesday; Tuesday was the day the fashion page appeared, so I didn't even think about

it. I just knew that *Women's Wear* would get it in on Monday, and *The Times* could then have it on Tuesday—everyone would be happy. Of course, I learned there and then that you must never say to a journalist "This is just between us, and I'm telling you because you're my friend." In journalism, the reporter always feels if they're told something, it is to be printed. So this nonsense about "off the record" does not exist in journalism. If you want something to be off the record, just don't tell them!

To my great shock, the next morning—*Saturday* morning—*The New York Times* had a blurb describing Barbara's dress in detail. Of course, my friend, Etta at *Women's Wear,* was a little upset. But then, so was I. When I said to Bernadine, "I told you we mustn't tell anyone," she said, "Well, then, I don't know why you even bothered to tell me—you know, my first loyalty is to the paper." Anyway, it all blew over, and by the end of that week, everyone knew what the dress would be and nobody seemed to care anymore who got it first, who got it second, and we released the sketches. The main thing was that Barbara Bush was happy.

Of course, I had to be very diplomatic and make sure that none of the other ladies who had the blue dress were going to wear it to the inaugural. I called each one separately.

"Tell me, dear, are you going to the inaugural?" I inquired. If they said yes, I would say, "What are you going to wear?" One of the three happened to say, "I thought I might wear that beautiful blue dress."

"Oh, you know, I think that's absolutely wrong for that evening. It's a bit too voluminous and, I think, there'll be such a crush. Why not wear the wonderful slim red dress we made for you?" I advised.

"Oh, isn't that darling of you to tell me," she said. "Thank you. Of course, you're right, I'll wear the red dress—see you there." I don't believe she realized why I was calling, but I wanted to make sure no one showed up in the blue dress except my star client and friend Barbara Bush.

I think when Mrs. Bush realized that we were doing great clothes for her, that she was looking exceptionally attractive and special, and that we had changed her image, she was really pleased. Barbara Bush suddenly became "America's most glamorous grandmother."

We made her lots of clothes, always with the thought that she would be photographed every day, which is part of a first lady's job. We made her

day dresses, cocktail clothes, suits and coats, and, of course, long gowns. One of my favorites pieces was a violet wool coat. It was just perfect for her and really set off her skin and white hair beautifully. But she chose not to wear it to the swearing in and instead wore it the day after to the church service. I recently showed the coat in my forty-five-year retrospective at the Fashion Institute of Technology in New York and everyone oohed and aahed over it. Her daughter, Doro, whose peach chiffon and lace wedding dress I designed, told me the other day that the violet coat was one of her favorite things I'd ever made her mother. I'd always thought the first lady would choose violet as her major

President and Barbara Bush at their Inaugural Ball

color to wear, but instead she became known for *Barbara Blue.*

We made her many beautiful suits. One in particular was of blue tweed, the jacket lined in a blue-and-violet rose-print silk like the blouse, which had a big pussycat bow at the neck. I remember at one lunch for the new first lady, Mrs. Bush rose to speak. "Well, look very carefully at me *now,* because this is the last time you're going to see me looking this way. You know—hair and makeup perfect and wearing couture clothes!" she said, opening the jacket and twirling around. The audience laughed and applauded, and I think really believed her—fortunately, she has never given up her Scaasi look.

All the clothes arrived at the White House after the swearing in—the blue suit, the lavender coat and dress, a cherry-colored matte jersey afternoon dress that she wore for their first Christmas party, and the wonderful evening dresses, all hanging in a row. Laurie told me that Barbara

opened the closet and stood there looking at the clothes, saying, "You know, Laurie, I never had a trousseau—I never had a proper trousseau. *This* is my trousseau." When Laurie repeated this to me, I almost wept. I was so happy for the new first lady.

My friend Parker Ladd and I went to Washington for all the inaugural festivities and everyone in the Bush contingent was just wonderful. We were included in everything as if we were part of the family. We went with Laurie and her friend to the ball at the Union Station. It was really a marvelous affair, very festive, with over two thousand people attending. I believe there were fourteen balls that evening at which the Bushes had to appear. At Union Station, they were sort of high up on a platform and, as is the custom, they danced together. I was standing right in front, and when they appeared, the crowd went wild. I think everyone was so surprised to see Barbara Bush as this glamorous image. She swept in, just beaming, and looked absolutely spectacular. As I was looking up, they stopped dancing and came to the front of the platform and George Bush began to speak. Suddenly, Barbara glanced down and saw me and waved *directly* to me! Well, you can't imagine how proud I was. Of course, I waved back wildly; she then nudged the president and pointed down at me. George Bush saw me and, smiling at Barbara, the new president of the United States gave *me* a thumbs-up, meaning how wonderful she looked and how good the dress was. Well, I was in heaven!

Parker and I left for New York the next day after the church service. The day after that was Monday and I was in the midst of creating my new fragrance. There was a major meeting and I had all the bigwigs from Revlon in my salon. I left explicit orders to my staff that while they were there I was not to be disturbed for any reason. We started the meeting and it was going along very well. There were about eight people around the room, and suddenly my assistant appeared.

"Mr. Scaasi, you have a phone call," she said.

"But, Judy, you know absolutely not to disturb me. I really want to concentrate on this meeting," I answered.

"Mr. Scaasi, you might want to know that it's the first lady on the phone. Barbara Bush," she sputtered. Everyone from Revlon laughed.

"For God's sake, Arnold, you *must* take the call," a VIP said. I excused myself and went to the phone. I had thought, of course, about calling

Mrs. Bush soon, but decided I would give her a couple of days to get used to being in the White House and the enormous changeover that was taking place in her life—I thought I wouldn't call until about Wednesday. Well, here it was, Monday morning, after all the inauguration festivities, and Barbara Bush was on the phone.

"Hi. How are you?" I said.

"Oh, everything is just wonderful. I feel great," she responded.

"Well, I wasn't going to disturb you until Wednesday, but I'm so pleased that you're calling me," I said.

"Well, you know, I couldn't wait another moment," the first lady went on. "I just had to thank you for everything you've done for me. The clothes are so beautiful, and you've made me feel so happy. Really, Arnold, it's just wonderful, wonderful—you took a sow's ear and made it into a silk purse." There was a long pause.

"Barbara, I think I should hang up now, because, if not, I may cry. Thank you so very much for saying that, dear, but, oh, my goodness, you know that's not true."

"Yes, it is. Yes, it is," she repeated. "You just did an amazing job and I couldn't be more pleased."

"Well, dear, I'll call you later. And I can't thank you enough for calling. You've just made my life—you know—wonderful!" I replied.

I went back into the salon. As I entered, these tough eight top-brass Revlon executives all applauded and made me repeat the conversation to them.

A great deal of my time after that was scheduled around the first lady's activities in Washington. I knew pretty much Barbara's schedule, and that we had to have clothes for each of the events. What I tried to do, because I realized what her world was like, was to make her feel comfortable in the clothes. Her day started very early in the morning and she might not get back to change until much later because of the many events and commitments she had. So once she was dressed at nine in the morning, she would have to look good for most of that day until late afternoon when she got back to change for the evening's activities.

We tried always to choose clothes that would photograph well, because the first lady is photographed at some point during her day, every day of her life! We made day clothes and more suits with contrasting

blouses. We made a great many things in *Barbara Blue*. Blue looked wonderful with her hair and skin tones and it photographed gloriously. I tried to keep her away from red as much as possible—Nancy Reagan had worn a great deal of red. But, every now and then, we just couldn't resist and there was something red in her wardrobe. It turns out that Barbara Bush looks great in almost any color. Perhaps it's the white hair and that wonderful alive face. I don't know. But almost every color enhances her.

I went to the White House many, many times. Sometimes for fittings, where usually we would have lunch afterward in the upstairs dining room created from a bedroom by Jackie Kennedy with the historic scenes of American battles around the room. This was the same room that looks out onto Pennsylvania Avenue that I had used for my fittings with Mamie Eisenhower when she was first lady—I had returned to my roots, to my beginning as a fashion designer. I was back in the White House, having lunch in the same room where Mamie and I had spent so much time twenty-nine years before.

About a year after Mrs. Bush wore her inaugural gown, she decided, as other first ladies had done, to give the dress to the Smithsonian Institution, which has a comprehensive collection of first ladies' clothing. One day Laurie Firestone telephoned me.

"Arnold, Barbara would like you to come down to Washington for the ceremony at the Smithsonian when she gives them her blue velvet and satin gown, on Tuesday January 9 at ten a.m. Why don't you come to the White House first and have breakfast with us at eight-thirty, then we'll all go on together?"

"Laurie, dear, I'd love to do that," I responded, "but I'd have to get up at five-thirty a.m. to arrive on time—knowing me as you do, I just don't think that's realistic—right?"

"I guess not," she laughed. "Maybe something can be worked out so you and Parker can fly down the day before—let me talk to Barbara about it."

A couple of days later, Laurie called back.

"How would you like to stay at the White House the night before the Smithsonian event? Then we can be sure you'll be on time!"

"It sounds really fine. Can I stay in the Lincoln Bedroom?" I asked, being my usual forward self.

"Well, maybe if there's no head of state visiting," she answered seriously.

"What about Parker—is Lincoln's bed big enough for both of us?"

"Parker can stay at my house," she responded, ignoring my question. "In fact, I'll give a dinner for you that evening."

On Monday, January 8, late in the afternoon, Parker and I arrived at the private entrance to the White House. An usher greeted us and we went upstairs to the Lincoln Bedroom. A valet appeared and asked if he could unpack my overnight bag. Meanwhile, we walked around, scrutinizing all the wonderful objects in this legendary historical room. There, in what would be my bedroom for the night, was the original Gettysburg Address, signed by Abraham Lincoln himself. Within a few minutes, the White House operator telephoned to say that Parker's car had arrived to take him to Laurie Firestone's. I perused the room once more and read the Lincoln document in depth. The valet surprised me by asking if I wanted to have my picture taken near the presidential bed.

"Everyone does it, you know—so don't feel embarrassed," he said, chuckling. I still have the photos to prove I was really there!

Suddenly, we heard a tap on the door—it was the first lady (in another Scaasi tweed suit), who had come to see if everything was all right. "Isn't this a marvelous room? Is there anything you need?" she asked.

"Well," I said, sheepishly, "there is something that I'd like, if it isn't too much trouble—there seems to be only two pillows on the bed, and I'd love two more."

"No problem." She left the room and returned a few minutes later, carrying the pillows herself, fluffing them up on the bed. She was just another gracious hostess, taking care of her guest.

"I hope you'll come have a drink with George and me before going to Laurie's—we'll be at the end of the gallery."

Parker telephoned to say he would pick me up at six-thirty. When he arrived, the eager-beaver valet insisted on photographing us together. Then in a state of euphoria, we joined the president and first lady as they greeted us warmly.

"Well, where are you fellows off to?" the president asked, standing to his full six-foot-three-inch height—he looked handsome and was full of charm.

"Laurie is giving a dinner party for us—you know, Mr. President,

we're here because Barbara is donating her inaugural dress to the Smithsonian tomorrow."

"Gosh, you guys have it made," he said, "I never get asked to any of the fun things—Barb and I just get to stick around this old place all the time!" He laughed heartily. After having a cocktail, we realized we had better leave for Laurie's house.

"Now let me take you boys down in the elevator," George Bush said. "You can get lost in this place very easily if you don't know where you're going!" We protested, but he insisted, escorting us down to the front door. We got into the car and waved good-bye to the president of the United States—he waved back!

Laurie Firestone's dinner party was great. We were twelve people seated in her charming dining room, and yes, she did have a wonderful cook. The food was delicious! I enjoyed talking to Jack Kemp very much and was pleased to see my old friend Joseph Verner Reed, who was then chief of protocol in the Bush administration.

As Parker was staying at Laurie's, Joseph was recruited to drive me back to the White House. His daughter, who had moved to California, had given him her Volkswagen. We set out on this cold snowy night (Washington can be the *coldest* place in January) in our mini-car, headed to what I thought was the president's house. After driving around for about twenty-five minutes, I turned to Joseph and said, "Shouldn't we be arriving soon?"

"Oh, yes," he answered, "we'll be there in just a few minutes." We continued chatting about the Bushes and his lovely wife Mimi, whom I had dressed since opening my couture salon in the mid sixties. Finally, I said again, "You know, Joseph, we've been driving now for over forty-five minutes, and as far as I can remember, it took me only twenty minutes to get to Laurie's house. Do we have a problem?" Joseph slowed down and turned to me.

"Arnold, I have to admit, I think I'm lost—you know, I've only ever gone to the White House in a chauffeur-driven car." He gave me a sheepish grin. After all the delicious wine at Laurie's house, all we could do was laugh.

"Joseph, I have to get home. Let's go into the nearest gas station and get directions to what is undoubtedly the *most* famous house in these

United States!" I teased. Of course, it took another fifteen minutes to find a gas station that was open at that time of night. Luckily, I spied a taxi near the gas pumps. Much to Mr. Reed's chagrin, I went over and asked the man if we paid him would he lead us back to the White House, and, of course, he agreed. I returned to the Volkswagen and kidded my driver all the way home, while following the taxi.

"Arnold, you must promise not to tell the President and Mrs. Bush what happened," Joseph begged. I laughed some more and promised as I got out of the car. I'm not quite sure how Joseph got to his house that evening, but I did think sympathetically as he drove away—"no good deed goes unpunished!"

A security guard let me into the White House and escorted me upstairs to the Lincoln Bedroom. The covers had been turned down and my yellow robe lay at the foot of the bed. I changed into my bright red white-trimmed cotton pajamas that I had purchased at great cost from Turnbull and Asser especially for the visit—usually I sleep in the buff! (I've never worn them since.) As is my habit, I decided to read a book before going to sleep. At least five lamps and the crystal chandelier were lit. One light switch turned off the chandelier, the second switch turned everything else

off—I was standing in the dark. Illuminating the room again, I discovered no switches on the lamps. To turn them off I would have to pull out each plug, leaving only the lamp by the bed lit to read by. I was scared to death, wondering if I followed this procedure would I screw up the electrical system in this historical room. After the mishaps that had happened that evening, I just went ahead and pulled the plugs, leaving the lamp by the bed on—that particular plug was unattainable, way under the mammoth mahogany bed. I fetched a hand towel from the bathroom and placed it over the glass globe, dimming the light. By then, I was so exhausted I

In my red pj's
in the Lincoln Bedroom

fell fast asleep, hoping the cloth would not catch fire and burn the place down!

There's a story about Winston Churchill retiring one evening to the Lincoln Bedroom. The next morning they discovered the British prime minister soundly sleeping in the Queen's Bedroom opposite. After my ordeal with the lights, I wondered if Churchill encountered the same problem and decided to slip across the hall for a good night's sleep!

The next morning, I was up bright and early. After replugging the lamps and making sure everything worked, I had breakfast in the alcove of the Lincoln Bedroom. There was a knock on the door and it was my hostess in a pretty violet wool crepe dress.

"Good morning. Did you sleep well—was everything all right?" she asked.

"Great," I replied. "Everything is perfect. I'm just finishing my breakfast." I decided not to regale the first lady with the traumas of the night.

"We'll leave in about fifteen or twenty minutes," she said, "Come out when you're ready."

Though it had been cold and snowy the night before, Barbara and I left for the Smithsonian on a brilliant sunny day. When we arrived, her inaugural gown was on a store-window mannequin with a wig that loosely resembled the first lady's hairstyle. Wittily, she made reference to it.

"I'd like to know the name of your hairdresser," she asked the plastic dummy! The presentation went off very well and after more remarks by the principals involved, we were in the car on our way back to the White House.

Beside the inaugural gown and stole, she also donated the Judith Leiber evening bag and three strands of Kenneth Jay Lane faux pearls and, of course, her twenty-nine-dollar pair of shoes! Both Mrs. Leiber and Mr. Lane had been at the presentation, having flown to Washington that morning. We all regrouped in the private quarters of the White House, where Mrs. Bush had invited us to lunch.

Barbara Bush has a wonderful motto: If it's not broken, don't fix it! She had told me when she first went to the White House that Nancy Reagan had recruited a superlative staff during the eight years of their administration—Barbara kept many of them on.

"I'd like to know the name of your hairdresser."

We were about a dozen people having drinks in the drawing room before going in to lunch. As usual, the food was excellent and the first lady was in a jolly mood. Finally, it was time to go—Parker and I had had a memorable experience, a kind of dreamlike twenty-four hours—being with the president and first lady *is* very special.

Often Barbara Bush would come to New York for an event. At these times, we would always try to sneak in a fitting at the Fifth Avenue salon. When possible, we'd have a picnic lunch prepared by my housekeeper. Glendina's famous chicken sandwiches were always requested. Other times, Parker and I would take the first lady to one of our favorite restaurants, Le Cirque 2000, owned by the great Sirio Maccione. One day Laurie telephoned.

"The president is going to New York next week to address the United Nations—as we'll be close to Beekman Place, Barbara and I hoped we could drop by and see your new apartment."

"Wonderful," I said. "Why don't you come to lunch? It'll be fun and you can finally get to meet our two Irish terriers."

It was arranged, and the following Wednesday the two ladies arrived. I was amazed at Barbara's knowledge and curiosity; she moved through the duplex, commenting on the art and all the special objets. We ate Glendina's chicken potpie sitting beside the bay window, facing the East River and the Renwick Ruin on Roosevelt Island. The first lady was completely relaxed—*we* had a great time while the President struggled with the auspicious group just three streets south.

Late in 1990, the President and Mrs. Bush started on a six-country tour. Barbara needed different types of clothes to cover all the climates and activities. In chilly Paris a warm coat was necessary, some suits and a long evening dress for President Mitterand's dinner at Versailles. Being an intelligent, frugal Yankee, she recycled a gown I designed for inauguration week. Next stop was Saudi Arabia, where, during the evening when the United States' president was at a men's-only dinner, Barbara went to a ladies'-only party given in her honor. As we knew the royal family would be decked out in their most formal attire with extraordinary jewels, I designed a long slim dress of red-and-purple painted silk chiffon with overlays of shimmering gold thread (this is still one of my favorites). Our first lady looked stunning and as is the custom

after dinner, the women retired to another room for coffee. Incense burners were brought in for fragrance and, I believe, to help heat the cold marble surroundings. Ladies-in-waiting moved the small burners under the women's long dresses. Poor Barbara was astonished, sure that her new Scaasi gown would go up in flames.

Parker Ladd and I went to one of the big 1990 White House Christmas parties, where we saw lots of friends who worked for the administration. The formal halls were decorated with towering silvered-white trees and there were classic green Christmas trees with handmade ornaments in every other room. Barbara wore the short fuchsia matte jersey I had made the year before—it was perfect for the occasion. Though there must have been over two hundred guests in attendance, it seemed cozy. We were privileged indeed to be invited to stay overnight, this time on the third floor with our own housekeeper and majordomo. Nancy Reagan had redecorated this part of the house quite recently, and it was charming.

With Queen Elizabeth and President George H.W. Bush

Barbara and George Bush love to entertain. There seemed to be a wonderful dinner for a head of state almost every two months after they arrived in the White House. Graciously, the first lady invited me to these special evenings. Though I usually arrived with my friend Parker Ladd, once in a while there were just too many men in attendance and Laurie Firestone would invite me to come on my own. Tuesday, May 14, 1991, is one evening I will always remember. It was the dinner for Elizabeth, Queen of England. Invitations were in high demand and scarcer than hen's teeth. I was thrilled to be included.

We knew the queen would arrive with the royal jewels in tow. Knowing that one couldn't compete in this category, we decided the first lady should wear a simple pretty dress with her strands of fake pearls, *BASTA!*

I found some "wedding cake," heavy white guipure lace for the top of the gown that had a violet taffeta full skirt. It was perfect, and Barbara Bush looked very elegant standing beside the charming royal, who was in a well-worn dowdy-looking 1930s type off-white satin gown, ablaze with diamonds—big, grand royal crown and all! Interestingly, the next night the queen looked ten years younger in a contemporary pink taffeta full-skirted dress with a tiny waist and sparkling black-beaded top.

Dinner was delicious as always, with platters of food and dining tables decorated in a British theme. At one point, the Marine Band marched in playing Anglo-American songs and the president and Queen Elizabeth started the dancing. Barbara Bush danced with Prince Philip while I partnered the vivacious Mrs. Colin Powell, next to whom I had been seated.

Before going into the music room to listen to the great opera diva Jessye Norman, Laurie insisted that I be photographed with the "Scaasi Girls." She arranged the beautiful philanthropist Carroll Petrie, Barbara Bush, Mimi Reed, and herself surrounding me for the photo op. Everyone else had disappeared into the music room when George Bush appeared frantically calling.

"Bar, for goodness sakes, let's go in to hear Jessye—hurry, the queen is bushed and wants to get to bed—she's got terrible jet lag—let's get this show on the road!" The photo was quickly taken as we rushed toward the music room.

I had flown down from New York with Carroll Petrie in her private jet,

*With Carroll Petrie, Barbara, Laurie Firestone, and Mimi Reed at the
Queen of England's state dinner*

but when we were ready to leave, the pilot informed us that it was too foggy to take off and that we might have to wait several hours. Carroll and I decided to hire a limousine for the seven-hour ride back to New York. About an hour out of Washington, we stopped at a fast-food truck stop. I accompanied Mrs. Petrie into the diner wearing my tuxedo. Entering the bathroom, she changed out of her luxurious Scaasi ball gown and Schlumberger diamond necklace into pants and a sweater for the ride home. The truck drivers at the counter, seeing the transformation, were surprised and more than a little amused. We waved at the spectators from our long white limo as we drove off laughing and reminiscing how wonderful the evening had been.

I marveled at the times we live in and the dichotomy of having just left the president of the United States and the Queen of England in the most famous house in America and ending up at a greasy spoon an hour later! We arrived on the streets of New York at dawn, having been part of yet another memorable historic evening in the capital.

I do think of Barbara Bush as a particularly good, true friend—she

always seems to be there for me, and wears what I think she looks great in with no questions asked. She wore the Saudi Arabia red-purple-and-gold chiffon gown when I was her date at *The Literary Lions Gala* at the New York Public Library in the early 1990s, much to the rude disapproval of the then chairlady, who's married to a Texas billionaire. The lady objected to my coming to the party because she hated the fact that I was a good friend of the guy's wonderful ex-wife! When she told me she was the chairman and I *could not come,* I replied, "I will do whatever the first lady of the United States wants me to do!" Barbara Bush and I went together!

In the mid-nineties when I invited her to the black-tie opening of my forty-year retrospective, *SCAASI: The Joy of Dressing Up!* at the New-York Historical Society, Barbara stood in the receiving line (wearing my favorite dress again) greeting the likes of Beverly Sills, Norman Mailer (and his beautiful wife with flowing red hair, Norris Church), Gayfryd and Saul Steinberg, Evelyn Lauder, Liz Smith, Diahann Carroll, and more than three hundred others. Afterward, she gave me a witty moving toast.

Again she came through for me in 1997, presenting my Lifetime Achievement Award from *The Council of Fashion Designers of America,* this time wearing a new long gray-silk dress with a mother-of-pearl embroidered sequin top. Of course, all two thousand in attendance rose to applaud her appearance at this fashion-oriented evening.

In 1993 I guess Barbara Bush sort of saved my life! I had decided to stop taking the mind-blowing steroid Prednisone, which put about twenty extra pounds on me, completely distorting, *I thought,* my face and body. She asked what the alternative was—I knew it was the shortening of my life span. She quickly said, "Well, there's no choice then, is there? You'd better keep on it 'cause we need you around for a good while yet." I continued the treatment and by 1994 was thinner and perfectly well— thanks to my friend, the outspoken Mrs. Bush.

Barbara Bush has always been devoted to literacy, having started *The Barbara Bush Foundation for Family Literacy* in 1989. So I knew it would be a natural for her to attend the black-tie *Literacy Partners Gala Evening of Readings* that Liz Smith, Parker Ladd, and I chair at Lincoln Center. We support adult and family reading programs. There are over forty million adults in the United States who cannot read or write at the fifth-grade level. We teach as many people as our classes will hold, free of charge. We

help to get them off welfare, try to find jobs, and put them on the road to a better life in their communities. Mrs. Bush has been a staunch supporter, attending our events, being a most responsive guest, and often speaking herself. Naturally, we go over what she's going to wear, and she is always a major hit with the audience.

After the summer of 2000, when we returned from visiting Mica and Ahmet Ertegun at their beautiful house in Bodrom, Turkey, I began to bug Barbara about clothes for the inauguration festivities in case her son George W. was elected. She absolutely sidestepped the question every time we spoke.

"Barbara, you know whatever we do—make a couple of suits, a new coat and day dress, you're going to need them for your life after January anyway. Shouldn't we get started?"

"No, no—I don't want to put a hex on this. No, I'm not ordering anything until we're absolutely sure he has been elected." That's when I realized Barbara Bush was superstitious, as I am the same way; I stopped asking about inauguration clothes.

Finally, when it was certain that Mrs. Bush's son was to be our next president, Barbara's secretary called.

"Could Mrs. Bush come in soon to fit her clothes for inauguration week? She just wants a few things—nothing too fancy. Is it all right if she calls you later to discuss what might be needed?" That day I spoke to Barbara and we planned the clothes: a Barbara Blue coat in the shape of the old violet one (if you buy good clothes they're rarely out of style during one's adult life span), a matching dress, a suit of wool crepe, a soft silk short dress, and a long silk crepe in black for the Inaugural Ball.

Big problem—as it was already late December, we had only slightly over two weeks to make these designs before the big day. Everything went into work immediately and ten days later, we fitted Barbara Bush in her new clothes.

"I love them!" she said graciously, knowing how hard everyone was working to get things finished. As I hadn't seen her for about six months, I decided we should take new measurements. After doing the last fitting, while she was still undressing, I went into the workroom and saw a bright red double-breasted coatdress with brass buttons that was almost finished for another client who was approximately the same size.

I knew Mrs. X didn't need the dress till February when she would be in New York; I decided to show it to Barbara. I knocked at the fitting-room door.

"Oh, come on in, you've seen me undressed before." Entering, I was surprised to see the former first lady undressed in a bra and panty hose—gone was the ladylike lace-trimmed slip of yore.

"Look, isn't this perfect?" I asked, displaying the red dress.

"It's great, but what makes you think it will ever fit me? You know how lopsided I am and I need these things by next Thursday."

We tried the dress on and I must admit it didn't quite close, but with a few minor alterations, there was no reason why it couldn't be made to fit. Thank God for Mrs. X—Barbara now had another new dress that would help her through the busy weeks ahead. Ironically, the brass-buttoned red coatdress was the most photographed of all her inaugural clothes.

On Monday, January 20, 2001, George W. Bush became our forty-third president—and (until the rains came) his proud Mom sat in the grandstand watching her son being sworn in wearing her basic Barbara Blue coat.

Though Barbara Bush left the White House on January 20, 1993, she continues to be a close friend and client. Ironically, she left wearing the violet wool coat on her *last* day in Washington—the very coat I had planned for her to wear on the *first* day she arrived at the White House. We still make clothes for Mrs. Bush's many speaking engagements, mostly suits and day dresses, but every now and then she splurges on a new long gown. Her shape has changed only a little after hip, back, and foot operations. (George Bush calls her "Eight," due to her having only four toes on each foot!) She insists on playing the same old record when fitting: "Don't take it in. Remember, I like my clothes loose, not tight. Arnold, *do not* take that in," she has said to me at every fitting for over fifteen years—I just ignore her, doing what I feel will make her look well turned out. It seems to work and as the lovely lady herself says, "If it's not broken, don't fix it."

There's very little to fix with Barbara Bush—she remains the same warm, intelligent, witty, smiling woman with fluffy white hair that I bumped into in 1986. What a momentous bump!

Joan Rivers, Parker, me, and Liz Smith
with Mayor Bloomberg's proclamation for Scaasi/Ladd Day

Patrick McMullan

CHAPTER XVIII

JOAN RIVERS

Dear Mr. Scaasi & Mr. Ladd:

Just to remind, dinner on Wednesday, April 2nd is at Miss Rivers's apartment and begins at 8 p.m. This is a black-tie party being given in honor of Miss Rivers's friend Lady Dufferin (aka Lindy Guinness), whose paintings begin showing at the Salander-O'Reilly Galleries on East 79th Street. If you have any questions, please feel free to call. Thank you.

Sincerely,
Jocelyn Pickett,
Assistant to Miss Rivers

I just attended a sumptuous dinner party at Joan Rivers's grandly decorated apartment in the East Sixties in New York. Thirty-six people seated at three beautifully accessorized tables in the large entrance hall adjoining the living room, which was once the ballroom of a very grand town house. Miss Rivers is the best hostess ever. Despite her raucous and wild, sometimes four-letter-word onstage delivery, she is a charming, gracious lady who immediately puts you at ease. You might think of her as being very Las Vegas/Hollywood but in truth she is your typical New York society lady.

She greets you at the door in a chic long evening dress, eyes flashing, head lifted for a kiss on the cheek; she wears marvelous jewels, and always has a query about *you*. On this particular black-tie evening, everybody

went all out, knowing the hostess would do the same and wanted her guests to measure up.

Joan Rivers and I go back a long way when she came to town prior to hosting the Johnny Carson *Tonight Show* at NBC in 1983. She had seen my clothes before and always liked them.

Her husband and business manager, Edgar Rosenberg, asked to see the collection to borrow clothes for the show. Edgar was an Englishman, very well groomed and a gentleman—perhaps too much of a gentleman for the tough show-business world the couple inhabited. He committed suicide in 1987, and Joan found herself alone with her teenage daughter, Melissa. Her parenting is superior, and Melissa is an exceptionally fine young woman—great looking, intelligent, and with a wonderful sense of humor. She now has a child of her own, and is the same great mother as Joan.

However, in 1983 they came to my salon on Fifth Avenue from the West Coast with Joan's hairdresser—a cute looking "blond" young man named Jason Dyl, whose taste the Rosenbergs respected. No matter what we showed, Joan and Edgar would look at Jason questioningly and would say yes or no upon his suggestion.

The fun part was that it was decided that Joan should look elegant—not flashy in a Hollywood way (or they would have gone to Bob Mackie), but pretty and stylish for the eighties. She wore a lot of beautiful evening dresses of mine; one, in particular, had a series of white-dotted net ruffles that began at the halter neckline and flounced down to the hem. When she would do her walk-on introduction at the beginning of the show, the audience was always wowed by the way she looked. Because most of her time was spent behind the interview desk, we would try to find clothes that had interesting necklines (shades of Arlene Francis on *What's My Line?*). In 1986, she left the *Tonight Show* and did the *Late Show Starring Joan Rivers,* which helped launch the Fox Network. We sent her boxes and boxes of outfits, and she always would choose the most exciting clothes.

Melissa made her debut in 1986, and had a beautiful coming-out party. Joan chose an elegant black cut-velvet gown of mine that had a large cabbage rose on the shoulder, where she anchored her giant diamond pin! A

year later, she was a standout in a bright red velvet gown that had small red velvet roses all around the décolleté and hemline.

Once in the early nineties, I was showing a new collection of evening dresses at Saks Fifth Avenue in Palm Beach. Joan had been invited to perform at a swanky private party at the Breakers Hotel. Parker Ladd and I were staying at the hotel, and we had a whole day to get reacquainted with the comedy star. It was wonderful to see close up the wit, intelligence, and compassion of this whirlwind lady. Though we don't see each other too often, when we do, the conversation just picks up where we left off the last time. We have been together on weekends at Mary Lou Whitney's in Saratoga and at the Kentucky Derby, and I find in a tough world Joan is always funny and upbeat—a joy to be around.

Ms. Rivers is a workaholic and has more energy than anyone I know. She thinks nothing of flying to London on a Thursday to do her one-woman comedy show (which gets rave reviews), returning Saturday to her beautiful home in Connecticut, going to Pennsylvania on Sunday to do a two-day QVC Channel sell of her classic jewelry collection and cosmetic lines, and then returning to New York on Monday to host a major charity event, before going off to police the Oscars in Hollywood on her and Melissa's E! Entertainment television show—whew, I am out of breath just writing this!

The relationship between Joan and her daughter is very special. To hear them joke and tease each other with such candor and joy is wonderful and Joan's pride in Melissa's accomplishments is enormous.

Joan has written and produced plays, one-woman shows, books, and a plethora of other productions, but the most profound one must be the wedding she gave for Melissa at the Plaza Hotel in New York City in 1999.

The young television hostess had said she would like to have a Russian wedding, and Joan went all the way, pulling out all the stops! The guests arrived at the very grand Hotel Plaza and entered a space that had been transformed into a winter wonderland—a forest of white birch trees grew out of a pristine white carpet, giving the impression of a snowy foreign place. Everything was white: the rows of chairs for the ceremony, the garlands of white roses sprinkled through the trees, and even

the dim blue-white lighting that seemed to make everything sparkle. The New York City Gay Men's Chorus sang, and a string quartet played classical music—you know, Bach, Mozart, and all that. But when Ms. Rivers, the mother of the bride, came down the aisle, resplendent in gold brocade and sables, the music switched to "Hey, Big Spender" from *Sweet Charity,* and everyone chuckled and applauded.

After the ceremony, we passed through the lobby of the hotel, where literally mountains of caviar and cold champagne were served, before going up to the beautiful ballroom. Preston Bailey had designed archways leading into the ballroom that were covered in every shade of red and pink roses. There were thousands of roses repeated inside the ballroom, on the tables, and encircling the room itself. Joan had ordered special chairs and purchased five hundred red crystal glasses to keep the color scheme intact. (She has offered to loan them to any of her friends who might also be throwing a party for five hundred!)

It was magnificent and totally original. No expense had been spared. As the brother of the groom remarked in his toast, "Well, you all thought my brother, John, married Melissa for her money, but, after coming here today, you know that's not true—Joan has spent it all on this wonderful wedding!" (The couple later divorced.)

People stayed very late and had the best time dancing and toasting the young couple. Joan Rivers certainly proved that evening that she was the "hostess with the mostess."

Recently, at the seventy-fifth anniversary of the Academy Awards, on her E! television broadcast and afterward at the gala parties, Joan sparkled in a bright gold soutache embroidered gown, studded with diamanté all over. There were many comments all evening that the "Fashion Police," as Joan and Melissa are known for their reportage on what actors attending are wearing, looked better turned out than many of the stars. The dress proved so successful that she decided to wear it again, at the party his Royal Highness Prince Charles threw one weekend at Windsor Castle. She was a hit both times, saying to me later, "Scaasi, the gold dress just blew everyone away. Even the prince commented on it and gave me a big hug and a royal kiss!"

Through the years, Joan Rivers's face has changed slightly, not so you

don't recognize her, but she has always honestly admitted that she is a wild proponent of plastic surgery, saying, "It's no use going to Los Angeles without getting a little tuck—here and there!" Consequently, Joan Rivers always looks beautiful and is beautiful—both inside and out—a wonderful person and a very dear friend.

Rosemarie Kanzler in her "diamond dress," with Prince Philip

ROSEMARIE KANZLER

In 1991 my longtime friend, Aileen Mehle ("Suzy," the beauteous gossip journalist) telephoned me with the most interesting news a couturier would want to hear: "Arnold," she said excitedly, "Rosemarie Kanzler—you know, she was married to Jean-Pierre Marcie-Rivière—just called me from Paris. She saw your new collection on CNN and loved it! She asked if I'd ever heard of Scaasi—imagine! Of course, I said I knew you very well. Anyway, she's had a big falling out at Saint Laurent, where she was one of their best couture clients for years, and she's dying to have you make her some new clothes. You know, she's unbelievably rich, only buys couture, and has great taste. Also, she's very pretty, model size, and loads of fun—what more could you ask for? Now do call her *right away,* here's her number."

What a surprise! I had read about the glamorous Rosemarie Kanzler for over thirty years, and about her fabulous houses filled with great art and priceless antiques. There was the sumptuous pied-à-terre in the socially exclusive seventh *arrondisement* of Paris, the grand residence in London, plus an amazing château in the south of France, overlooking the Mediterranean, and *La Favorita,* the 1,800-acre *estancia* outside of Buenos Aires. She also owned one of the most beautiful properties in Greece, the *Villa Hinitsa,* high in the Peloponnese Mountains, from which you can see the island of Spetsos. She traveled in the most aristocratic circles in the world that included royalty, movie stars, and all nationalities of the very rich—what a coup it would be to have her as a client!

I telephoned the number that Aileen had given me, and a French male voice answered, "Bonjour."

"Bonjour. Est-ce que Madame Kanzler et là? C'est Monsieur Scaasi de New York," I said in my perfect French without a trace of an American accent! (Remember, I studied the language as a child in Montreal and then in Paris, where I went to design school.)

"Un instant, je vais voir" came back the voice from Paris. A few moments later, a deep, guttural *feminine* voice said, cheerfully, "Hello, is this *really* Scaasi? I'm so happy to speak with you—oh, I love your clothes—can you make some for me?"

"Of course," I said, following her lead, "it would be a pleasure. When can you come to New York?"

She explained that she had to be in Detroit (the home of her fourth, and most favorite, deceased millionaire-husband Ernest Kanzler) for Christmas and New Year's, would then go on to Palm Beach to see some friends, many of whom I knew, and then come to New York at the beginning of February.

"Wonderful. I look forward to meeting you then. Please let me know what date would be best for you to come to the salon and see the collection—I can't wait to meet you, Aileen says you're just great," I said to her.

"Aileen says the same about you!" she said, laughing. "I look forward very much to seeing you in February. Au revoir," her voice trilled off.

I had heard so much about this woman. In social circles her life was legend. Her father had been a part-time builder in Switzerland, and she was barely out of her teens with no money when she ran off to Germany with her lover, a well-known impresario-composer, to do a concert tour. She had a nice voice, and he hoped to make her another Dietrich. The story goes that after one of her public appearances in Munich, two SS men arrived and told her to come with them; Hitler had requested she sing for him. After nervously going before the führer in his secluded apartments, she began the private performance, singing some of his favorite Viennese songs. It has never been explained why but—the German leader fell asleep!

There are so many fascinating stories about this blond bombshell, who became one of the world's richest women, working her way through five marriages until she was well into her seventies. I could not believe I was finally going to meet up with this phantom figure.

I called Aileen immediately, thanked her for the introduction, and

said I hoped that the three of us could have lunch together in February.

"Arnold," the columnist countered, "you *know,* I try to never go out during the day." I'd forgotten this was a rule of the strong-willed "Suzy," who never takes calls till after 11:00 a.m. "However, do keep in touch. I'd love to know what happens—she only likes exciting things, so I know she will *love* your designs."

Promptly at two-thirty on Tuesday, February 11, the petite blond Dietrich-looking Rosemarie Kanzler arrived at my Fifth Avenue salon, and our relationship began. I found she spoke with a lilting voice that had a slight German accent. Michael, my assistant at the time, offered her some tea, but she preferred plain water.

"Let me show you some of the clothes," I said, after she was comfortably seated on the dove-gray damask banquette.

"Oh, yes, please do—I want to see *everything.*" She was visibly excited. I found out that she went to the Salzburg Music Festival in Austria every year and was a high muckety-muck among the Euro social group that attended this musical event.

Contrary to what we usually do, I began by showing her long evening dresses that she could wear during her two-week stay in the hilltop town. She loved a bright red sequin flowered gown that was appliquéd all over with hundreds of glistening embroidered petals.

"That will be perfect with my new diamond earrings, they have big rubies in the center," she said enthusiastically. I had been told that Rosemarie Kanzler had the most incredible collection of jewels acquired during the past fifty years through those fortunate marriages.

Next I showed her a short black thick guipure lace dress over nude with a very deep V neckline and then a white dinner suit with shocking pink embroidered in chalk-white sequins. I kept rotating long and short evening clothes and she seemed to like everything—her enthusiasm was catching and my staff got into it with equal excitement—after all, here was a woman who *loved* shopping and seemed to want all the clothes we showed her—we were all having a great time!

Next a long silvered lace dress that was see-through with bands of pink silk crepe in all the right places, embroidered in flashing stones and tiny pearls, caught her eye—it looked gorgeous on her.

"Perfect for my beautiful diamond necklace and new earrings from

Winston." It turned out that Harry Winston was her favorite and she visited the jewelry shop on Fifth Avenue often.

"I must have some evening pajamas," she suddenly said. "It's the only thing I wear at my villa in Greece." I immediately showed her some exotic fabrics that would be perfect for the fancy dress-up outfits—favoring bright colored prints or chalk-white and brilliant red-beaded cloth. We also decided on some black-and-white silk pants with a wild frilly white silk organza top. That afternoon she ordered fourteen outfits, all to be worn after six in the evening. I was beginning to understand Rosemarie Kanzler's lifestyle—it was obviously one big party after another!

Mrs. Kanzler left a major order, but there was a slight problem: she wanted everything ready to fit by the following week's end. That meant putting aside all of our other clients' orders to satisfy our new *friend*. Of course, we did it; an over one-hundred-and-fifty-thousand-dollar commitment didn't happen every day.

She undressed and I realized that the seventy-something lady had had a little work done on that famous body; she looked amazing for her age. We took all the usual measurements.

"My, you take more measurements than they do at Saint Laurent—I am very impressed."

"Oh yes," I said, joking, "but don't worry, they're filed in a secret vault, no one will ever know your true dimensions." She laughed, and we gossiped about some mutual friends, including Valerian Rybar, my decorator, who had done up all of her houses around the world—the lady and I obviously had an instant rapport (very necessary when designing made-to-order clothes).

Parker and I saw Mrs. Kanzler socially whenever she was in town. She had a sensual charm and wicked sense of humor—she must have had great fun snaring all those rich men. Rosemarie was *very* pretty with a tiny doll-like figure, short shoulder-length blond "flip," and bright china-blue sparkling eyes; you could see why so many men fell in love with her—she was a real femme fatale!

About a year after I met her, I gave a dinner party for twenty in her honor at my Beekman Place duplex. It was a wonderful evening and I invited many of Rosemarie's old pals—she was delighted and looked beautiful in her short black lace dress with loads of diamonds. During the

evening, I found I had made a small faux pas when two of her old beaux seemed unhappy about the other being there. Later, I found out that Rosemarie had had mad affairs with at least five of the ten men present!

We discovered that this chatelaine was a great hostess when we went to visit one summer at her beautiful *Villa Hinitsa* in Greece. It was built high on a sort of cliff in the Peloponnese Mountains. The main house was majestic, all white against the blue, blue sea, with huge long hedges of red geraniums everywhere. The separate flagstone guesthouse where we stayed had three bedrooms, a full kitchen, dining room and drawing room. We were looked after by Maurice and Jeanette, our own private butler and maid. Rosemarie had a wonderful Italian cook and a great French chef. We would go up to the main house for dinner on nights that the captain didn't take us in her boat over to the island of Spetsos—it was the grandest luxe and we obviously had a terrific time.

To arrive at this paradise, you would fly to Athens and then drive for more than five hours along the curvy mountain roads to Porto Heli, or, if you were really flush, you hired a helicopter and reached the heliport just above Rosemarie's house in twenty minutes. You landed at Emilita Fortabat's villa, the Argentinean millionairess who had taken over her husband's cement business after he died and made it an even greater success—she was known as the richest woman in Argentina, once purchasing a great Turner painting and paying the highest price ever for the artist at that time. Rosemary and Emilita were really great friends, though there was always a little jealous rivalry of each other's boyfriends, jewels, and wealth.

In front of the guest cottage was the most wonderful swimming pool with no rim around it. Hugging the cliff, it spilled over into a ravine below. When you were in the pool, you felt suspended in midair, only seeing the sea and the isle of Spetsos. Each day at noon, the incomparable Rosemarie would come down from the main house, take off her robe, and, standing completely naked, descend slowly into the magical pool for her daily swim!

I found she had an amazing eye and love of beauty: in art, antiques, furniture, clothes, jewels, houses, gardens, and people. Her taste was unsurpassed.

One day I showed her a black satin swingy short dress embroidered

with rhinestones in a design of arches around the skirt and very low décolleté. She loved the dress and I saw her wear it many times in Paris, London, and New York—she called it her "diamond dress."

During the eight years we knew her, Rosemarie spoke often about putting down on paper her fascinating life story. She had the title set in her mind—*Yesterday Is Gone*—and was always asking Parker what publisher would be right.

"You know, I better get started," she would laugh. "After all, I'm getting on—I may soon be up *there,*" she would say, pointing to the heavens and smiling mischievously. The book came out in September 2000 and does indeed tell the story honestly of this unique woman's life. At the book party on October 22 at the Hotel Grosvenor in London, she wore her favorite "diamond dress" and was greeted by the Queen of England's husband, Prince Philip, Duke of Edinburgh, an old friend (an old flame?). Mrs. Kanzler is pictured smiling cheerfully at the royal personage, exactly as she had done to other royal friends throughout her long life.

On Saturday, December 9, 2000, she died suddenly, swimming in her palatial pool—she was eighty-five. Observing how the world has changed, sadly, we will not see the likes of the dynamic Rosemarie Kanzler again too soon.

With Diana, Princess of Wales, at Hatfield House, England,
July, 18, 1990

PRINCESS DIANA

I first met Diana, Princess of Wales, on Wednesday, July 18, 1990, at Hatfield House, the historic seventeenth-century castle outside of London where Elizabeth I was told she had become the queen of England at the tender age of fifteen at her half sister Queen Mary's death. I had come to England to be part of a gala weekend that was being given for the Foundation for the Deaf. Diana was the patroness and cochairman of the evening, along with my friend and client the American philanthropist Carroll Petrie.

I noticed the princess come to the entrance of the reception room where the cocktail party was taking place. That amazing countenance attracted one at once. She stopped short in the doorway, totally alone, and looked into the long room from left to right, took a visibly deep breath, and marched into the crowd. There was no formal announcement of her arrival—she was just suddenly there.

Diana moved through the room, smiling, asking where each member of the American contingency had come from. She stopped beside me and was particularly charming and interested, especially when I told her I was the designer Arnold Scaasi. She said she knew and loved my clothes.

"I am so very impressed with the way you dress Barbara Bush." She giggled and asked if I liked the dress she was wearing.

"May I come and see your collection when I'm in New York?"

"Of course," I said. "I would love to show it to you." After a bit more chitchat, she disappeared into the crowd. I thought it was charming of her to speak about my work and ask to see the collection, though I knew

full well that being married to the future king of England prohibited her from wearing anything but British-made clothes.

When cocktails were over, we all walked through a lovely English garden into an astonishingly huge fourteenth-century stone dining hall. There were twelve people at each of the long refectory tables. Tall standards with flags at each of the massive stone columns lined the walls, giving the room a marvelous royal atmosphere from another time.

I sat down where my place card indicated and found that Veronica and Randolph Hearst were at the same table. Parker Ladd, Carroll Petrie, and Jerry Zipkin were also with us, as were other friends from Washington.

When we were all seated, I saw that the chair on my right was empty and had no place card; I wondered who could be so rude as not to appear. Suddenly, we heard bagpipes and in marched the beautiful, smiling princess in her flowing, flowered chiffon gown. The dress was white printed with small blue flowers and green leaves and had a tiny bodice that was draped into a halter neckline. I always thought Diana had great taste in clothes. Though sometimes exaggerated, there was often a playfulness about what she wore that suited her girlish personality and stunning good looks. She was certainly an arbiter of eighties fashion—just as our American royal, Jacqueline Kennedy, had been the epitome of sixties fashion.

Before I knew what was happening, the Princess of Wales walked to the empty chair and sat down next to me! Well, I can tell you, I was in shock and, of course, overjoyed. I remember there was much laughing and a lot of fast talk. I asked Diana where her husband, Prince Charles, was, and she said he was at home with a broken collarbone. We had seen pictures of him with his arm in a sling in the newspapers. We talked a lot about her children, and that they'd all been on a yacht in Spain, where the Spanish royal family was with *their* children.

"It was great fun, and we all swam off the ship every day in different coves," she said. She obviously loved the whole idea of being a family on holiday. I found that she was very much like any mother speaking lovingly about her children. I kept having to remind myself that this was not a Scarsdale matron, but the future queen of England.

At one point, we were both giggling about the menu card in front of

each place setting, discussing the food that would be served and what each of us liked and didn't care for. Suddenly, she asked if I wanted her to autograph *my* menu card.

"Of course," I said, and suggested that every person at our table sign his or her menu card and pass it around, so we'd all have a wonderful souvenir of the evening. Everyone began signing the menus, laughing uncontrollably like children at a birthday party. I asked Diana if she minded doing this.

"Not at all," she answered. "When I was visiting the Reagan White House with the president and Nancy, they asked me to sign everything that wasn't tied down!"

We ate and drank and laughed a lot, and my friend Sharman Douglas, who had arranged the evening, said that she couldn't believe how much fun we seemed to be having at our table and was sure that throwing rolls at each other was about to happen at any moment. I *did* find the Princess wildly charming.

Suddenly, it was time for her to leave. I don't know how she knew that—she just all of a sudden stood up.

"Mr. Scaasi—Arnold," she said, correcting herself, "I so enjoyed being with you. Thank you very much." Out of the blue, she whispered in my ear, "Now be sure and see the film *Pretty Woman.* I know you'll love it." I was mesmerized—she got up and turned to me with that lovely smiling face.

"Come outside now and see the trooping of the colors. It's really great—they always do it when I leave somewhere, and I love it! It's one of the things I like most about going out," she said with a giggle. Floating away in her chiffon dress, she was suddenly lost in the crowd.

We went out to see the trooping of the colors. There had been chairs set up at the edge of the courtyard where she stood watching this spectacle, that great smile on her face and her long scarf blowing in the breeze. When it was over, she got into a grayish-green Jaguar and was whisked away. She smiled and waved to me as she passed. I had the feeling that she really liked Americans and that her fun of the evening was not at all put on—I think she had a very good time. I, of course, had fallen in love with this fairy-tale princess.

I saw her many times afterward and she always greeted me affection-

ately. We met at the Council of Fashion Designers of America Awards at the Metropolitan Museum of Art in 1995, where she was an honored guest.

"Is it true that you want to come and live in America?" I asked. "Everyone's talking about it—saying that you'll probably work at *Harper's Bazaar* with your compatriot Liz Tilberis. That would be wonderful for us, but how would *you* feel about leaving England?" She laughed, but made no positive declaration. I also bumped into her a couple of times at San Lorenzo in London, where she liked to lunch. One knew that she was inside, what with the gaggle of paparazzi surrounding the restaurant— they followed her everywhere. It's a wonder she had as many private moments as we now read about.

The last time we met was at the reception before the auction of her clothes to raise money for AIDS research at Christie's on Park Avenue. It was June 25, 1997. Ironically, the blue-flowered white chiffon dress was being auctioned. Veronica Hearst won the bid for over twenty thousand dollars. The gown the princess had worn the first night we all met was donated to the Costume Institute at the Metropolitan Museum of Art. Before the auction began, Diana and I were standing together and had a chance to talk. She seemed ecstatically happy.

"You look really great—prettier than ever," I enthused.

"Oh, thank you. So you think America and divorce agree with me, don't you? Now, at last I can have a Scaasi frock!"

"Absolutely," I said. We laughed and hugged each other, and said good-bye—I only wish she had stayed.

Parker, Laura, and I at the FIT Scaasi retrospective

LAURA BUSH

In the early fall of 2000, I first called Laura Bush in Austin, the capital of Texas, where her husband George W. was governor. She came to the phone immediately and greeted me warmly. After we exchanged pleasantries, I said I hoped that she would let me do some clothes for her and that she would come and see the collection. I chatted her up a bit and we got on very well. I found her charming and open. However, she did say she was not ready to get any clothes at the moment; she had no idea what the outcome of the presidential election would be and as the time grew nearer we would speak again, she would be in touch with me. Laura thanked me profusely for calling her and for thinking of her. Fade out.

Fade in—two months later, when we knew that indeed George W. Bush was the forerunner on the Republican ticket against Al Gore on the Democratic ticket, I called again and this time Laura did not come to the phone. Andi Ball, her chief of staff, told me that it was premature and that they were not sure that Governor Bush would win the presidency, and that they would get back to me.

In the interim, I saw quite a bit of my friend Barbara Bush. We were fitting clothes, and, as I've mentioned, I could not get her to discuss clothes for the inauguration either. Because of all the voting problems in Florida, no one knew what the outcome of the election would be. After knowing her for over fifteen years, I suddenly discovered that Barbara Bush was superstitious! She would not order anything until after her son was confirmed as president.

"What do you think about Laura and her clothes?" I asked her.

"I really don't know. You know—we're all in such a state of upset," she

243

answered. As time went on before the final decision, I brought it up again.

"I think Laura has somebody in Texas who does her clothes and she has probably planned what she is going to wear if, indeed, George W. gets in," Barbara replied.

I never heard from Laura again. But when George W. Bush became president, I sent a fax on my personal stationery to Laura, congratulating them, and saying not to forget "My trusty needle is here to help in any way we can—whenever."

Of course, before the inauguration, I read all the press stories that Michael Faircloth distributed about the clothes he was doing for the new first lady. It seemed strange that Laura had allowed so much to be printed so far in advance. Of course, I saw the sketches in *Women's Wear Daily* and read the articles about Mr. Faircloth, and I concluded that it was a fait accompli that Laura Bush had her designer and that she would be dressed from then on by him—we would see the clothes he did for her in the press for the duration of the presidency.

I was surprised when I finally saw the new first lady in the Faircloth designs, because I had remembered her as being pretty and petite, with a nice curvaceous figure. The outfit that she wore to the Inauguration, on the afternoon of January 20, 2001, was a very attractive bright blue color, pretty for her and flattering, but it had this little black collar and small lapels that looked skimpy and didn't do justice to Mrs. Bush. Also, the coat was almost mid-calf, but I noticed when she walked, the matching dress underneath came just below the knee. There seemed to be a good four inches difference—it just looked very odd. It didn't have any particular style to it and did not have the best proportions for her body—it made her look dumpy, which of course she isn't. The form-fitting inaugural ball dress was in red, meaning it would stand out and was a very good color for her. Unfortunately, the dress had bad proportions for an evening dress in the year 2001. It had large shoulder pads, not very flattering to the new first lady and not pretty under a lace dress. The neckline, not low, high, or wide, but rather narrow in a scooped out shape, was strange. Even though she has that wonderful smile and her hair and makeup were perfect, there was something about the dress that didn't look right, that didn't flatter Laura Bush.

Well, I ignored all this, as it had nothing to do with me. I like Laura very much; she has a lot going for her. She is intelligent and bright. She has a pleasing, cheerful smile, and she came to the position of first lady with wonderful credentials. But she *had* a designer, and I forgot about doing any clothes for her.

In April I got a phone call from Quincy Hicks, who had been Barbara Bush's aide in Houston, and was now the appointments secretary for Laura Bush in Washington.

"The first lady would like to arrange to come see your collection. Would the morning of April 24 at about 10:30 be okay?" I was stunned—never expecting this.

"Of course, I would love to show Mrs. Bush the collection," I said. "We have some wonderful clothes for her." Immediately, I began to think of what I would like to show her, what the changes I felt were important to make in the new clothes, how we would fit them differently from the way that her other clothes had been fitted.

On Tuesday, April 24, 2001, Laura Bush arrived at the salon at 16 East Fifty-second Street. There was a great furor in the building. We are on the third floor; two days before, the Secret Service arrived to examine the salon. They checked out all the rooms that Scaasi Incorporated occupied, the bathrooms, the hallways, and our neighbor's space, too. We were used to this because every time the former first lady Barbara Bush came to us, the same thing happened, but not as exacting as when, suddenly, the new first lady was coming. Laura Bush had a much larger secret service detail.

When I arrived at the salon that morning, Laura and Quincy were already there. She immediately got up and came toward me and kissed me on the cheek—and I thought that was very nice and very warm of her, especially as we hadn't seen each other in quite a while and didn't know each other very well. Then I greeted Quincy, whom I had known for a long time because of all the years she had been with Barbara Bush.

As we usually do, Jerry Sirchia, my assistant, asked Laura if she would like something to drink. She accepted a Diet Coke and I began to show her the clothes. Now one of the first things I showed her was a red suit with a "fencer" type jacket. It has a princess-line pleat going from the shoulder over the bosom down to the hem of the jacket. The same line continues down the slightly A-line skirt.

"Oh, I like that very much. But won't that make me look fat on camera?" she asked. I noticed, of course, that she was not fat; on the contrary, she was quite slim. She might have been a little bit larger than a size eight, and she had a good figure. She was a nice height and she has a long neck, which, of course, any woman would give her eyeteeth to possess. I saw that she had very good legs, but, as she wore skirts that were too long, we never got to see those great gams! I realized that we would have to change the proportion of her clothes. We tried on the little red jacket, and she immediately lost inches in the mirror! So I think that gave her confidence in what I could do for her.

We began to look at other clothes: I showed dresses with mainly flared skirts that moved well, because I felt that she moved gracefully, not in a clunky manner like some women. So far, I had only seen her photographed in tight skirts, which, I think, confined her movement and were not terribly flattering, emphasizing her round hips.

As I learned with Barbara Bush, the first thing that you have to realize about doing clothes for a first lady is that she is photographed all day long. She will have meetings that might begin at eight-thirty in the morning, and then have a different meeting or a different event all day long, every hour or so. She will probably meet with different groups and different dignitaries several times during her day. At each of these meetings, she will be photographed with whatever group or person she's seeing, and, of course, somewhere in the world, these photographs will appear—either on television or on the Internet, certainly, or in newspapers and magazines. So she is never out of the limelight. Because of this, it's important that when the first lady is photographed, the shape and fit of the clothes must be the best possible for her and, also, the colors should be bright and clear.

When Laura put on the red suit with the pleat seam, she began to try to make it narrower on top by turning it in slightly. Also she said, "I think I need more padding on the shoulders, don't you?" Well, I didn't—I thought from the beginning that her shoulders were too padded and that it wasn't flattering. She examined the length of the jacket very carefully and she had, I noticed, an eye for details. But they were minor details, all things to be decided upon in the fittings. They really didn't encompass the overall look of the suit, which was wonderful on her, even though it was not her size. She began to try on other things.

By the end of the first meeting, Mrs. Bush had picked out a day dress and a coatdress. She said, "Let's get started with these two things and we'll see how they go." So she really wasn't convinced that I was going to design clothes that suited her or that would make her totally happy.

She went into the fitting room and the fitter, Miss Lucy, began to measure her. I realized that she was quite modest—I never saw her without clothes on, though she had to be measured that way to get the correct dimensions. She would be undressed—in her bra and pantyhose, as with all our made-to-order clients. The reason we always take sixty-five measurements is not only to get the right size of the person but also to establish the way they stand and where the body's curved and where it's flat.

When she came out of the fitting room, we had clothes spread around the salon that I thought she might like and that she had shown interest in during the previous hour. I had discussed with Quincy before they came to New York what Laura Bush would like for lunch at the salon.

"Those delicious chicken sandwiches would be nice, nothing fussy, just something quick," she said. It had been a tradition with us to serve Barbara Bush chicken sandwiches and she loved them. Glendina arrived with the platter and some of her little homemade cookies, too. After the measurements were taken, the first lady sat down on the dove-gray silk damask banquette and was served lunch.

While Laura was eating, I went over the clothes with her.

"Don't you think you should have this?" and "Wouldn't this be good?" I said, pointing out different things. We knew that the president and first lady were going to Europe in June, George W. for the first time. They would visit Spain, Belgium, Sweden, Poland, and Slovenia. Laura needed clothes for events in all these different countries. I suggested first a little day dress, which we made in bright red wool crepe. The shape was very good for her—slim, belted, and flared at the hem.

"Do you think the flare should be slightly less pronounced?" she asked. Well, there had to be a certain amount of flare or her hips would not look slimmer in photos. I decided that A-line skirts were going to be better for her than straight skirts. If there was a jacket that shadowed her hips then we could do a straight skirt. (There's always an exception to the rule in fashion.) Also, interestingly, she did not want to have a blouse or any-

thing unnecessary under the jacket, because she felt that added bulk. Obviously, she had thought about this detail a lot.

We decided on the short red day dress with the flared hemline, but with less flare. Also, she selected a light navy silk coatdress with white collar and cuffs. The main thing that I wanted to do was to lower all collars and necklines on her. She liked a bottle-green sequin lace off-the-shoulder short dress. The first thing she said was, "Of course, I can't wear off the shoulder."

"Let's try it," I suggested. It had a low neckline, and she looked wonderful in it.

"Yes, I love this dress. Yes," she enthused. And so we had gone a step further in changing her look by convincing her that a low neckline was not unattractive on her. In fact, it was good for her; you see, it breaks the line of the bodice from the neck to the waistline, making one look less top heavy. Also there was absolutely no reason why she couldn't show some chest and some shoulders in cocktail or evening dresses.

"Mr. Scaasi, you don't mind seeing the freckles on my chest?" she asked.

"No. I never even noticed them. But if it bothers you, you can always put a little makeup on. The neckline is really very flattering on you."

Of course, the length of the skirts became very important because I think that she had always had her knees covered and probably wore her skirts about an inch or so below the knee. I realized that in pictures this made her body look very long and her legs look short. (When a short dress is too long, you can very often look like you're standing in a hole in the ground!) We established a length that was mid-knee. Naturally, you don't want the first lady to have her knees hanging out when she is over fifty, but you do want her to look elegant and of the moment. As she had good legs, there was no reason why she should wear anything below the knee. So we established a length that was twenty-one and a half inches from the waist, which brought her skirts to mid-knee. (The length of a skirt really changes for *each* person according to the length of leg and where the knee is.)

"Well, now let's do that red suit in something," she suddenly said. So we decided to do it in red silk shantung, as it could be quite warm in Europe in June. I thought a coatdress would be wonderful for occasions

when she had to greet people unexpectedly. She could just pop it on at a moment's notice and be perfectly dressed. So, we had decided on four things. Then she said, "Yes, yes, of course, we must do the short bottle-green sequin lace."

Next I showed the first lady a short three-tiered lace dinner dress with long sleeves and a high neck that was in brown over light beige silk. She liked it very much. It had a belted waistline, which defined her small waist and was very flattering.

"You know, I think I should have that."

"Great," I said. "Let's do it in black. I mean, it's probably good to have one black lace dress that can be worn often without making too much of a statement."

"But, you know, I *like* brown," she said.

"Yes, but we're going into spring and summer, and perhaps brown is a little wintry," I replied. The dress looked wonderful on her. It gave me the idea suddenly of what her clothes should look like: elegant but snappy.

Then I brought out a dress that I had designed a few years ago. It is a classic of mine in gray flannel, draped like a silk dress all to one side. I'd done it in flannel because I thought it was chic to do an evening look in wool, which you could also wear during the day. She thought it was wonderful, and it gave me an inkling again that she had a dressmakers' eye. Somebody who appreciated how to make a dress would like the complicated draping that was very difficult and involved to do in wool. She decided to order it.

"Well, we started with two

dresses, now we're up to six," Laura suddenly said. It was obvious she needed some new clothes.

We looked at a couple of long evening dresses and she liked a chiffon dress that had circular insets at the hem. It moved very beautifully, the sort of dress Ginger Rogers would have worn to dance with Fred Astaire. It had a very thirties look—a great shape for Laura Bush. We decided to make that dress in turquoise chiffon, because it's a wonderful color for her. Almost all the clothes she selected were in bright colors; the only ones that were different were the gray flannel and, of course, the black lace.

"Oh, let's keep the lace over the pale beige instead of doing a black slip—it will look lighter for spring and summer," Mrs. Bush said. Well, I realized she was a quick study, getting the picture right away!

Before leaving, I showed Laura a beautiful white guipure heavy cotton lace in a four-leaf clover pattern—she was very enthusiastic about it, so I sketched a scoop-neck top with short sleeves and a short A-line skirt of black silk double organza. She thought it was perfect for warm summer evenings.

Well, our session was over and it was time for her to leave. The first lady not only loved her chicken sandwiches, I realized she liked the clothes, too.

I went downstairs with her to where the three limousines were waiting. Small crowds had gathered on East Fifty-second Street, wondering who was upstairs with all this security. When the first lady came out, she seemed surprised to see the crowds. Many people applauded and called out, "Laura, Laura, Mrs. Bush, how's George?" She smiled at the crowd. I kissed her good-bye on each cheek and she got into one of the cars and drove off. As I went back into the building, of course, everyone said, "My gosh, was that *really* Laura Bush? Oh, isn't that wonderful, that was the first lady—I just saw Laura Bush!" Of course, this was very exciting for us—my staff was thrilled. Here we were, having dressed one Mrs. Bush, whom we loved, and now we were about to start dressing another Mrs. Bush, who was a really nice lady also.

Laura came back on Wednesday, May 9, and we had most of the clothes ready! We had padded a dressmaker form almost exactly to her shape and the clothes fit very well with few changes. Though there was a lot to do (eight outfits) to have everything perfect for the European trip,

we did manage to chat a bit about her mother-in-law and the wonderful fifteen-hundred-acre ranch in Crawford, Texas. They were decorating the limestone house, and Laura told me how much the president and she love it there.

"It's really beautiful—you know, peaceful—you'd probably hate it!" she kidded me.

That day the first lady chose a few more things. She liked the navy coatdress, so we decided to make another in raspberry linen, a wonderful color for her that would show up in photographs. She also ordered the turquoise silk chiffon long evening dress that moved so well. Then a little shocking pink silk jacket we called "Laura's Classic Jacket," as we did it in many colors for her. It's just a little extra accessory that she can wear with pants and other skirts. Laura told me she wore the pink one at the ranch when the Russian president, Mr. Putin, and his wife came to visit—she also wore it on TV interviews, as the color was flattering and great on camera.

I realized she liked things that sparkled and brought out a lollipop-red sequin-embroidered guipure lace. We put it over hot pink silk, and the red and hot pink contrasted beautifully together. This dress would be a complete departure from what we had seen Laura wear in the past. I added a red taffeta skirt as a foil for the sparkling top. The skirt was quite full at the bottom hemline but flat through the hips. It moved well and I loved the "swish" it made when she walked.

When we set up the next fitting for May 24, I suggested that perhaps we should have lunch out instead of just sandwiches in the salon.

"Yes, that *would* be nice," Laura said.

"Let's go to Le Cirque 2000," I suggested. "It's just one block away from here, it's attractive, the food is delicious, and the main thing is that it's quiet enough so we can talk."

"Maybe Libby [Pataki] could come, too? I like her so much," she said. As I like her also, it was a nice suggestion to invite the New York governor's wife.

At ten-thirty, Thursday, May 24, 2001, Laura Bush was back again for her final fitting on the clothes for Europe and a first fitting on the two long evening dresses: the turquoise chiffon and the lollipop-red sequin and taffeta. I was very pleased 'cause they all looked beautiful and her

Laura Bush in sparkling red lace top and taffeta skirt

secretary, Sarah Moss, and her chief of staff, Andi Ball, both flipped over the designs.

"Oh, Mr. Scaasi, they look great and they're so snappy—really cute!" they said while Laura was fitting the new clothes. I was to find out that Texas girls say "cute" a lot!

We were fitting so many things that I worried Laura might get tired. Not so, she has boundless energy. I was to find out that the president and first lady retire early and are up at the crack of dawn—maybe a throwback to those early ranch days. Laura was interested in every phase of the fittings.

"You can always come and run the salon," I said to her jokingly. "You have a wonderful eye and we could use someone like you around here!"

"Well, you know, I *did* go to the Singer sewing center in Midland," she laughed. "So don't think I couldn't do it."

I once sat next to the charming Mrs. Colin Powell at a state dinner, where she told me in detail how she made her own clothes. She was wearing a lovely dress, and I was duly impressed. I had a fleeting vision of Laura doing the same thing!

After the fittings, we all went downstairs, surrounded by a phalanx of security guards; there was a new small crowd in the street, wanting to catch sight of the first lady. The two Texas colleagues left and Laura and I got into her car to go to the nearby restaurant. Laura wanted to walk.

"No, we really shouldn't. Everyone will want to say hello and we'll never get there," I said. "Laura, you know I thought the article on you in this month's *Vogue* was very good. I know Julia Reed well and she's a fine writer and lots of fun too—don't you think?"

"Did you really feel it was all right?" she asked. "You know, she's from Texas and I liked her a lot—I thought she was really nice. I'd like to have her as a friend, but of course now I just can't, after all, she's part of the press." The first lady sighed. I understood what she meant. She was the *most public* figure now, the wife of the president of the United States—she wasn't the librarian from Texas anymore. This must have been difficult for her to adjust to—George W. had been in office only five months.

Of course, they fawned over us at Le Cirque. However, we didn't have my usual special table by the window, we were more into the room. Mario, the maître d'hôtel, told me the Secret Service would not allow the

first lady to *ever* sit by a window. Libby Pataki and Parker Ladd were there, Parker having brought some books for the two first ladies. The conversation flowed easily with both women talking about their daughters at college and how difficult it was to keep the young girls' lives private and out of the press—just good mother-talk! Laura Bush didn't come back to New York to fit again until after the European tour.

As Parker and I were in Europe that June, we saw the first lady on television a great deal from either our suite at Claridge's in London or from the Hôtel Crillon in Paris—she did look smart indeed, and I was very proud.

She wore the navy silk coatdress to greet the queen of Spain; she looked terrific. We had decided against the white collar and cuffs but I suggested she carry white kid gloves, which gave an elegant look to the outfit. Her assistants told me she had worn the white guipure lace and short black organza in Spain also and looked great. The next time we saw her, she was wearing the red suit, standing next to the wife of the president of Poland— looking very chic. This is the suit Laura chose to be photographed in when she was with the president and her black Scottish terrier on the cover of *Newsweek* magazine on December 3, 2001.

After these first clothes, I think Laura really felt good about herself and how she looked. I received kudos from the press and friends who remarked on how I had "improved" Laura's look. Well, I think I *did,* but it was the first lady's decision that made it happen. You know, I believe we can do miraculous things in the salon, but once the client leaves, she's on her own. Laura Bush made a great impression during that first jaunt to Europe; with her cheerful good looks and perfect demeanor she certainly made a lasting wonderful image as first lady of the United States.

In June I received an urgent call, asking me if I could do a basic two-piece suit in black in the shape we had done previously. Laura was to have an audience with the pope and needed a simple black outfit. We hurriedly made a black linen jacket and matching skirt. As there was no time for the first lady to come to New York, happily the suit fitted perfectly. Laura called and asked "what kind of hat should I wear?" I suggested perhaps a simple black lace kerchief would be correct when she visited the pontiff. Near the same time, there was a photograph on the front page of *The New York Times* at Buckingham Palace. Queen Elizabeth, smiling broadly,

is greeting the United States president and Mrs. Bush. Laura, in the red wool crepe flared day dress looks truly smart. I was pleased; she had the right clothes for each important occasion. We had done a fine job in making the first lady look smart.

We saw each other again at the end of August, and Laura seemed happy with the European summer trips and a holiday at the ranch, even though the temperature rose to 103 degrees in Texas. I guess home *is* really where the heart lies—no matter how hot it is! We planned a few more suits and day dresses and began to think of the fall evening events in Washington.

On September 5, 2001, President and Mrs. Bush gave their first White House state dinner for the president of Mexico, Vincente Fox, and his pretty dark-haired wife. When the presidential couple came down the grand staircase with the Foxes, there were audible oohs and aahs from the invited guests below. Laura looked absolutely radiant in the scoop-neck sparkling red top full-skirted bright taffeta dress. Even though I was not at the dinner, I got the skinny from Laura's assistants, who all said she looked "divine." The next time I spoke to Barbara Bush, she said the same thing, noting that the dress was "absolutely perfect"—I was happy. This was the first time I could do something really glamorous and dressy for our new first lady.

Two nights later on September 7, 2001, Parker and I flew to Washington to attend Laura Bush's black-tie dinner at the magnificent Library of Congress, celebrating her first National Book Festival weekend. We had spoken about what Laura would wear, but I was not prepared for the wonderful surprise when she came through the arch at the back of the small stage. The slim turquoise chiffon dress with low décolleté flared out and moved beautifully when she made her entrance. It was almost breathtaking—she looked like a movie star! I felt great with Parker on one side of me and novelist Barbara Taylor Bradford on the other—they both kept poking me in the ribs, giggling and telling me how fabulous Laura looked.

She had been so happy with the turquoise chiffon dress that the following year she ordered the same dress in a flattering coral shade. Her daughter Barbara, whom I had never met, arrived at the salon with her mother from a lunch at the Waldorf-Astoria where the first lady had just

been honored. Barbara turned out to be really glamorous, somewhere in the vicinity of six feet tall with all the right proportions for a young twenty-year-old. She has long black wavy hair and wore tight jeans and a see-through blouse and, of course, the obligatory high, high stiletto heel sandals. I was amazed at the dichotomy of mother and daughter—the first lady had arrived in a beige pantsuit. Laura was hesitant about the coral chiffon dress, mainly because she had one exactly like it in turquoise. The vivacious Barbara, seeing her mother in the gown, was most complimentary.

"Oh, Mama, that's so beautiful, so flattering to you. Oh, Mama, I love it!" I think this gave Laura a bit more confidence about the dress. I saw her on television about a year later at one of the state dinners wearing the coral chiffon and looking quite splendid.

Following Thanksgiving, the White House takes on a festive air, planning for all the Christmas parties that take place at the residence. There is one almost every other evening for different groups of the enormous staff and multitude of friends and supporters from all over the country.

On December 2, Laura attended the Kennedy Center Honors, recognizing lifetime achievement in the arts. She sat in the presidential box with George W. and the distinguished honorees, wearing a gown I had designed with a skirt of five tiers of flounces of black organza and a white reembroidered lace top with pearls and tiny sparkling sequins, her small waist tied in black satin ribbon, ending in a bow. The effect was perfect.

The following evening, Laura had to attend the Congressional Christmas Ball at the White House. I designed a red damask long-sleeved A-line floor-length evening dress with the now-accepted low décolleté. It was very Christmassy and perfect for the occasion and for my distinguished client. Interestingly enough, she wore the red damask gown again last year to the 2003 Kennedy Center Honors. When you're going to as many functions as the first lady does, it is mandatory to recycle your wardrobe.

We also added for the Christmas festivities a bordeaux velvet jacket and matching skirt, and ended the year on a high note with a chic pink multicolor gold brocade cocktail suit—whew! With all the other clients we were taking care of, the workrooms certainly deserved their Christmas holidays, never forgetting that the first lady *always* comes first.

2002 was equally busy for Laura Bush, as the presidential couple went off on another European tour in May. Laura became more casual in her dress, favoring pants with colorful jackets or pantsuits. We continued to make her classic suit in a variety of colors and different fabrics, sometimes doing one that could double for a cocktail reception at the White House.

For the Kennedy Center Honors that year, we did a jet embroidered black lace over fuchsia scoop-neck top, full-skirted black taffeta dress—it was glorious. Before going off to the Kennedy Center while Parker and I were being photographed in front of the great White House Christmas tree with George W. and Laura, the president admitted in his Texas drawl, "Laura looks beautiful—but Scaasi, you're breaking the bank here!" Obviously, I do special prices for first ladies, but I have to admit you pay for what you get—and what you get from SCAASI is pretty darn good! It's what couture compared to ready-to-wear is all about.

One of my favorite things I made for Laura Bush was a flowing chiffon dress, shading from plum to shocking pink. Cut on the bias, the skirt was high on one side, dipping to the floor on the other. Everyone agreed the first lady looked truly chic that night at one of her National Book Festivals, the colors of her gown setting off her glowing personality.

In an exclusive interview in *Harper's Bazaar,* Laura makes it clear: "I'm not that particularly interested in clothes, which is probably obvious."

However, I feel this is *not* obvious and may not be entirely true—maybe on the ranch her interests are different, but in the "dress up" society of our nation's capital Laura Bush can certainly hold her own as a charming, stylish, fine first lady.

Hillary and President Clinton.
The First Lady is wearing her Scaasi black chiffon gown.

CHAPTER XXII

HILLARY RODHAM CLINTON

I've always thought Hillary Clinton was good-looking. She has a wonderful expressive face that everyone can relate to—you know, sort of Martha Stewart-ish—a face that looks natural and appealing, not put on or uppity, with a wonderful smile and a great laugh. Also I think Mrs. Clinton is smart. Now I will admit that she didn't act with too much insight when Bill Clinton became president. I mean all that Healthcare mess and the firing of the White House travel office staff—not too smart, all that. But she pulled herself together, and while being there for Bill Clinton personally through all his travails, she was distancing herself from him *publicly*—getting back on track and continuing on. People who know tell me she was a very good mother to Chelsea during her husband's eight years in the White House.

After George and Barbara Bush left and the Clintons took over the presidential mansion, I remained close to Barbara and to this day I treasure our friendship. Naturally, I made no attempt to get to know Mrs. Clinton, thinking it would be disloyal both to the former first lady and to the Republican Party. After all, I had received reams of great press on my collaboration with Mrs. Bush and as a friend I felt it was unnecessary to get to know the *new* first lady.

Just after Bill Clinton won the presidential election, I received a phone call from someone in Mrs. Clinton's office (I guess, from Arkansas). I was out, so I couldn't take the call. I never telephoned back.

When the Clinton administration began, I was still doing luxurious ready-to-wear sold in stores across America. So I was not too surprised to find that Tipper Gore, Vice President Al Gore's wife, liked my clothes and

259

had purchased some designs from a local shop. Of course, the owner of the shop was all excited and telephoned to tell me "the great news." Well, I was beside myself, keeping this out of the press and hoping Barbara Bush would not find out. Even though it had nothing to do with me personally—I sort of felt like a traitor to the cause! Obviously, I am not politically very sophisticated, even after dressing four first ladies—after all, what was I so worried about?

Before the inauguration, *Women's Wear Daily* asked several top designers to sketch what they would like Hillary to wear to the inaugural ball. I refused to do a sketch, while Bill Blass, Oscar de la Renta, and others, including some European couturiers, submitted their ideas. I thought I was being noble and true to my friends, the Bushes. (Was I really so naive?)

I saw the inauguration ceremony on television and realized that Mrs. Clinton had some physical problems. The clothes she wore were dreary—in no way flattering and only emphasizing her worst feature—her legs. I would have immediately put her into a chic pantsuit in a really flattering color, in a contemporary way, so that our eye went to her pretty face. Also who on earth advised her to wear that hat? No, I think the whole look was unmemorable, unlike her predecessor; although older and larger, *her* inaugural week wardrobe remains a memorable image to this day.

I think Mrs. Clinton, sadly, had no help or if so, the wrong advice. The inaugural ball gown was equally unattractive, made of purple sequin lace, a tough color for anyone to wear, in a shape that was trying too hard to make the new first lady look contemporary and thin but ended up looking sort of sexy—not as elegant as we would like the president's wife to appear.

However, as time went on, I was interested to watch her change before our eyes, becoming a smart-looking American woman, mainly in pantsuits or long evening clothes that were definitely more flattering. Her hairstyle was changed also until she began to look like the intelligent, savvy lady she obviously is—the vibrant, serious, good-looking New York senator we see today.

In the summer of 1994, I went to an opening at the Museum of Modern Art and before I knew what was happening, I was introduced to Hillary Clinton—wow, was I surprised!

"You're Arnold Scaasi," she said, smiling broadly. "I love your clothes!" (A phrase that can melt a designer's heart and raise his ego no end.) "I have the *most* beautiful long dress of yours, tiers of pleated chiffon that stand out and flutter when I walk—it's one of the prettiest gowns I own." Turning to an assistant, she continued, ignoring the crowd that was waiting impatiently to speak with her.

"You know that wonderful black chiffon gown I have? This is Scaasi, the man who designed it." Turning toward me again, she said, " We have a great picture that we'll send you. Oh, I'm so happy to meet you. We'll send the photo off right away." Well, I was stunned, but within minutes the aide had taken down my address.

Of course, at that moment, I found Hillary Clinton perfectly charming and I resolved there and then that I would never have an unkind thought about her again. A few days later, the picture of the president and Mrs. Clinton arrived, she looking beautiful in the ruffly dress. The inscription read: *To Arnold Scaasi with appreciation and best wishes— Hillary Rodham Clinton.*

I met her again backstage at a Council of Fashion Designers of America rally and she seemed genuinely pleased to see me, asking when she could come to view the collection. Later, we spoke at a get-together for Democrats and although, for the moment, I'm still an Independent, the more I see the senator the more I like her. I think she has a very strong personality and seems to have great insight into what she's about. I believe she's doing a fine job in the Senate for my home state.

On May 3, 2004, Hilary Rodham Clinton took the time out from her busy senate schedule to fly from Washington and spend an hour reading to us from her bestselling book *Living History* at our *Literacy Partners Evening of Readings Gala.* When she arrived on the stage wearing the black chiffon tiered gown the audience applauded wildly. She truly looked dazzling and I received many compliments. I thought it was particularly nice of her to wear the dress, having to do a quick change from her senate clothes and then change back again after her appearance to fly right back to Washington. What a bright, sparkly lady.

I'm still wild about Barbara and Laura, but after all, a guy has to play the field a little and, you know, I have great affection for blondes—they *do* seem to have more fun!

ACKNOWLEDGMENTS

When I was approached to do this book, I thought it would be a cinch! After all I had told many of these stories to friends over the years—how difficult could it be? By the sixth edit on my first six handwritten pages, I understood why my concerned assistant Jerry Sirchia asked "Could we please get a computer?" I must always thank him for bringing me into the twenty-first century and helping finish this manuscript so efficiently. Also, my thanks to Loretta Nauth for cheerfully making the changes that my wonderful editor Lisa Drew so wisely set forth.

Lisa was continuously encouraging—this book would not exist without her and I must thank her always, for turning me into an author! And thank you to her great staff at Scribner, who were forever helpful.

Also quietly and determinedly nudging me on was the "no-nonsense" Roz Lippel who from the moment I met her became the life force in making this book as close as possible to what I hoped for. She is a peach of a girl! Behind these stalwart talents stands the strong supporting trio of friends, Carolyn Reidy, Susan Moldow, and the "no contest" Michael Selleck. Of course, I must thank "my family": Parker Ladd, Glendina Weste, and Kelly and Clarabelle, my two Irish terriers who all gave me ongoing support when I so sorely needed it. Who knew it would take so many beings to bring forth this book? Thank God, the wonderful Lisa Drew stopped me just in time or you might not have read this 'til next year!

Part of the author's royalties from this book will be donated to:

The Breast Cancer Research Foundation

God's Love We Deliver

Literacy Partners

INDEX

Page numbers of illustrations appear in italics.

267

INDEX

ABOUT THE AUTHOR

ARNOLD SCAASI is an American fashion legend. He has dressed hundreds of eclectic notables and a Mother Superior and her convent! He lives in New York, Long Island, and Palm Beach.